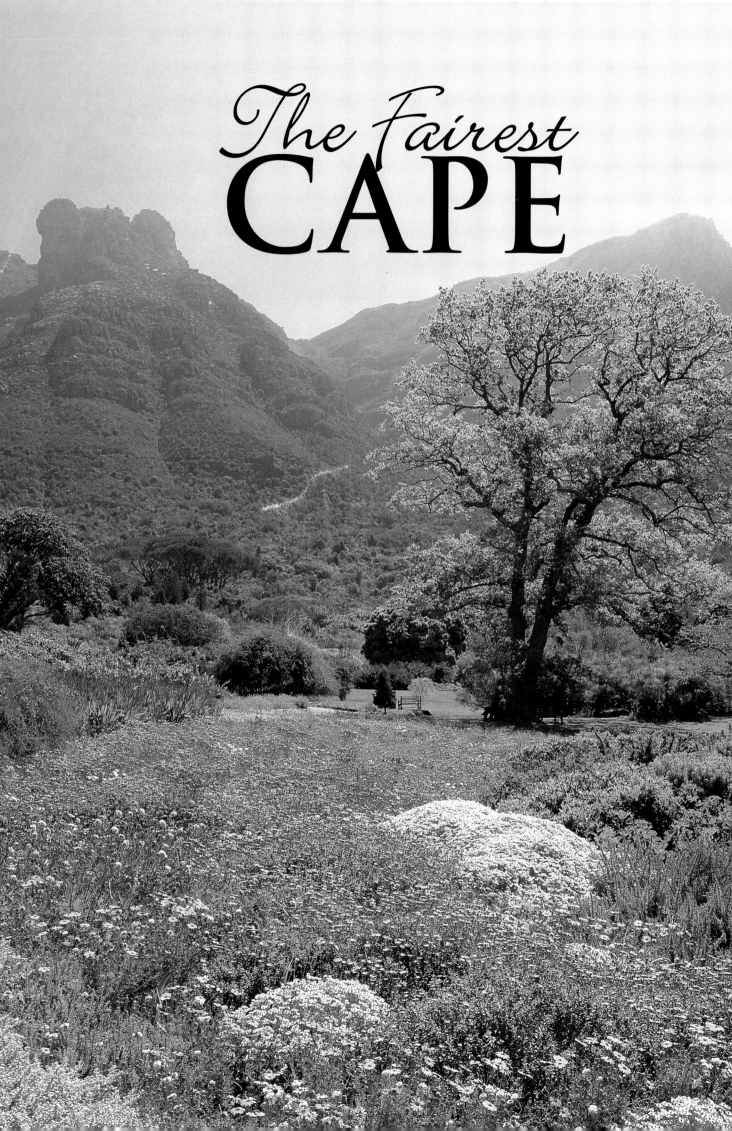

The Fairest
CAPE

SUNBIRD
PUBLISHERS

First published 2001
Second edition 2006
2 4 6 8 10 9 7 5 3 1
Sunbird Publishers (Pty) Ltd
P O Box 6836, Roggebaai, 8012 Cape Town, South Africa

www.sunbirdpublishers.co.za

Registration number: 4850177827

Publisher Natanya Mulholland
Editor Brenda Brickman
Designer Mandy McKay
Production Manager Andrew de Kock

Reproduction by Unifoto (Pty) Ltd, Cape Town
Printed and bound by Tien Wah Press (Pte) Ltd, Singapore

ISBN 1 919 93846 X

TITLE PAGE *The Kirstenbosch National Botanical Gardens, pinpointed
by the Castle Rock buttress, is the city's most acclaimed reserve.*
BELOW *The beaches of the Cape are a natural treasure house, among
the gems the unusual pansy shell, or sand dollar.*
RIGHT *Cape Town's cityscape is a balanced amalgamation of natural
beauty and contemporary development.*
OVERLEAF *The Vergelegen estate, one of the Cape's most highly
regarded wine producers, is equally esteemed for its fine Cape
Dutch architecture.*

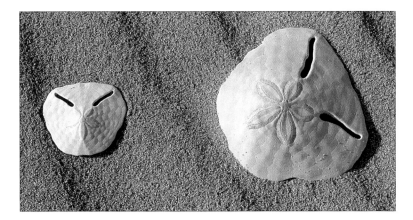

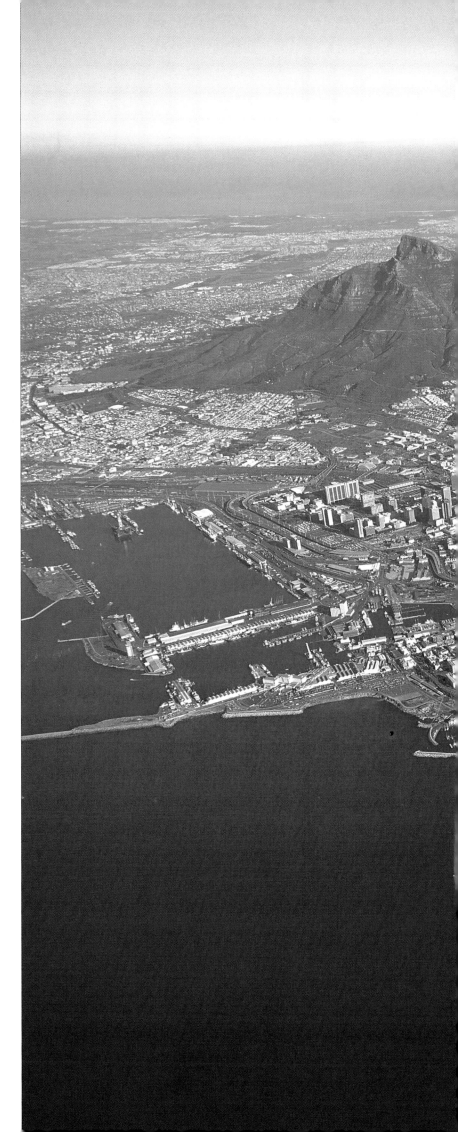

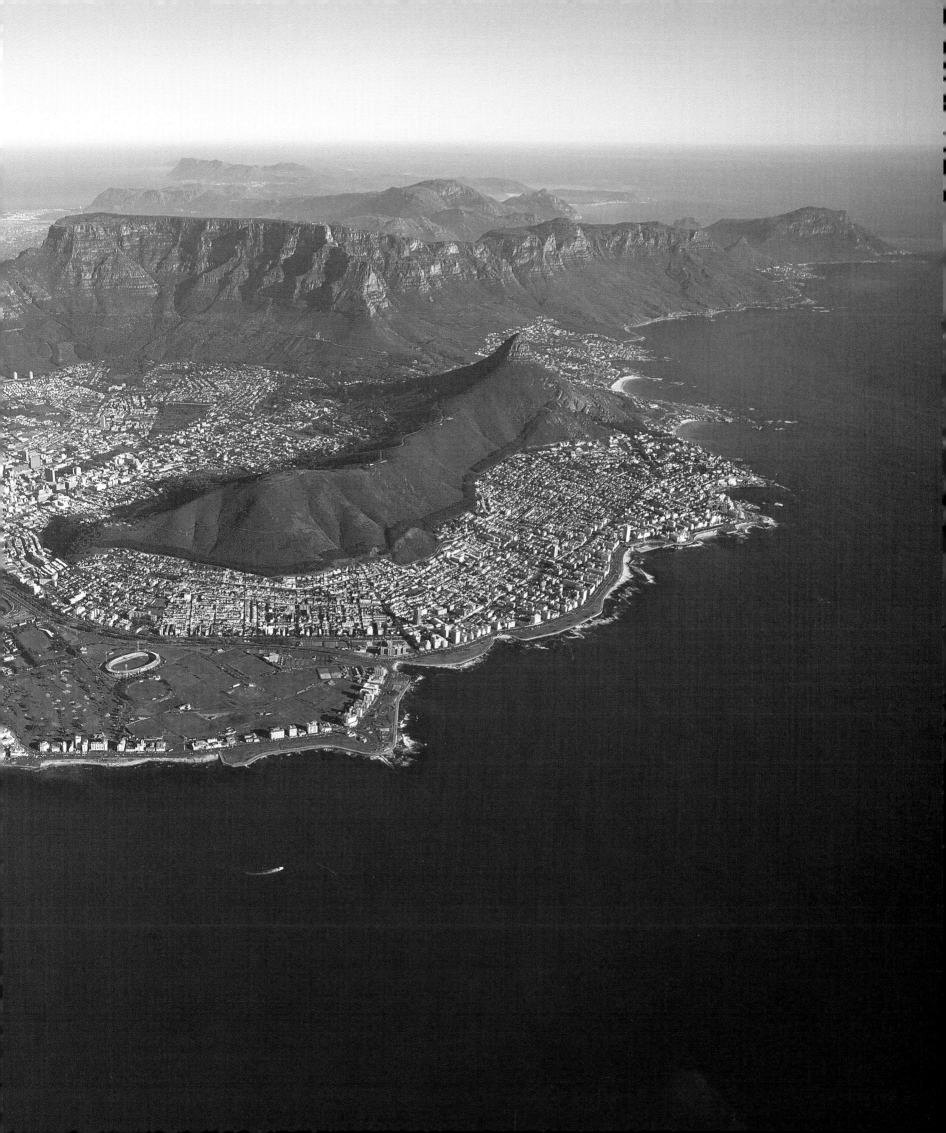

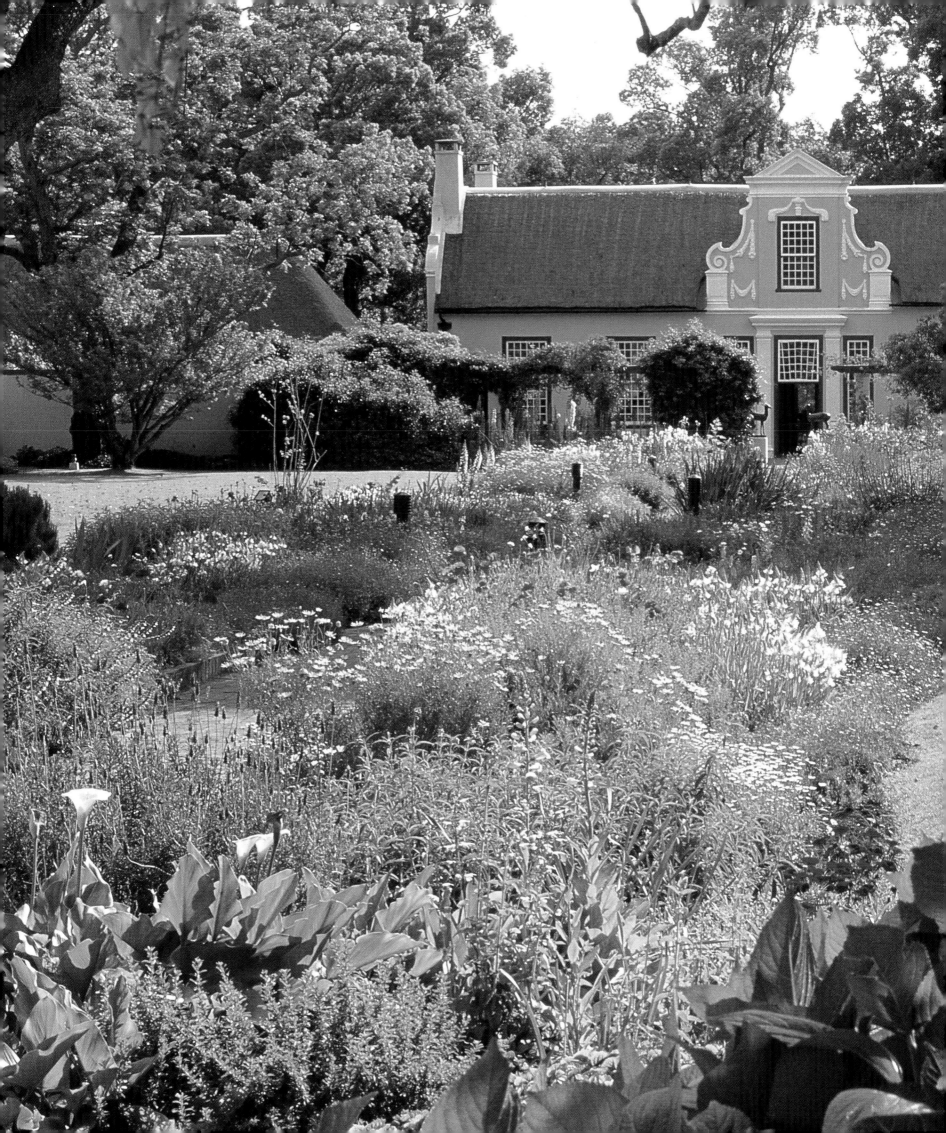

CONTENTS

THE FAIREST CAPE

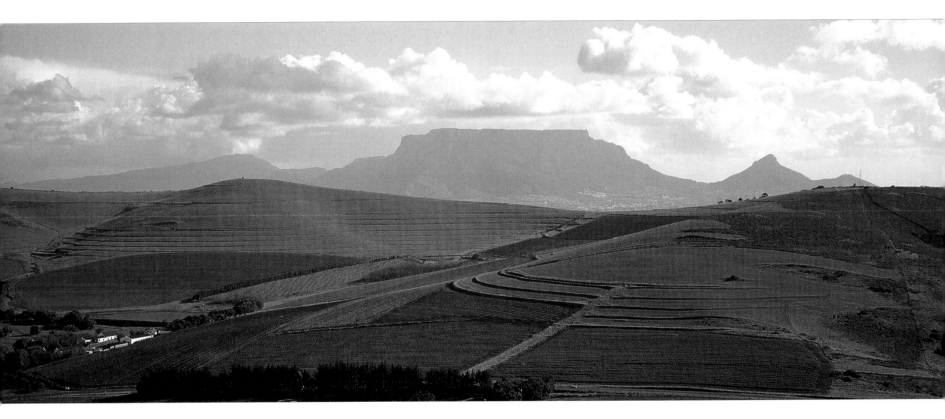

Long before all the great empires and military powers of the world sent out their fleets and legions to explore the four corners of the globe and lay claim to the most productive and most beautiful lands, seas and islands, the picturesque peninsula at the very foot of Darkest Africa had already been settled by an indigenous folk for more than ten centuries. These were the Khoisan, a small wandering group of people who spent at least part of their semi-nomadic lives in the small caves and on the rocky veld near the sea or river mouths on what came to be known during the later colonial era as the Cape of Storms. These descendants of a simple yet astonishingly innovative Stone Age community were the original settlers of that wild and ruggedly beautiful finger of land jutting out into the unpredictable waters of the mighty Atlantic.

Although the skyline may have changed quite considerably over the centuries – most notably in the last 300-odd years since settlement by Europeans – the Cape Peninsula remains as alluring, albeit in a rather different sense, as the days when its sandy beaches were first trod by the ancient Khoisan. The natural wonder of its craggy mountain face, its salt-sprayed shore, and the lush woodlands of its interior offers one of the most picturesque vistas on the entire continent and, largely because of this unrivalled splendour, one of the most sought-after protectorates in the history of colonisation.

Its turbulent past notwithstanding, the natural heritage of the Cape Peninsula has emerged virtually unscathed from centuries of settlement and development.

Although the city of Cape Town is indeed a modern metropolitan centre boasting all the amenities and conveniences of a First World city on a largely Third World continent, contemporary Cape Town is a happy mix of trendy city life and the gentler, laidback lifestyle that has made it South Africa's premier holiday destination. And yet, despite the enormous progress it has seen in the erection of grand new hotels, burgeoning enterprise, busy shopping malls and extensive entertainment centres, it is the magic of its natural beauty that remains its most enduring legacy. From the perspective of the botanist, zoologist and conservationist, the Cape is a naturalist's haven, comprising as it does innumerable treasures of enormous importance not only to the microcosm that is its immediate ecosystem but to the greater Western Cape region as a whole.

The Cape Peninsula today is one of the few remaining urban centres on the continent that has successfully married the needs of

a growing population with the requirements of a sustainable ecology that elsewhere is having to make way for human development and modernisation. Although there is evidence that the ideal of mutual cooperation between humankind and Mother Earth has been sacrificed in the name of 'progress', these instances are few and far between, with much of the 75-kilometre (47 mile) stretch of peninsula a happy blend of suburbia and relatively untainted wilderness.

The busy intersections, teeming thoroughfares and lively pedestrian traffic of the central business district are evidence that this is indeed a modern, thriving city that has embraced a far greater heritage than its legacy as a wonderland of mountain, beach and wooded valleys.

The term 'Mother City' was only adopted in the 1930s, when the city was first officially acknowledged as a metropolis. Today Cape Town is a flourishing centre of the performing arts, fine art and haute cuisine, *a treasure-house of history and one of Africa's great melting pots of cultures and peoples.*

But Cape Town is so much more than the city and its immediate surrounds, incorporating the imposing backdrop that is Table Mountain, the bustling Victoria & Alfred Waterfront on the shores of Table Bay and world-renowned Robben Island on the not-too-distant horizon. Greater Cape Town comprises a string of leafy suburbs dotted along the ridge that forms the spine of the peninsula. In the fertile hinterland lie the spectacular Cape Winelands, while along the shore that stretches north of the city is the equally picturesque West Coast.

To the east of the Hottentot Holland mountains lie the wide open expanses that comprise the Overberg and the Little Karoo, while beyond – on an extraordinarily scenic stretch of coast – winds the splendour of the Garden Route.

Cape Town's city centre is a microcosm of Greater Cape Town. Along its avenues and boulevards, most of which find their origins in the mid-1600s when the Dutch colonists first established their victualling station on these shores, stand offices and apartments, lofts and retailers. As the central business district, the shallow bowl at the foot of the hills and mountain that encircle the city is a bustling conglomeration of traffic and people.

With such a diverse history that has seen the influence of British and Dutch naval powers, the influx of Indonesian and Malaysian slaves, and settlement by rural migrants in search of employment in the urban centres, Cape Town is a fascinating blend of culture and politics, from the stained-glass windows of St George's Cathedral on Wale Street to the porticos and pavilions of the Houses of Parliament on Government Avenue. Sprawled out alongside the latter is the old Company's Gardens, originally planned by one of the city's founding fathers, Jan van Riebeeck, in order to supply the passing Dutch fleet with fresh produce. Interspersed among the city's many landmarks of historical significance are reminders of the vibrant and exciting society of a more modern era: the Artscape Theatre on the Foreshore – much of which was reclaimed from the sea in the late 1930s and early 1940s

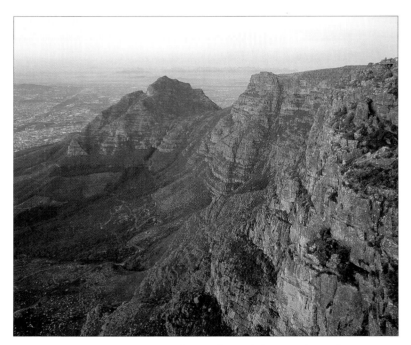

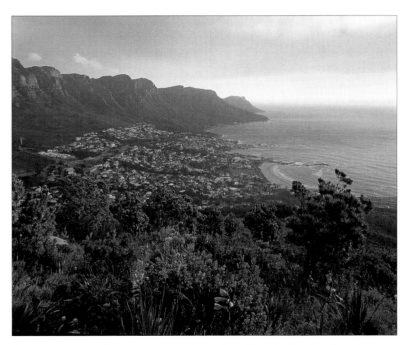

OPPOSITE *Looking from the verdant valleys of the Cape's northern suburbs beyond the limits of the thriving metropol, lies the rugged mountainscape of Table Mountain.*

LEFT AND ABOVE *From vantage points offered by the Twelve Apostles (left) and Lion's Head (above), vistas extend from the rocky slopes to the waters of the Atlantic.*

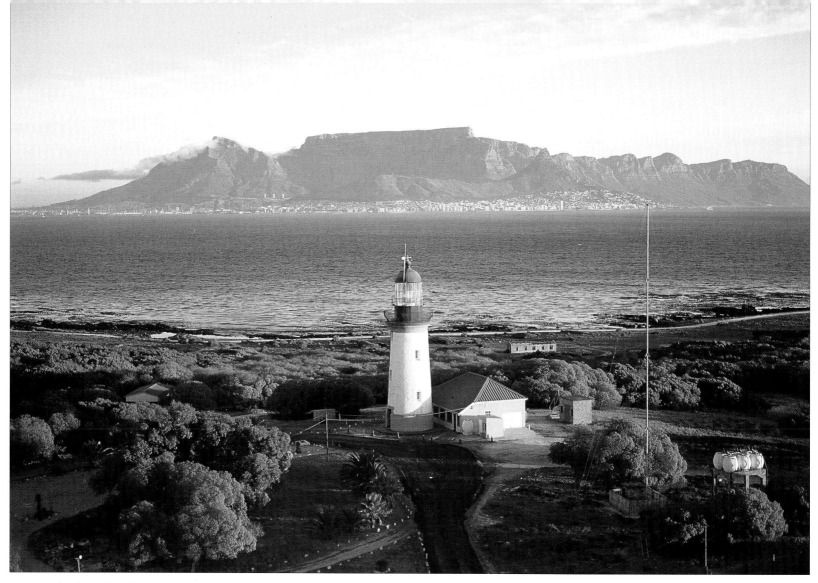

ABOVE *The face of Table Mountain – seen here from Robben Island – may be spotted on the horizon from some 200 kilometres out in the Atlantic.*

– and the new international convention centre making its mark on the outskirts of the harbour.

Towering high above the bustle of the city centre is the edifice of the famed mountain, a shale, sandstone and granite monolith covered

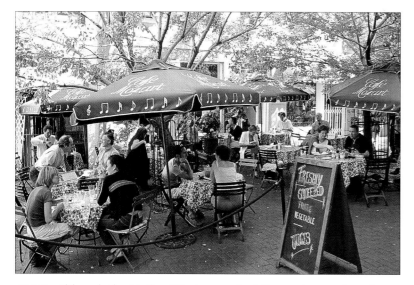

ABOVE *Although the Mother City is every inch the modern metropolis, informal trading stalls dot its quaint, old cobbled corners.*

with a sandy sediment deposited some 500 million years ago. There was a time when an assortment of wild creatures roamed these rocky slopes. Today, however, it is the domain of the dassie, or rock hyrax, which scampers up and down the steep embankments.

The highest point on this instantly recognisable landmark is MacClear's Beacon, which reaches approximately 1 086 metres (3 564 feet) above sea level, but it is the slopes and the table-like summit rather than the highest peak that draws the visitors.

Having operated for some 70 years, the old cable cars that ferried visitors to the flat top of the mountain were relatively recently replaced by the Table Mountain Aerial Cableway Company with modern state-of-the-art cars, offering a full 360-degree panorama out over the mountain face, the city below and across the Atlantic Ocean. And yet, with all its impressive views and unrivalled scenic beauty, it is the natural heritage of the mountain that remains its greatest attraction. Table Mountain lies in the very heart of the Cape Floral Kingdom, the world's smallest floral kingdom, 80 per cent of which comprises fynbos – hardy fine-leaved shrubs and plants that have taken root in these nutrient-poor soils. Prime among them are the dominant erica, reed and protea families of plants, which contribute much to the more than 8 500 species that can be found on Table Mountain.

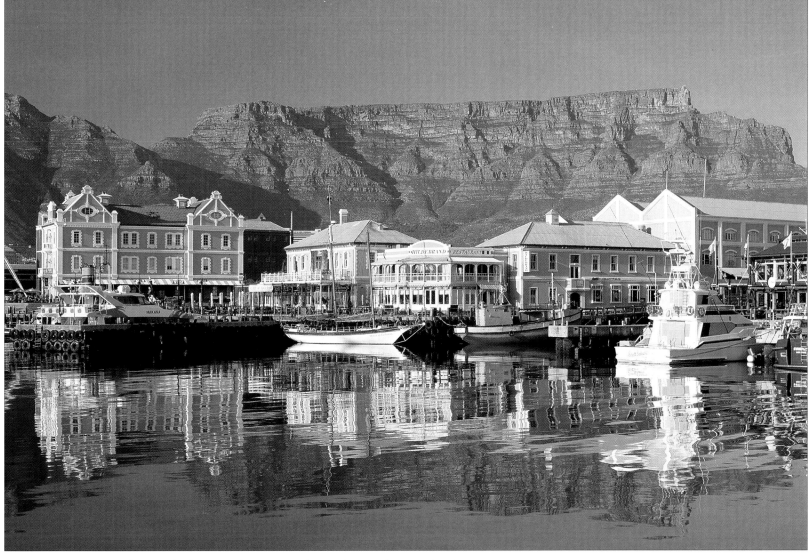

ABOVE *The V&A Waterfront is the kingpin of Cape Town's most innovative new developments.*

For a closer look at this unique array of flowering species, hundreds of thousands of visitors make their way to the 500-hectare National Botanical Gardens at Kirstenbosch. Approximately 95 per cent of this ground is covered by indigenous fynbos and natural forest, but more than 35 hectares of the world-renowned gardens have been given over to research and cultivation.

It is against this impressive legacy of wildlife and indigenous flora, culture and history that the modern city has established itself as the country's holiday mecca, at the centre of which is Cape Town's Victoria & Alfred Waterfront established on the largely rundown docklands of Table Bay in the early 1990s. In fact, what started out as a simple, innovative idea to rejuvenate part of the old docks by opening one or two pubs and eateries in the dilapidated buildings that lay disused along the jetties has grown into South Africa's most impressive tribute to its ever-growing hospitality industry. Today, the V&A Waterfront is Cape Town's biggest attraction, drawing visitors and travellers from across the globe to its trendy cafés and cosmopolitan restaurants, haute couture *boutiques and row upon row of fashionable shops.*

Although the Victoria Wharf, with its wide and spacious walkways open to the heavens through impressive skylights and domes, is but part of the shopping and entertainment haven that is the Waterfront, it is the heart of the complex. To be found here are a number of *cinemas, restaurants, music shops and Cape Town's finest department stores. The passages and walkways – most especially during the peak of the December holiday season – are inevitably packed with spirited*

ABOVE *Some of the city's golf courses – including Mowbray – are established landmarks with a long and proud history.*

ABOVE *Like many of the settlements along the West Coast, Langebaan traces a long and proud association with the sea and its treasures.*

shoppers and late-night revellers, either strolling from shopfront to shopfront or flitting between the various entertainment venues until the early hours of the morning.

It is also from the lively V&A Waterfront that visitors embark on the ferry that carries them to that other Cape Town landmark – Robben Island, symbol of South Africa's long struggle for democracy. The island, comprising only just over 570 hectares (1 400 acres) of unspoilt land, lies less than 12 kilometres (7 miles) off the shores

of Table Bay, and from the island one can see the imposing face of Table Mountain looming on the mainland. With its years as a refreshment station for passing fleets and a penal and leper colony long since over, Robben Island is today a living museum of cultural and natural history. Conservationists have hailed it as one of the few remaining unblemished natural ecosystems in the world, while historians consider it a remarkable monument to the sociopolitical struggle for democracy fought in South Africa over the last 50 to 100 years. It is here that labourers toiled to extract stone from the quarries and lime from the beaches in order to build the gigantic walls of the Castle of Good Hope in the fledgling mainland settlement between 1666 and 1679. It is here, too, that Nelson Mandela did much the same some 300 years later.

Since 1991, the status of the island has enjoyed much debate. Should it be declared a national park of sorts, reserved exclusively for the purposes of conservation and research, or should it – as such a vital symbol of latter-day democracy – be opened to the public? It seems that a combination of the two is to be the compromise, and Robben Island was declared a World Natural Heritage Site in 1999, further emphasising its significance to the global village.

The tiny island is but a satellite of Cape Town that comprises not only the City Bowl, but also the series of pretty suburbs that runs around its rocky ridge. From old and established suburban settlements such as Observatory, Mowbray and Rondebosch to the newer, more rural enclaves on the outskirts of Cape Point Nature Reserve – among them picturesque Noordhoek and Scarborough – the suburbs of the peninsula are a fine tribute to the history of the Cape. The grand old

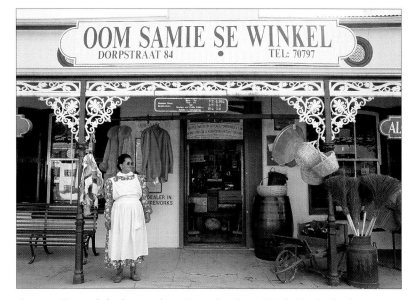

ABOVE *General dealers such as Oom Samie se Winkel in Stellenbosch still pay homage to the days of old in the Cape hinterland.*

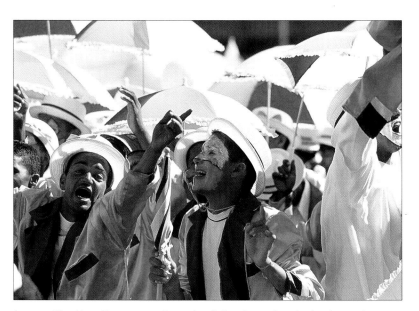

ABOVE *The New Year sees minstrels of the Coon Carnival take to the streets in celebration.*

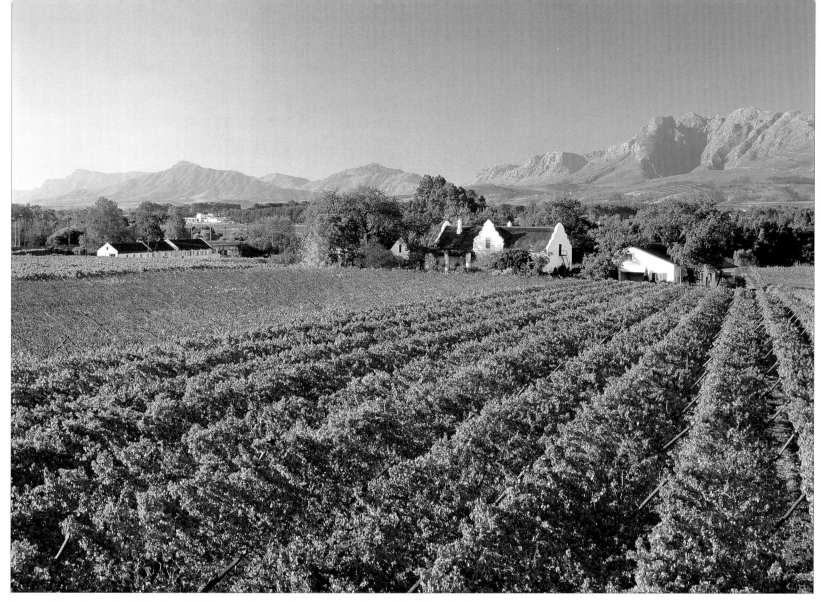

The vineyards of the Paarl Valley are backed by the stony face of the Klein Drakenstein mountains.

Victorian homes of the Southern Suburbs, incorporating Rosebank, Rondebosch, Newlands, Claremont, Kenilworth and beyond, stand side by side with burgeoning commercial centres, dotted with modern shopping malls. Further south along the peninsula, towards Cape Point, the buildings are equally grand, but more often than not interspersed with homes and business blocks of a more contemporary design. The closer one gets to the southern tip of the Cape Peninsula, the more rural the landscape becomes, the wild, open spaces more frequent and more extensive than the park-like grounds closer to the city. Many of these areas fall within protected terrain, preserved for their contribution to the local ecosystem and the animals and plants that make their home here.

While the landscape of the southern peninsula is most noted for its natural and wildlife heritage, the Northern Suburbs – that extend in the hinterland east of the city centre – are coming into their own, quickly becoming popular for the wide open spaces that surround the clusters of homes and the lavish and impressive entertainment centres that have sprung up here in recent years. Most significant of these new developments are the Century City Office complex, with the adjoining Canal Walk shopping centre and the GrandWest casino development.

But the pride of the Cape must be the fertile soils of the bountiful Cape Winelands even further inland. This is a world of lush vineyards, vines heavy with the juice-filled grapes that have made Cape wines famous across the world. It is in these nutrient-rich fields and along these productive valleys that viticulturists cultivate and tend vines first brought to Africa from the vineyards of France and the rest of Europe when the Huguenots settled the district from 1688, after fleeing persecution. It is here, too, that some of the world's most successful vintners source their wines for distribution across the globe.

The small semi-rural towns of Stellenbosch, Paarl and Franschhoek, established in the early days of the farming settlement, cater not only for the wineries so prolific in the area, but also for the wider farming community. As a result, the atmosphere in these little towns is quite charming, reminiscent of a long-gone era, their wide old streets lined with Victorian shopfronts and general dealers selling an endless variety of hand-made and homemade goods. Although there are inevitably the trappings of a modern society – especially Stellenbosch, with its vast university campus and the many young students who have set up home here – it is the old-world charm of the towns that is their most enduring attraction. Filigreed ironwork

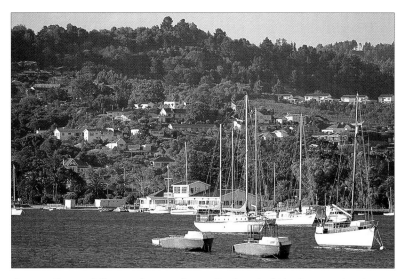

ABOVE *Tranquil Knysna lagoon forms the heart of the burgeoning town, entrenching it as one of the Cape's premier holiday stopovers.*

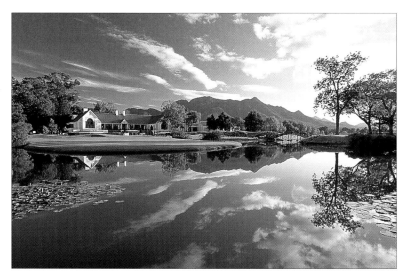

ABOVE *The Fancourt Hotel and Country Club on the picturesque Garden Route has gained an enviable reputation for its fine golf course.*

ABOVE *The small town of Oudtshoorn was once the lifeblood of a thriving ostrich-feather industry.*

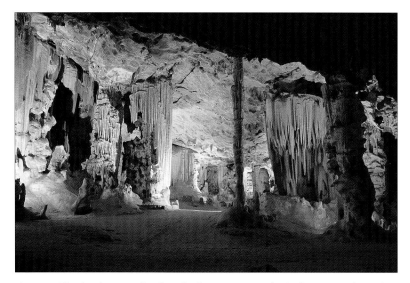

ABOVE *The intricate web of eerily lit caverns and winding tunnels makes the Cango Caves the most popular attraction on the Garden Route.*

decorates the single- and double-storey buildings that line the thoroughfares, old stone walls hemming them in from the wide streets once traversed by horse and pony carts.

In fact, this is true of many of the smaller towns and hamlets that punctuate the Cape countryside, from Langebaan, Saldanha, Paternoster and Lambert's Bay on the West Coast to Robertson, Montagu, Swellendam, Caledon and Bredasdorp in the Overberg. All have a distinct allure that seems to transport one to another time, another era; yet the towns of the rugged West Coast have an appeal that is all their own. Generally, the people here are a simple folk, and the whitewashed cottages that line the wave-lashed shores are characteristic of the region. While some of the towns are little more than small conglomerations comprising a post office, general dealer, church and rectory, the larger towns are surprisingly well developed – especially considering the lonely stretches of white beach and rocky road that separate the West Coast from urban Cape Town. Many have built on their historical association with the environment and have become centres of modern industry, most notably the fishing industry. Relying on the diligence and enterprise of the local communities, many of the country's top-flight fishing companies have established themselves here, earning a reputation worldwide for the quality of the seafood originating on the West Coast.

The Overberg and the Little Karoo are, however, an entirely different story. Where the West Coast is fringed with an expansive blue ocean, much of the inland terrain – although quite fertile in parts – is comparatively dry. At the same time, however, heavy winter rains can contribute considerably to the productivity of the farmland, most notably the fruit farms in these regions. Craggy and rough, the mountains and valleys of the Overberg and the plains of the Little

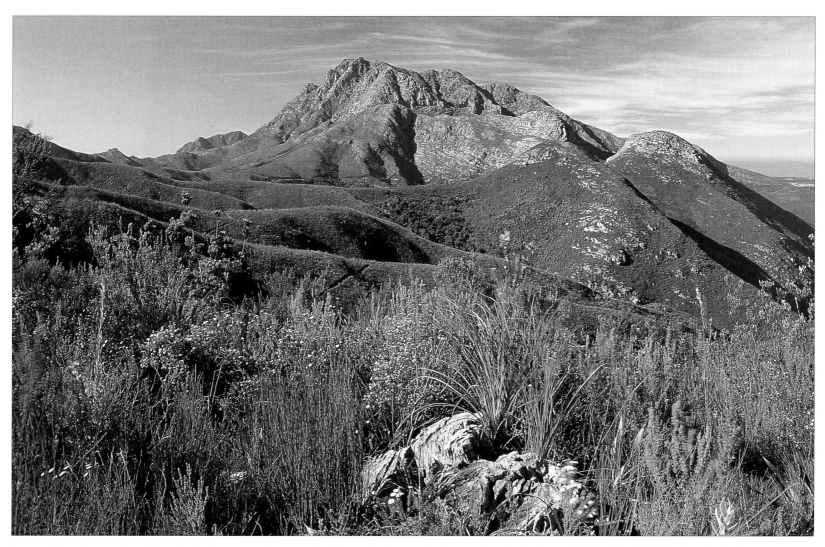

The stony peaks of the Outeniqua range form part of the rocky barrier that separates the lush coastal stretch of the Garden Route from the less verdant interior.

Karoo boast some spectacular scenery, from the steep inclines of the precipitous passes to uninterrupted stretches of pasture.

Indeed, much of the landscape of the southern Cape is very impressive, varying from endless expanses of fynbos to thickly wooded plantation, sparkling white beach to verdant vineyards, but nowhere is it as all-encompassing as it is on the southwestern coast between the town of Mossel Bay and the mouth of the Storms River. This is the Garden Route, an extraordinarily beautiful countryside that winds along the contours of the subcontinent for no more than 200 kilometres, but is hailed far and wide as South Africa's great Eden.

Lined with one charming town after another – including some of the country's most notable holiday resorts, such as that of Plettenberg Bay and Knysna – the Garden Route is the most spectacular of all the country's scenic routes. This stretch of shoreline is abundantly vegetated and boasts an extraordinary array of flora and wildlife.

The rolling beach sands attract an endless caravan of adventurers and holidaymakers to this wilderness. Flanked in the east by the warm waters of the Indian Ocean and in the west by the sometimes parched hinterland, this place of solitude and tranquillity is a traveller's paradise. Much of the coastline, battered in parts by wind and pummelled by the ocean, is traversed via well-developed road, with occasional dirt roads, usually leading to out-of-the-way havens.

The sandy dunes of the Garden Route are liberally sprinkled with innumerable species of indigenous flora and visited by a wide variety of small mammals. In parts, boulders and rocks dot the beaches, while at other points bountiful rivers spill out into the sea.

This region is clearly far from barren, and not for nothing is it known as the Garden Route. The patchwork of colour and shapes of the flowers, fields and rock-strewn seascape hold pride of place on this South African landscape already blessed with abundant beauty, from the wonder of the West Coast to the glory of the Garden Route.

THE MOTHER CITY

Long before the Dutch and English colonists set foot on the shores of what is today Table Bay, small communities of indigenous Khoisan walked this windswept beach, living off the fruits of the tumultuous ocean and taking shelter in the caves and overhangs of the striking flat-topped mountain that forms its backdrop. This rugged massif of sandstone and shale would come to symbolise not only the trading post that found its roots here in the seventeenth century, but also the thriving metropolitan centre that remains the gateway to Africa.

Between the docklands of the Foreshore and the green slopes of Table Mountain lies a sprawling city of architectural gems – from the Castle of Good Hope and the Houses of Parliament to plush new hotels and convention centres – historic reminders of the past, business enterprises and an endless sea of market stalls and coffee houses, all peopled by suited bankers and financiers, street vendors and artists, hoteliers and restaurateurs, tradesmen and civil servants.

Although not large by international standards, Cape Town's city centre, with its colonial-inspired façades and high-rise office blocks, is every inch the cosmopolitan heartland of not only the peninsula, but indeed the country. With its colourful history dating back to the scattering of semi-nomadic communities who gathered here from time to time during the year, the metropolis of today has seen unprecedented growth in recent years, as it has become the ever-growing tourism industry's most popular drawcard.

Cape Town – like many of the country's urban centres – has in the past been plagued by the political turmoil that saw many of its people repressed, dispossessed and displaced, but it has risen Phoenix-like from the ashes to take its place as the pride of the nation. Its busy thoroughfares, lined with some of the finest examples of Dutch and Victorian architecture on the continent, throng with traffic, while high above the pedestrian walkways tower multistorey buildings housing the commercial interests of the city. Filling the spaces between the grand old edifices of yesteryear and the modern structures of the new South Africa are small oases, reminders of Cape Town's humble past. Elaborate fountains, islands of green and statues of statesmen and 'founding fathers' stand proudly alongside mosques, shrines and cathedrals, reflecting the rich cultural history of Cape Town's people – from the Indonesian roots of the descendants of slaves who helped establish the early colony to the Dutch and English traders and farmers who settled here in the mid-1600s. Interspersed are contemporary additions to the social life of the city.

Modern Cape Town is entertaining and exciting, filled to the brim with chic new eateries, lively nightspots and cosy theatre venues that form the pulsating hub of the city as the sun slips behind the mountain and darkness settles over Cape Town.

RIGHT *The detrimental effects of floodlights on Table Mountain's fauna means that the façade is now lit only occasionally.*

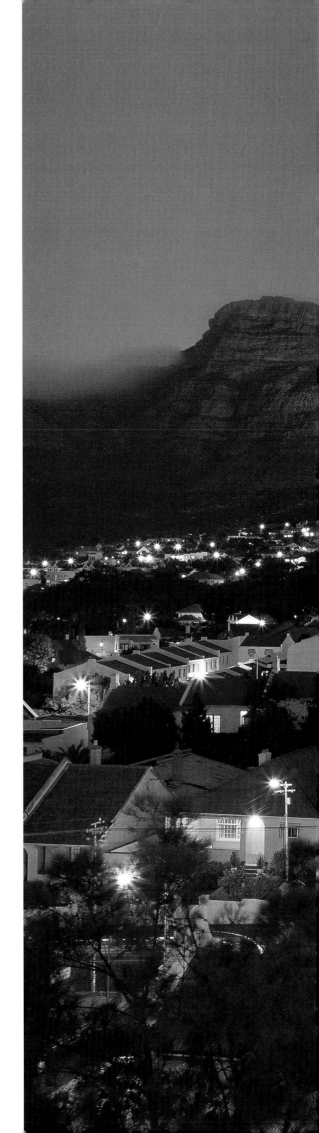

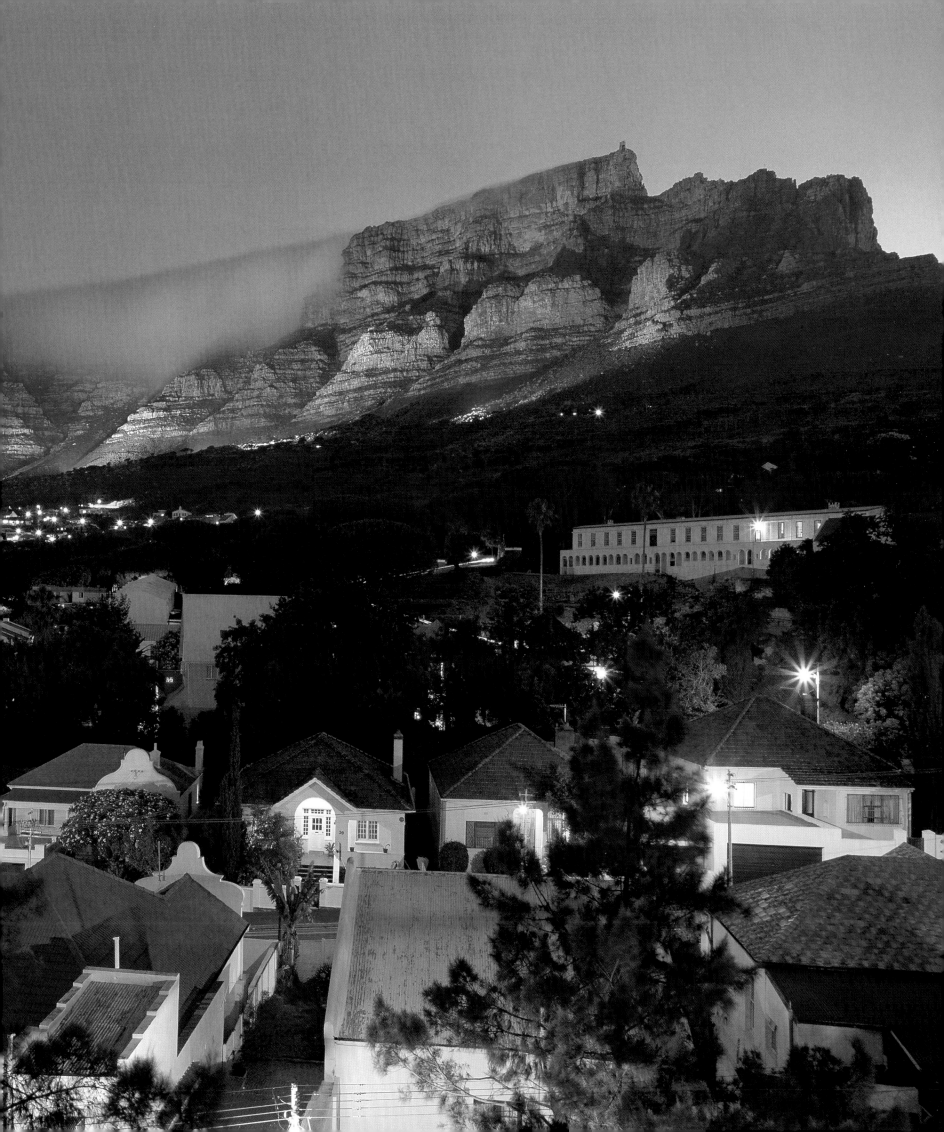

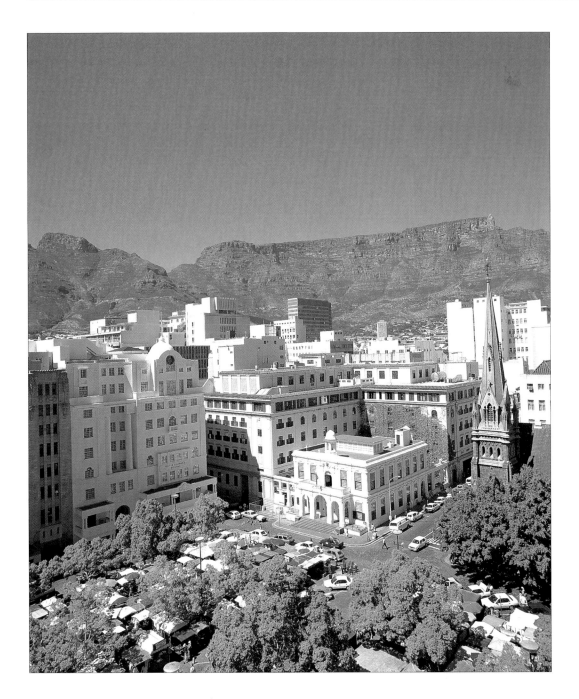

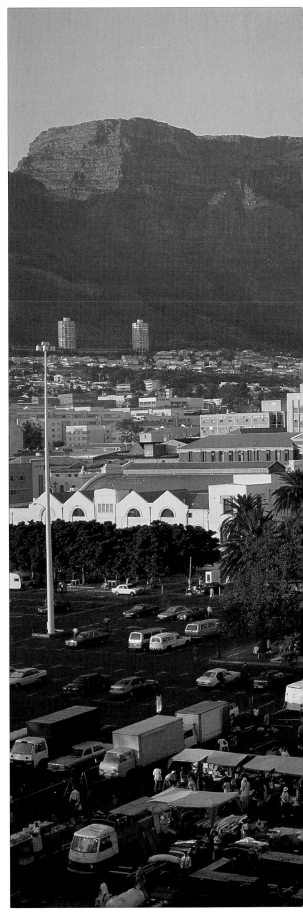

ABOVE *In the heart of the city stands a cobbled plaza that was once the centre of the colony's produce market. Today, charming old Greenmarket Square is a hubbub of informal trading and street entertainers.*

RIGHT *For nearly 100 years, the Italian Renaissance façade of City Hall has held pride of place over the latter-day market activity of the Grand Parade, originally the parade ground of military garrisons stationed at the outpost during the colonial era.*

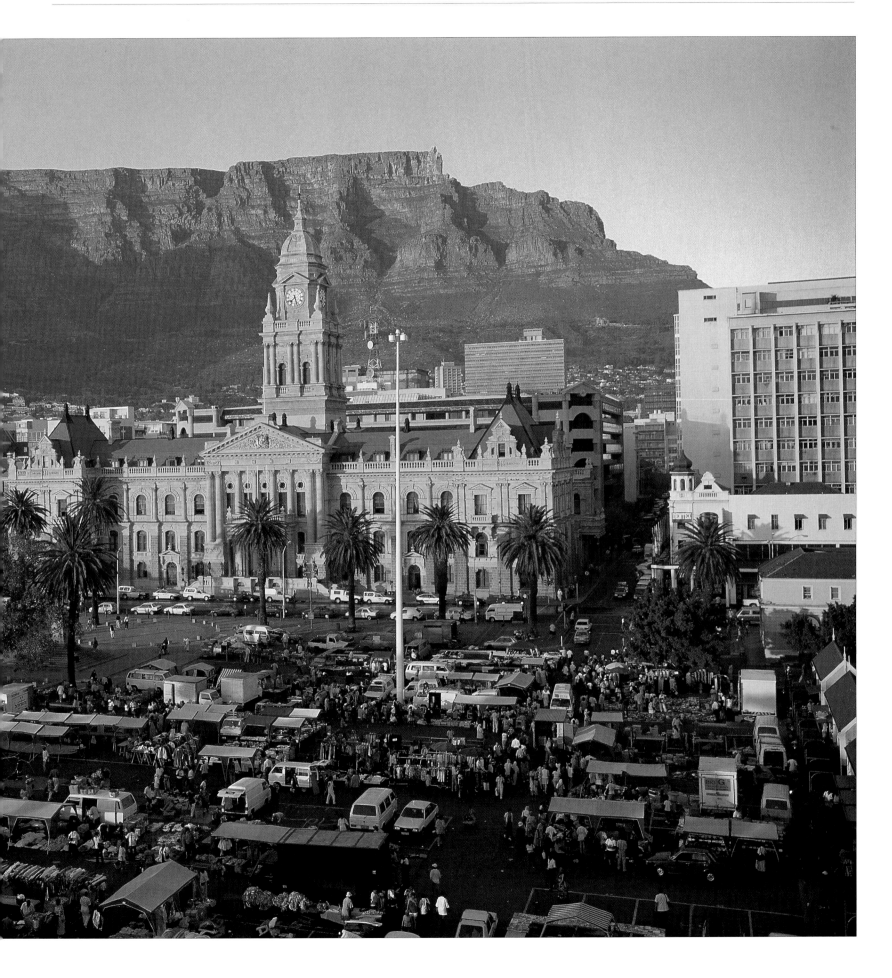

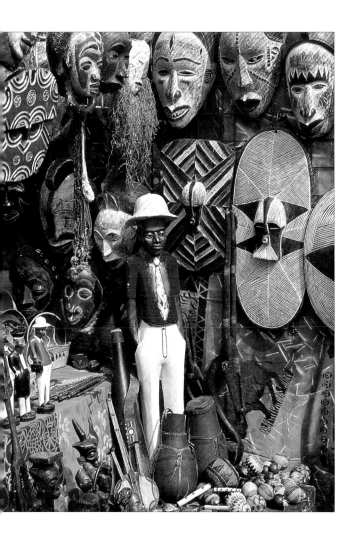

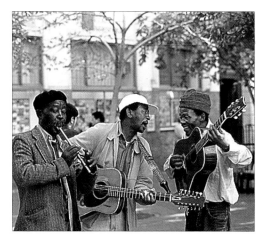

ABOVE LEFT *The tourism industry is a vital cog in the economy of Cape Town, and enterprising local traders have cornered the ever-growing informal market for curios that offer a memento of a visit to Africa.*

TOP RIGHT *Amid the flurry of curio vendors, flower-sellers and informal traders, the malls and thoroughfares of the city see a constant parade of industrious street performers set on entertaining the visiting throngs.*

ABOVE RIGHT *To add to the carnival atmosphere of the city centre, a number of street musicians have claimed their spot on the shop corners and pavements of the Mother City.*

RIGHT *Cape Town may well be hip and trendy, with a distinctly cosmopolitan feel, but the curio trade, with its hand-painted fabrics and roughly hewn sculptures, remains vital to the economy of the city's informal sector.*

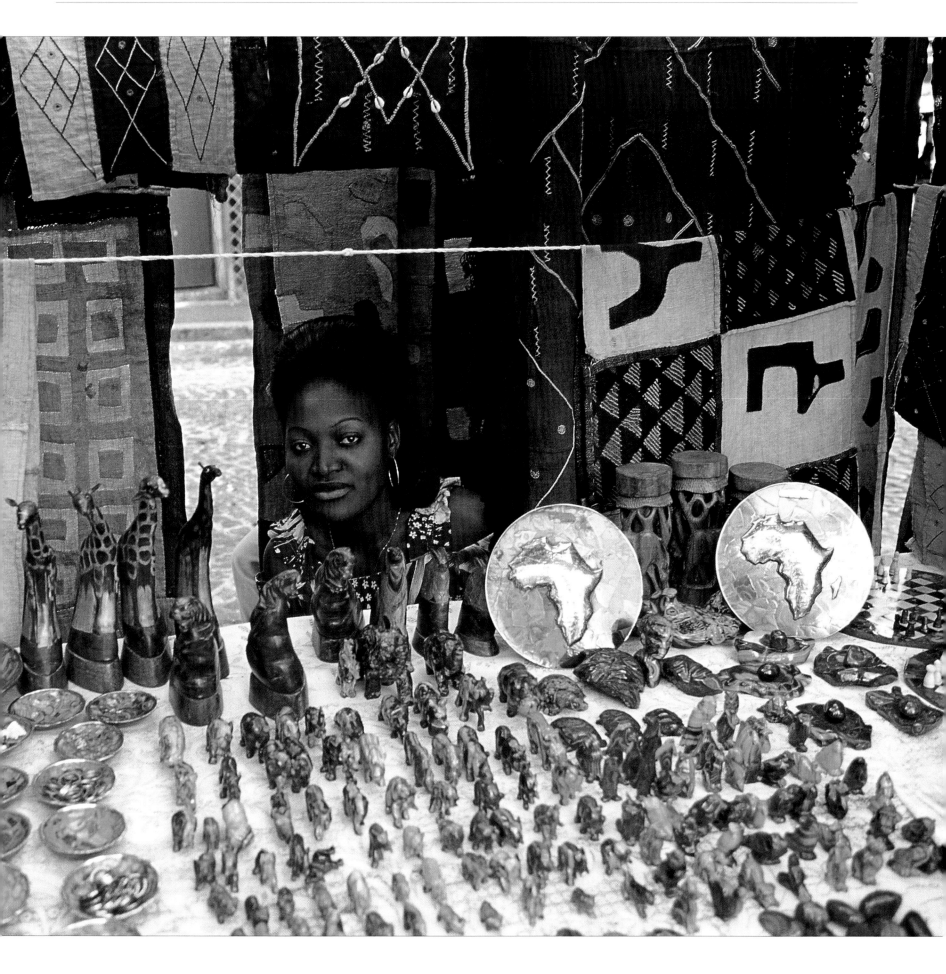

ABOVE AND ABOVE RIGHT *Much of the architecture of the city – from renovated private homes (above) to the garden façade of Tuynhuis (above right) – relies on contemporary influences of the colonial era and the Victorian, Edwardian and Georgian styles of the day.*

OPPOSITE *Of all Cape Town's streets, lined as they are with gracious old structures of yesteryear, the grandest and most extraordinary of these must be Long Street, an amalgamation of architectural styles and cultures, and today the heartland of the city's nightlife.*

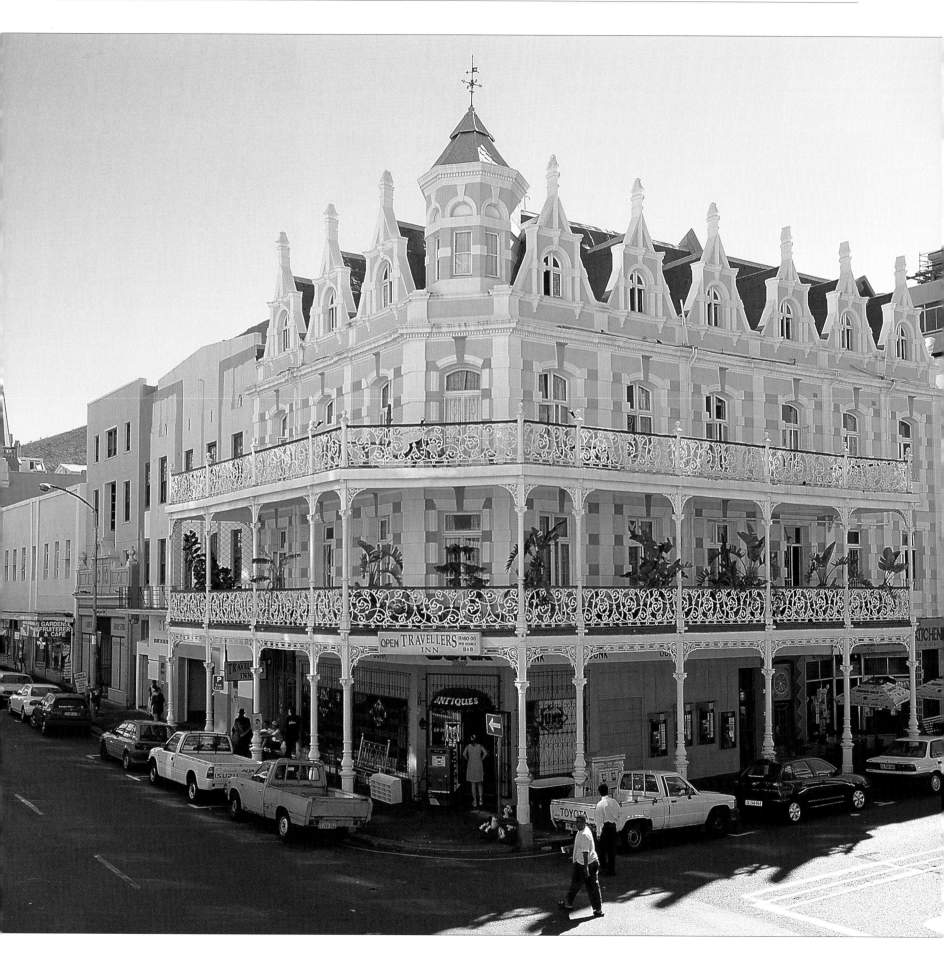

Top *Remnants of a time when freed slaves first settled in the 'upper city' on the slopes of the mountain, many of the century-old homes of today's Bo-Kaap community remain faithful to the architectural styles of the mid-1800s.*

Above *Many of the Cape's Muslim community trace their heritage to the slaves and political exiles first brought to the fledgling colony from as far afield as Indonesia, India, Malaysia and Sri Lanka. Today, Cape Town's Muslims remain a religious and tight-knit group, who contribute much to the heritage of the modern city.*

Right *Cape Town is a place of many faces – an amalgamation of the descendants of Afrikaner farmers, Indonesian slaves and Anglo-Saxon settlers – but it is the colourful character and lively banter of the city's flower-sellers that are most typical of the Mother City.*

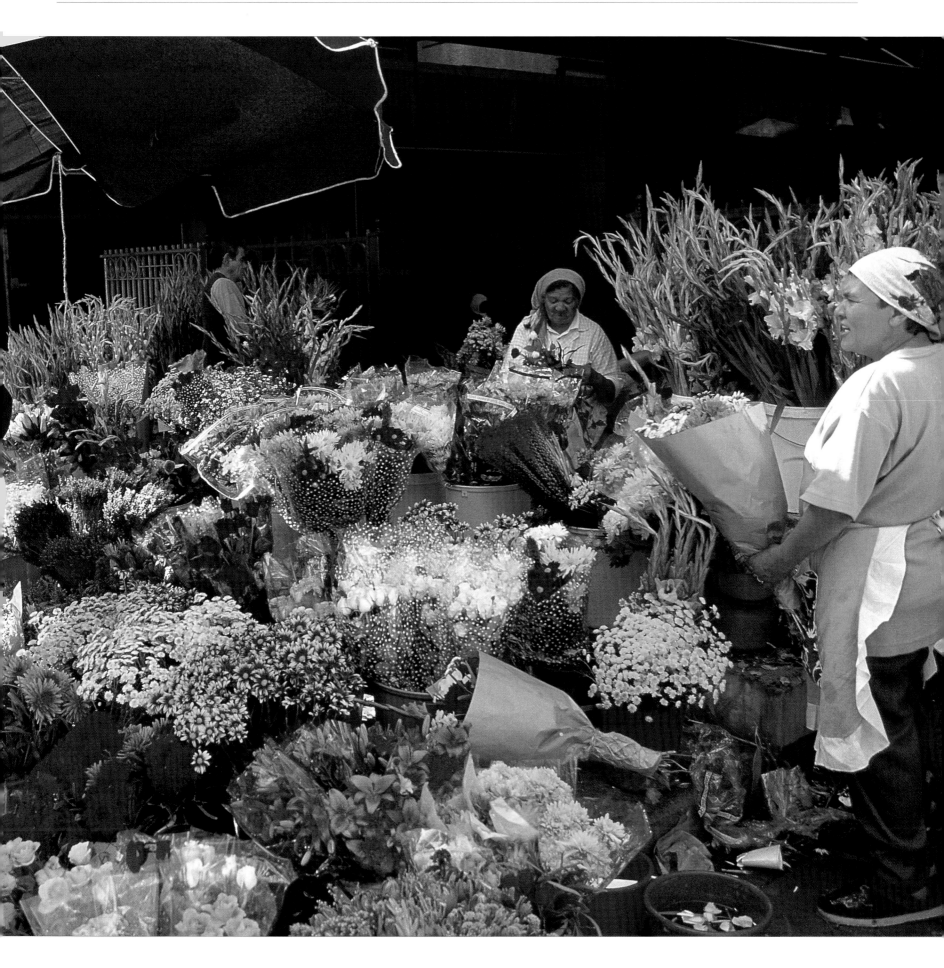

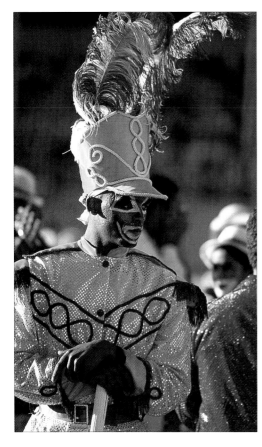

ABOVE The musicians and minstrels that make up the Cape Coons are from the coloured community, and many of the virtuosos are taught as children the colourful art of popular entertainment and street performance.

LEFT Picking up popular themes of the day and combining a patchwork of colour and stage make-up, the costumes of the Cape Coons make individual statements that help identify the many different troupes taking part in the parades.

OPPOSITE TOP Preparations for the city's annual New Year celebrations begin almost a year prior, and the costumes and choreography for each troupe are a closely guarded secret until the clock strikes midnight on 31 December.

OPPOSITE BOTTOM Although few of the musicians who take part in the annual Coon Carnival are formally trained, the lively strum of the banjo and resonant sound of the horn nevertheless combine to make a spirited parade.

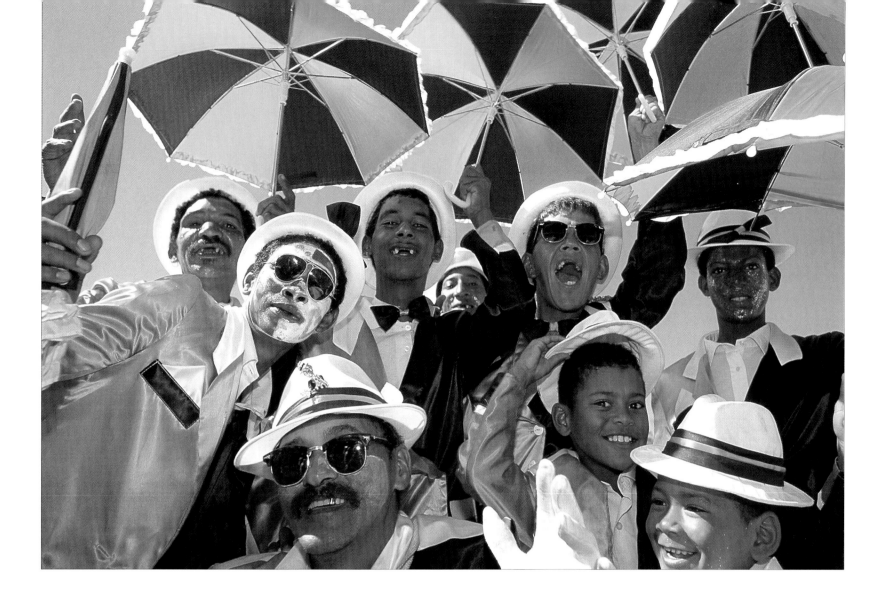

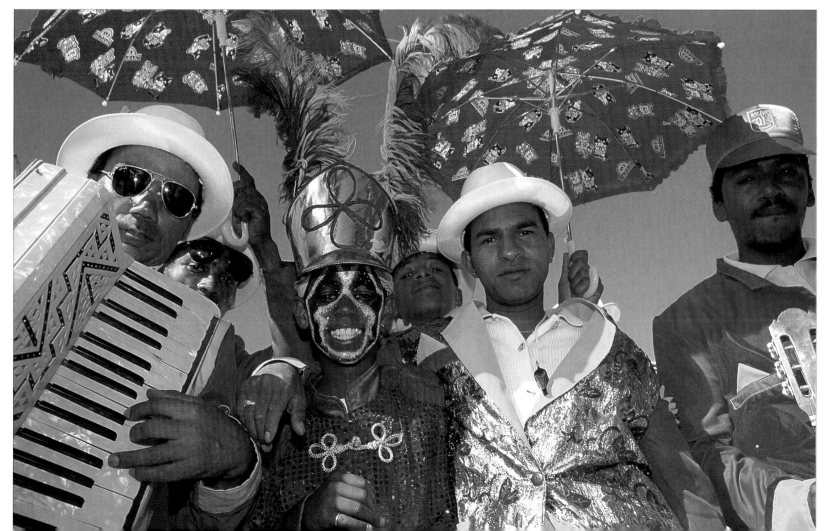

TABLE MOUNTAIN

For the citizens of Cape Town, the mountain has come to symbolise the very heart of the city and its people. The mammoth sandstone structure towers over the metropolitan nucleus, and forms the centrepoint of life in the City Bowl. It is the compass by which everyone – locals and visitors alike – navigates the roads, highways and avenues of the city, and the landmark that most readily identifies the Fairest Cape across the globe. And the place it holds in the hearts of Capetonians is second only to the natural beauty of the mountain's dramatic landscape.

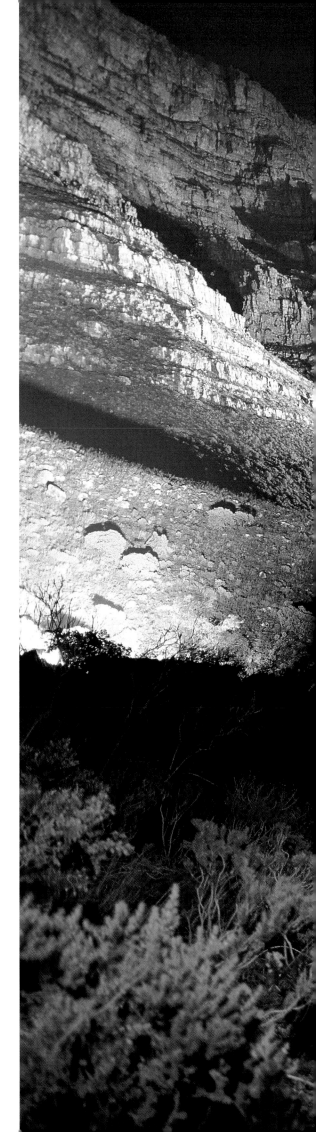

Table Mountain, together with its extraordinary array of indigenous vegetation, is the centre of the Table Mountain National Park, an expanse of protected natural heritage covering some 30 000 hectares (74 000 acres) of state and privately owned land, reaching from Cape Point to Signal Hill.

This, too, is the heartland of fynbos country and the unique Cape Floral Kingdom – the smallest (in extent, but not in species) of the world's six floral kingdoms. The Cape Floral Kingdom includes more than 8 500 flowers, shrubs and trees and virtually all the indigenous flora of the Cape Peninsula. The mountain's hardy evergreen fynbos reaches its picturesque peak from mid-August onwards, when some 1 500 species of plants explode into bloom, carpeting the slopes of the mountain – and even beyond, into the hinterland – in a riot of colour.

The mountain edifice is guarded on each side by equally renowned peaks that make their own statement on the city's landscape; to the east of the great, grey bulk stands the jagged crown of Devil's Peak, and to the west, the rounded crest of Lion's Head, and the gentle slopes of Signal Hill.

For decades, the famed flat-topped mountain has been one of the nation's top tourist attractions, visited annually by hundreds of thousands of tourists and locals who take the cable cars up to the plateau. The relatively new Swiss-manufactured 'gondolas' carry up to 65 people and boast revolving floors for a full 360-degree view. The vista from high up on this impressive elevation over the city bowl and beyond to the horizon of the Atlantic is simply breathtaking, while the world-renowned Kirstenbosch National Botanical Gardens on Table Mountain's eastern slopes enjoys unparalleled supremacy as the nation's top natural attraction, drawing more than two million visitors a year.

The elaborate network of demanding but not too challenging hiking trails and footpaths has no equal in the Cape, and the mountain slopes are blessed with abundant fauna and flora, the latter most conspicuously on display at Kirstenbosch. From the birdsong filtering through the rockeries and amphitheatres of indigenous plants to the 'glass house' or conservatory and visitors' centre, the tree-lined avenues of the gardens are havens of quiet and exceptional natural beauty.

RIGHT *The central landmark that differentiates the Mother City from any other in the world, Table Mountain rises more than 1 000 metres (3 280 feet) above Table Bay and the city below.*

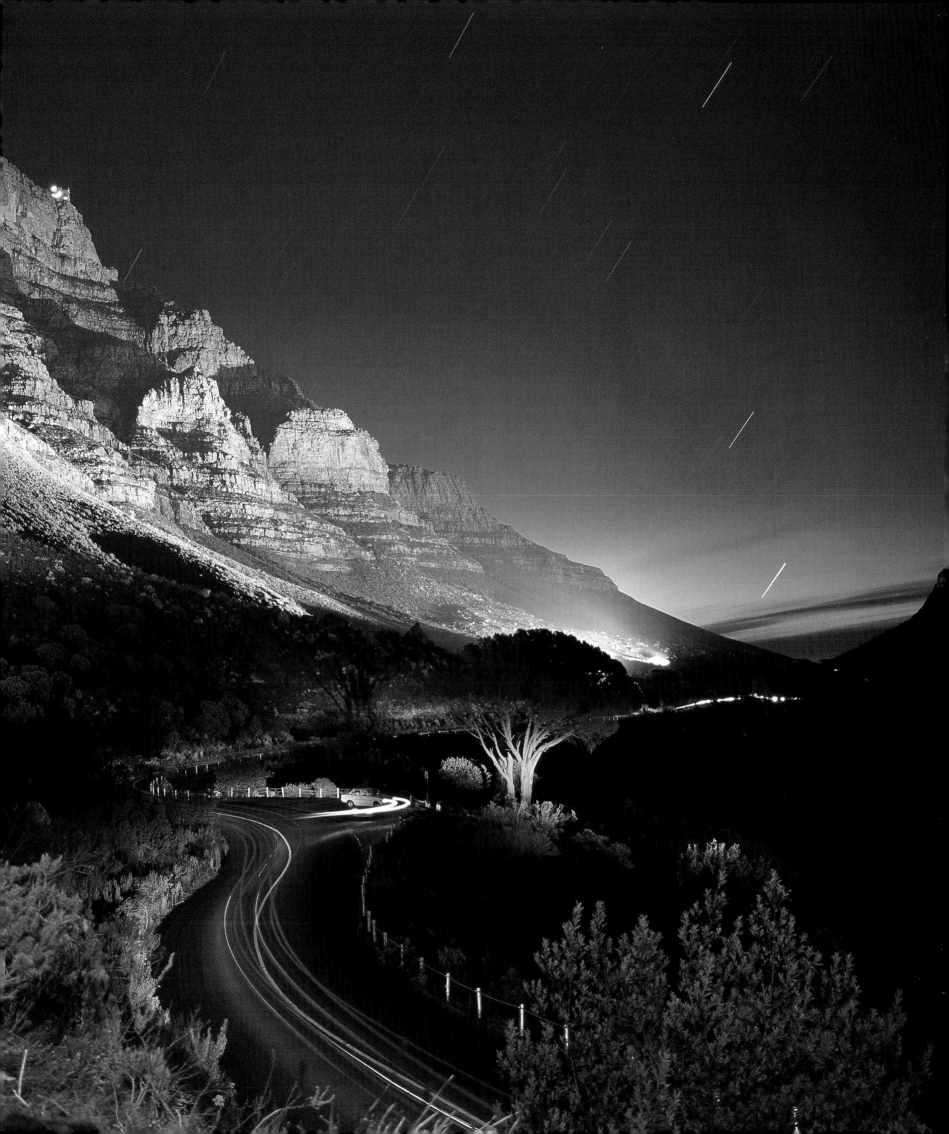

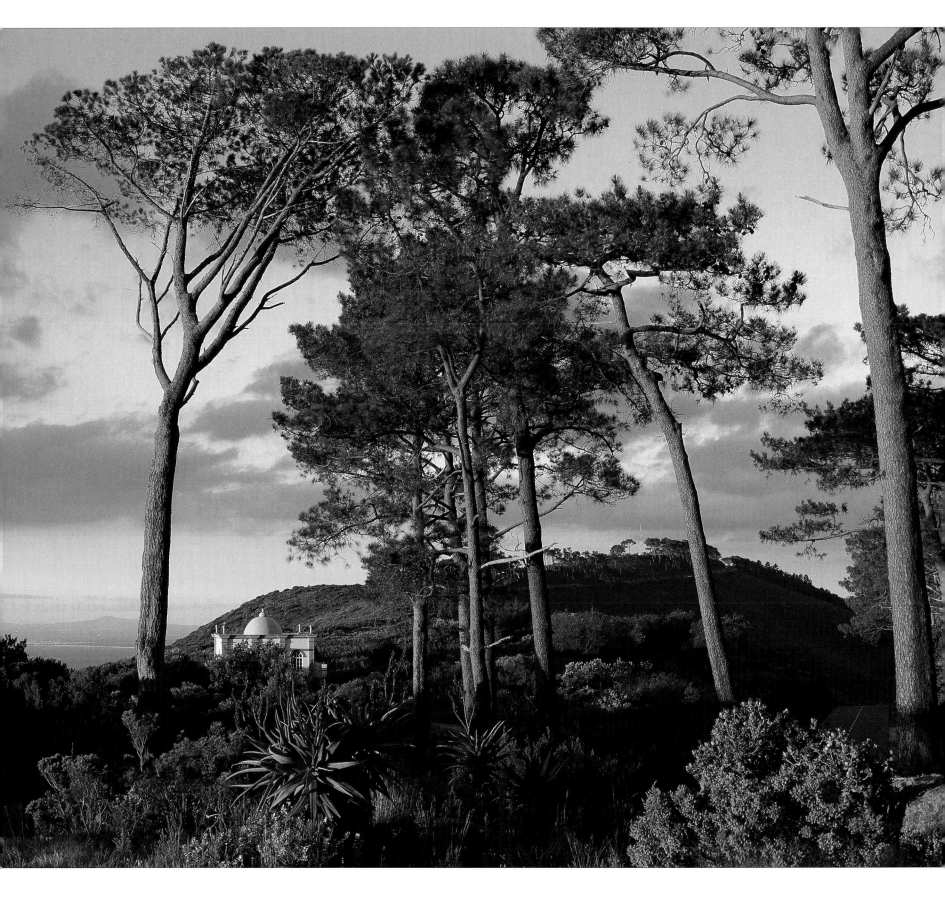

ABOVE *Kramats, the holy shrines that may be found on the slopes of Table Mountain (above) and throughout the peninsula, were erected by the Muslim community to honour spiritual leaders of Islam, and many are still visited by devout followers on religious occasions throughout the year.*

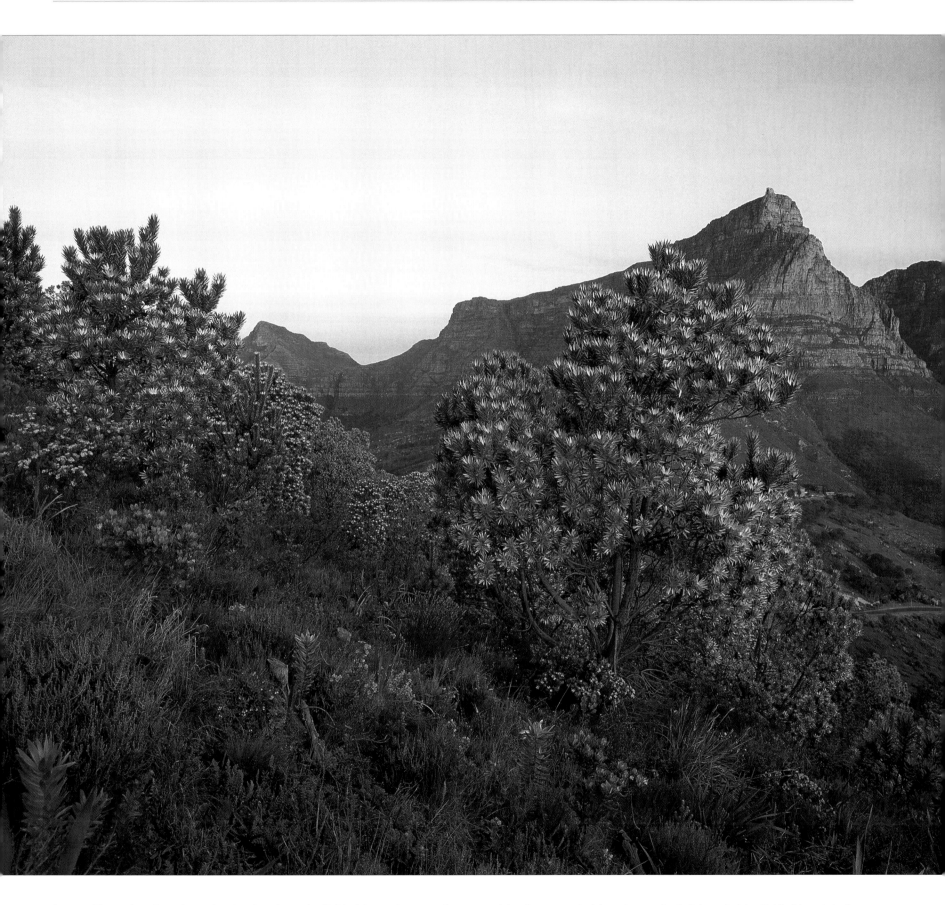

ABOVE *The series of peaks and vales that form the Table Mountain range is a rugged landscape and although seemingly inhospitable, Table Mountain is home to an extraordinary diversity of plant life, the primary focus of which is fynbos, including the silver trees (above) of the* Leucodendron *species.*

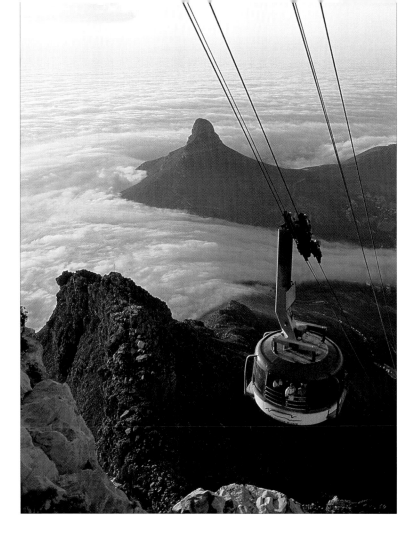

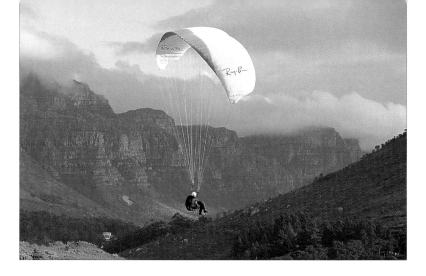

LEFT AND ABOVE *Table Mountain, accessible via cable car or on foot, is not only one of Cape Town's most notable natural heritage sites, but also a playground for adventurers, such as paragliders, who drift on the currents that circle the mountain top.*

BELOW AND OPPOSITE *The slopes of Table Mountain are a popular walking ground for hikers and climbers, and some 300 demarcated walks and trails criss-cross the rugged face and summit, which boasts a fine restaurant and other visitors' facilities.*

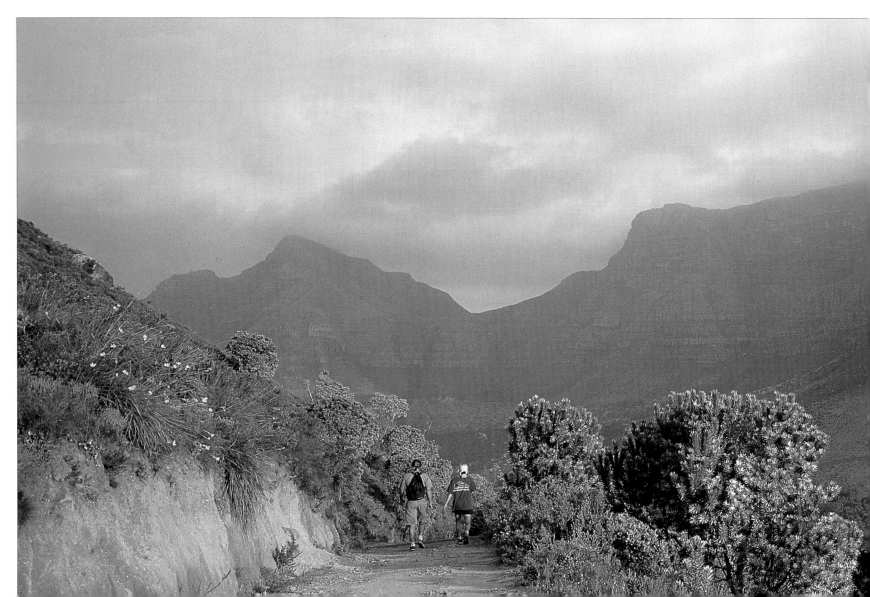

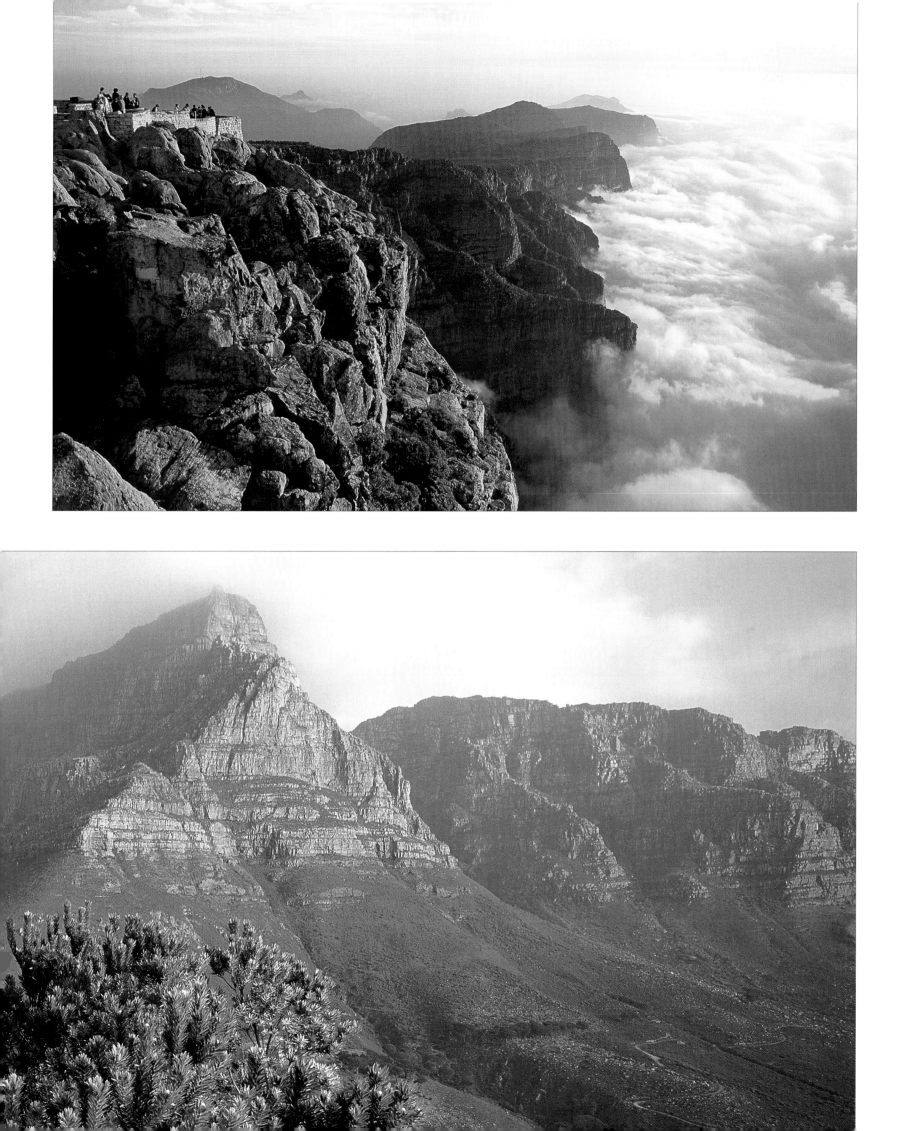

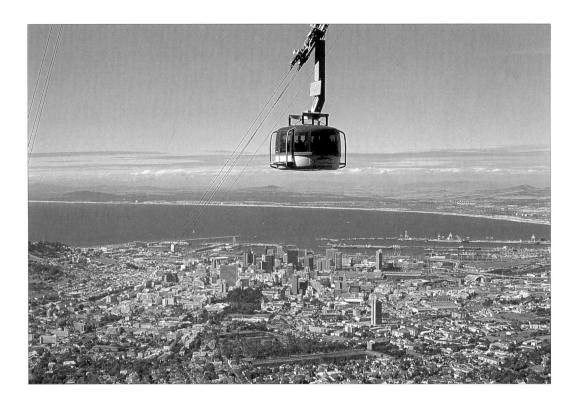

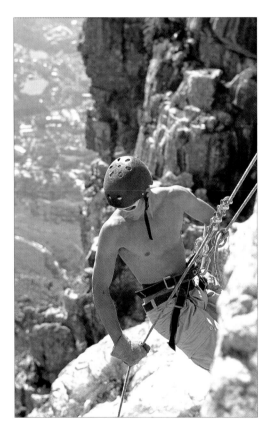

ABOVE AND RIGHT *Every year, hundreds of thousands of visitors – and, in the off-season, Capetonians – climb aboard the cable cars for the most breathtaking panorama the city has to offer.*

LEFT *Apart from the day visitors and hikers who traverse the mountain slopes, also at home here on the rugged cliff faces and mountainous terrain are the rock climbers who hail Table Mountain the country's most scenic climb.*

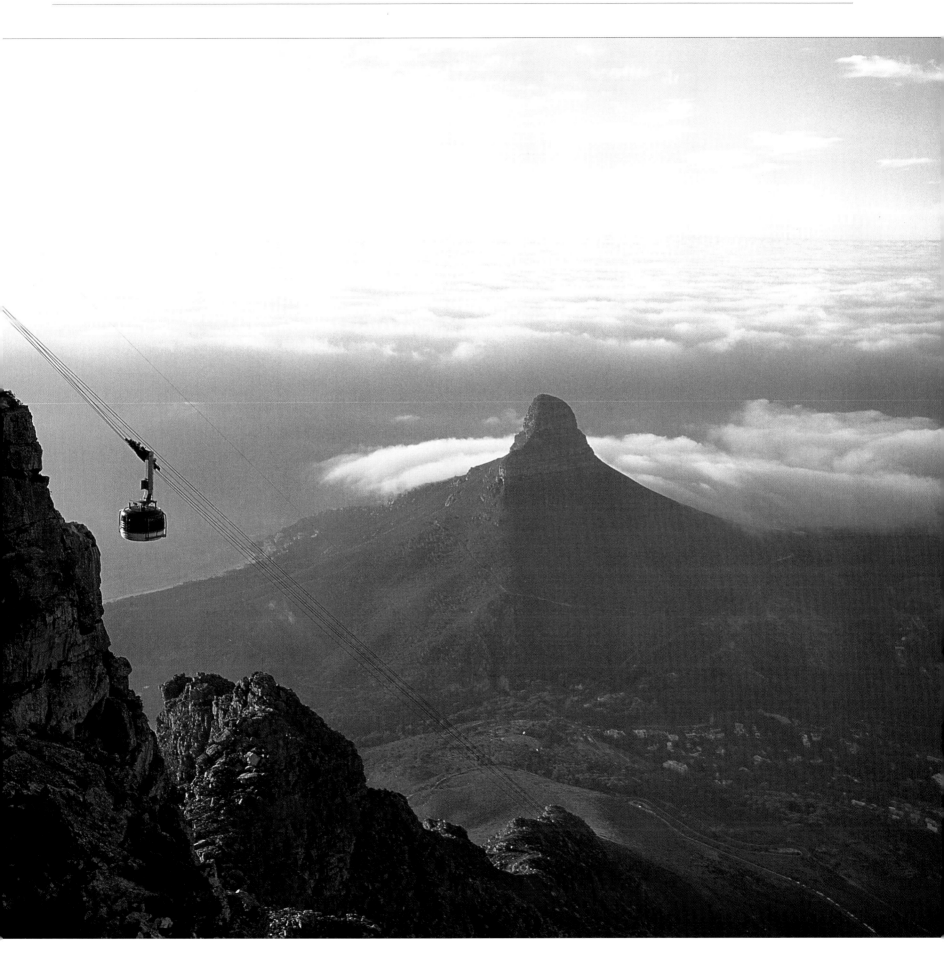

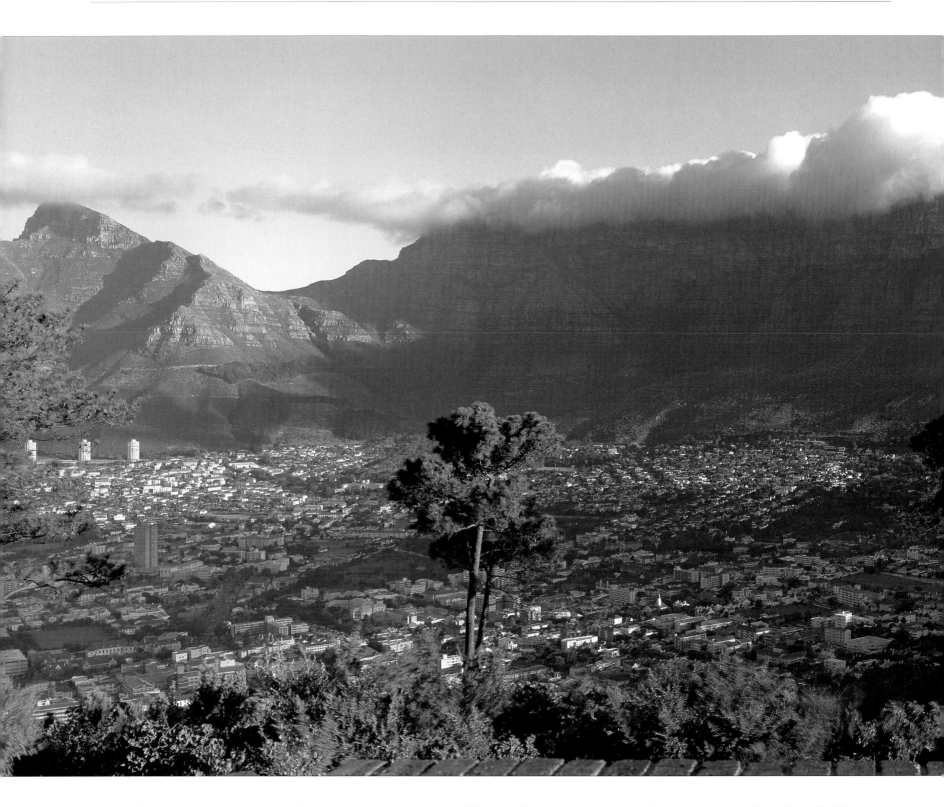

Table Mountain once teemed with an even greater variety of wildlife than it does today. However, the slopes that now form the wall of the City Bowl are still home to innumerable floral species and an extraordinary wealth of wildlife, including birds, reptiles, fish and small mammals.

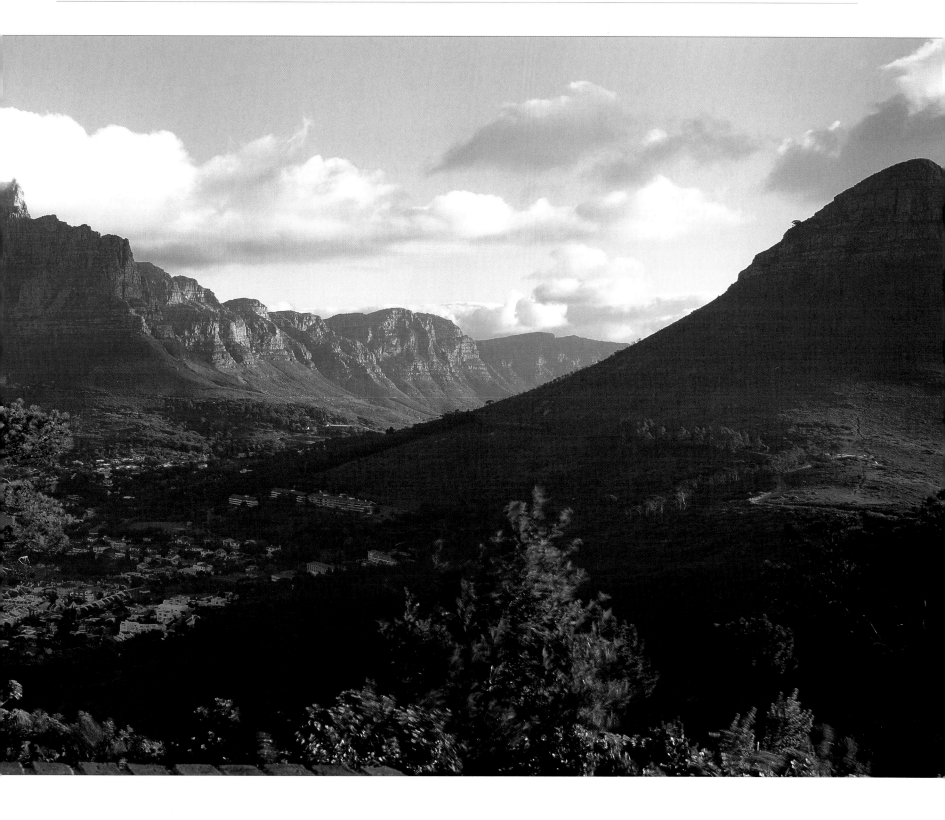

THE WATERFRONT

When the new Alfred Basin was inaugurated by Queen Victoria's eldest son, Prince Alfred, in 1860, there was little to indicate that the somewhat modest jetty and simple dockworks would become the epicentre of the country's maritime history and the focal point of the city's leisure industry in the twenty-first century. The simple landing dock and unassuming harbour of colonial times was to grow into one of the continent's most significant ports, and the modern Victoria & Alfred Waterfront complex a mecca of shopping and entertainment.

The V&A Waterfront is today at the very front of the Mother City's hospitality industry, drawing millions of visitors to its palm-lined, neon-lit playground every year. Initially little more than a single pub and unofficial red-light district catering for the seafaring travellers who regularly stopped on its shores and a haven for prostitutes plying their trade on the docks, the shipping yards that have serviced Table Bay since the mid-nineteenth century continue to offer harbour facilities for the passing maritime trade. But much of the light industry of the docklands has now given way to a considerably less sombre preoccupation – Cape Town's lively and spirited, yet distinctly laidback lifestyle.

The nightlife here is animated, cheerful and exuberant, with a plethora of vibey restaurants, serving everything from pizza, steak and Chinese, to the seafood for which the city has justifiably built an enviable reputation. Jostling for space among eateries and popular fast-food outlets, fashionable nightspots are filled with the laughter and chatter of Capetonians and the many visitors to their city – from both abroad and upcountry.

The atmosphere at the V&A is chic and cosmopolitan, an energetic spirit that permeates every market stall, vending barrow and fashionable retailer, among them jewellers and couturiers, curio outlets, art galleries and delicatessens.

In stark contrast to the luxury items for sale in the Wharf's glass-topped malls, and the grand hotels that have hosted royalty and diplomats, movie stars and rock bands, is windswept and rather desolate Robben Island, the spiritual capital of the nation's struggle for equal rights and democracy.

Having served throughout history as a leper settlement and a victualling station, Robben Island was later reserved for those who were once considered the country's most notorious 'criminals', many of whom are today hailed as national heroes. This holding place of political prisoners now enjoys unprecedented international interest, not the least of which is from conservationists intent on preserving the delicate natural ecosystem, and protecting the 574-hectare (1 420 acres) island – including the numerous stone and slate quarries, the slogging grounds of the prison's inmates – as a breeding place for sea birds and indigenous flora.

RIGHT *Flagship of South Africa's leisure and tourism industry, the V&A Waterfront remains the Mother City's most popular drawcard.*

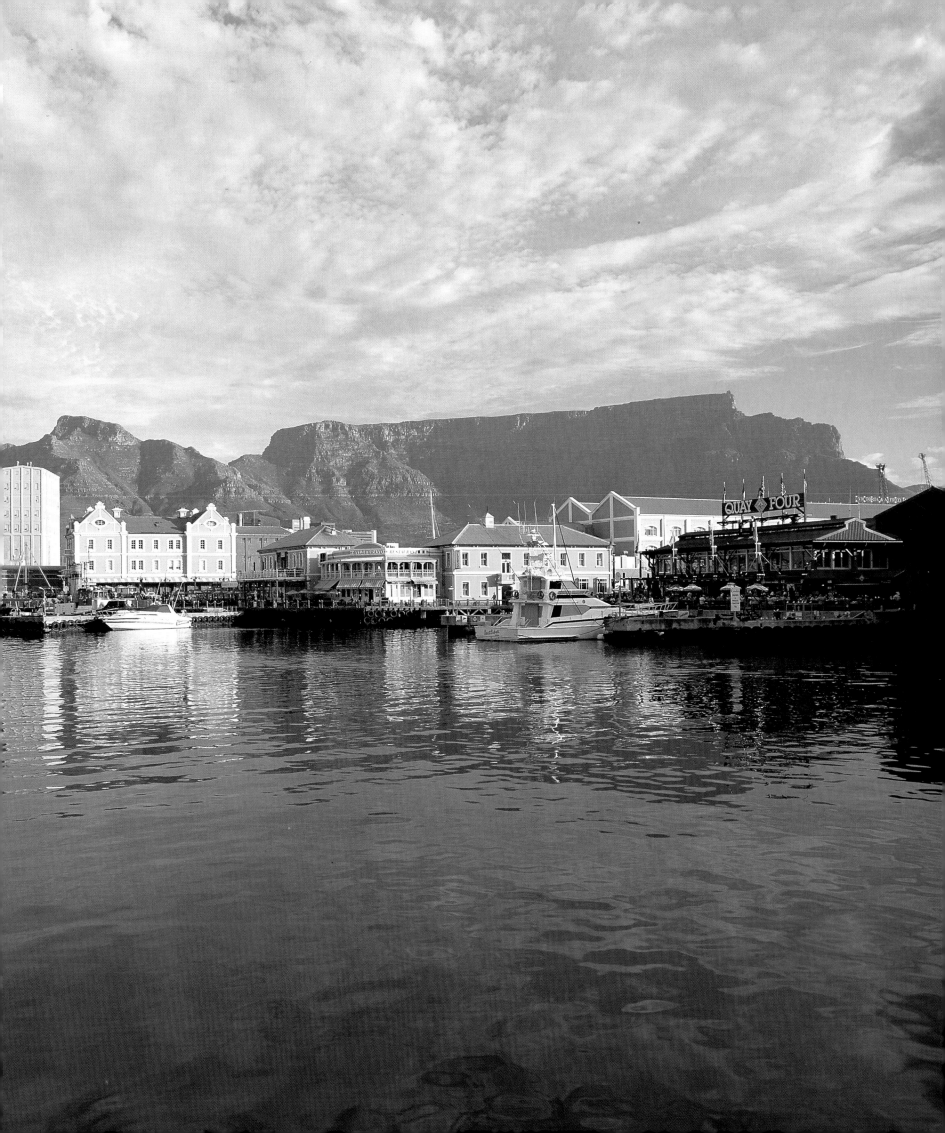

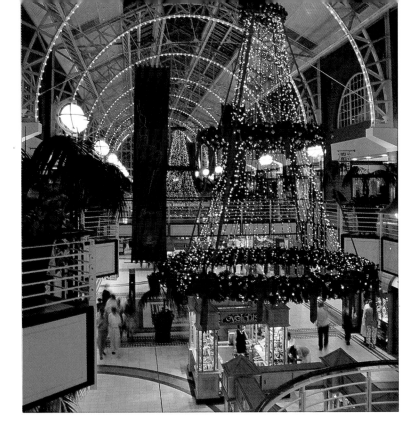

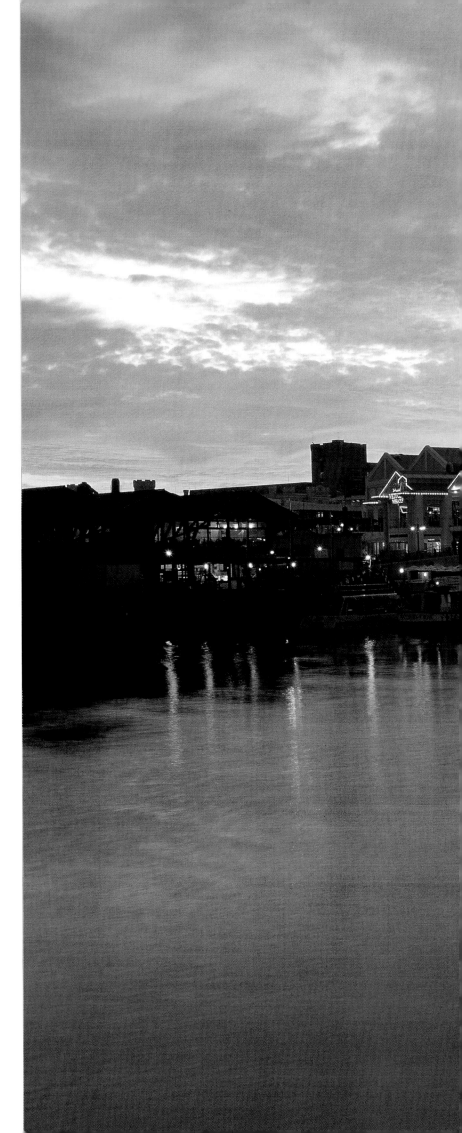

THESE PAGES *The night as another dimension of the glamour of the waterfront. Built on a disused landfill, extensive the Victoria Wharf shopping mall (top and above centre) houses hundreds of retail outlets linked by indoor piazzas and covered gallerias.*

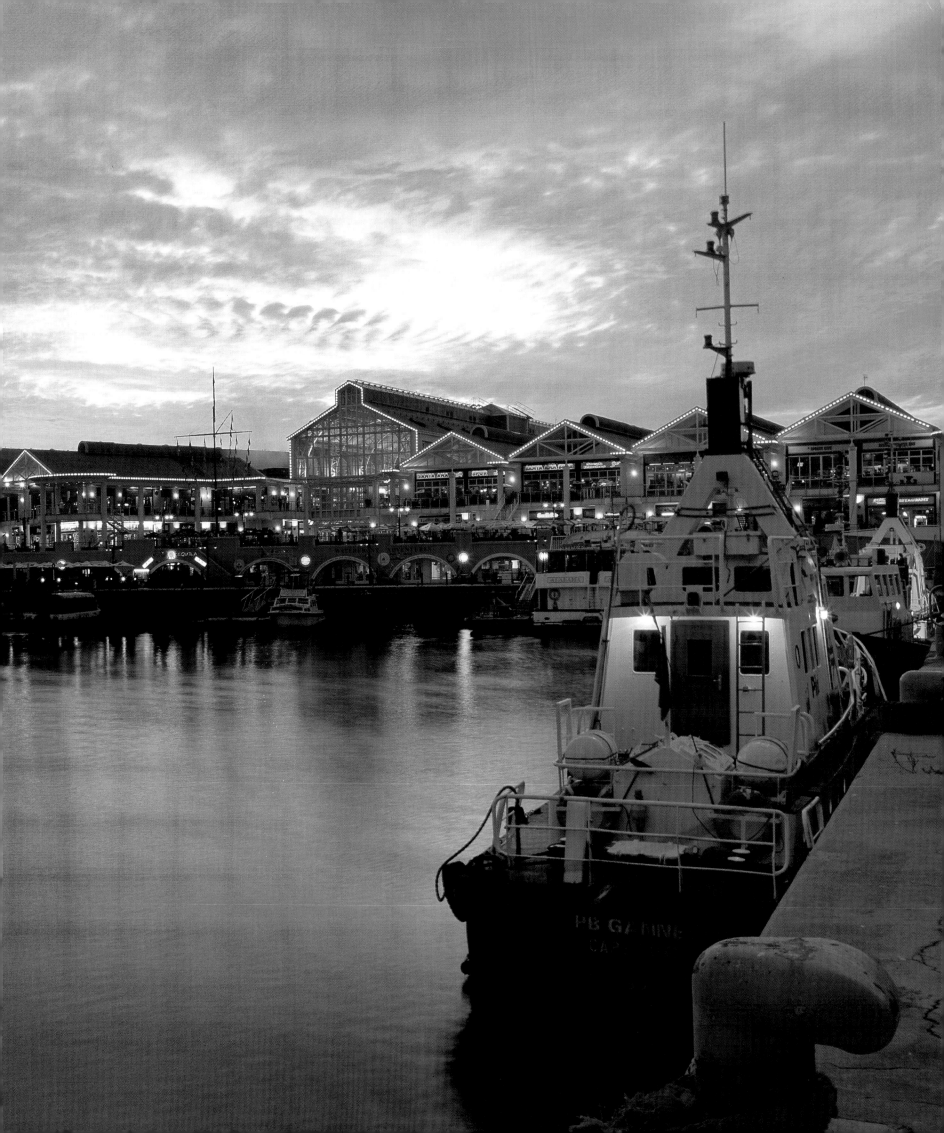

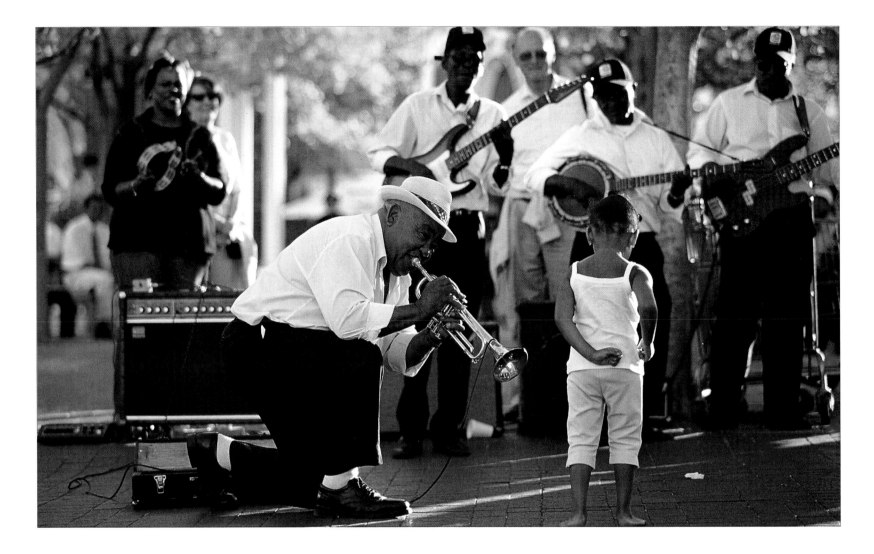

ABOVE AND OPPOSITE *From the establishment of the first pub and small hotel, the V&A Waterfront has grown into an enormous playground peopled with street musicians and performers, from fire-eaters to mime artists, and spectator sporting events.*

LEFT *The undisputed centre of the Mother City's hospitality industry, the V&A Waterfront's Table Bay Hotel is one of the city's most acclaimed. The plush hotel, with moulded ceilings and marble floors, serves as the Cape Town base for visiting dignitaries and statesmen, movie actors and rock stars, whose visits are recorded on plaques at the base of the statue.*

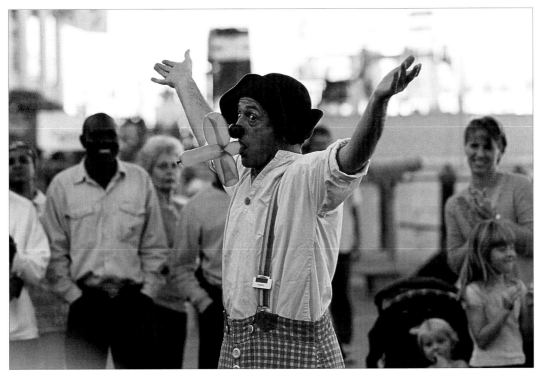

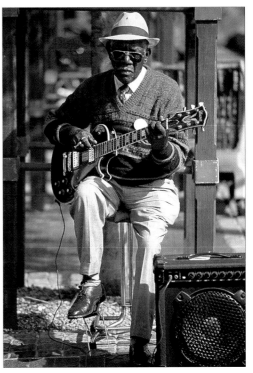

BELOW AND BOTTOM *The world-class Two Oceans Aquarium is a marine wonderland of underwater tunnels, tidal pools, and glass tanks holding the country's most comprehensive collection of marine life, from seals and penguins to sharks and eels.*
RIGHT *Among the treasures of the sea on display at the Aquarium is the cuttlefish, which – because it is the source of sepia ink – is also known as the sepia squid.*

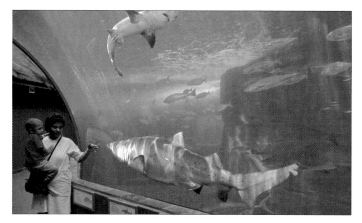

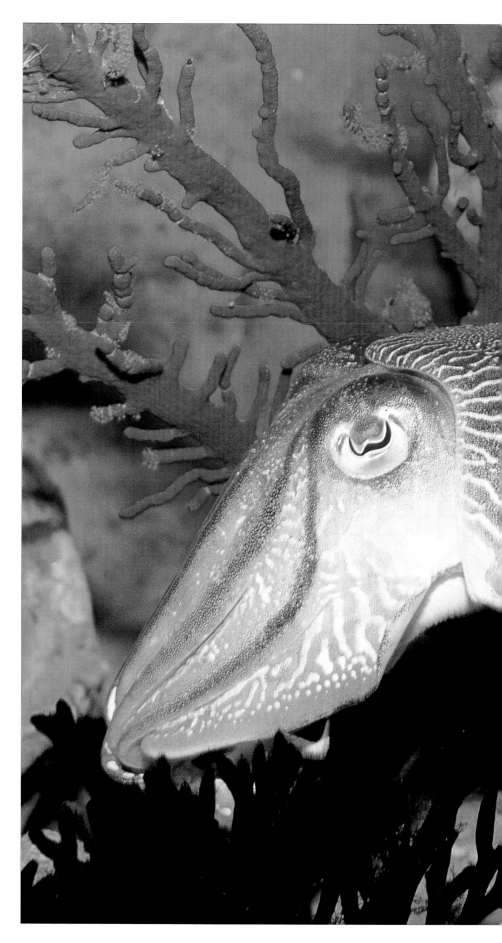

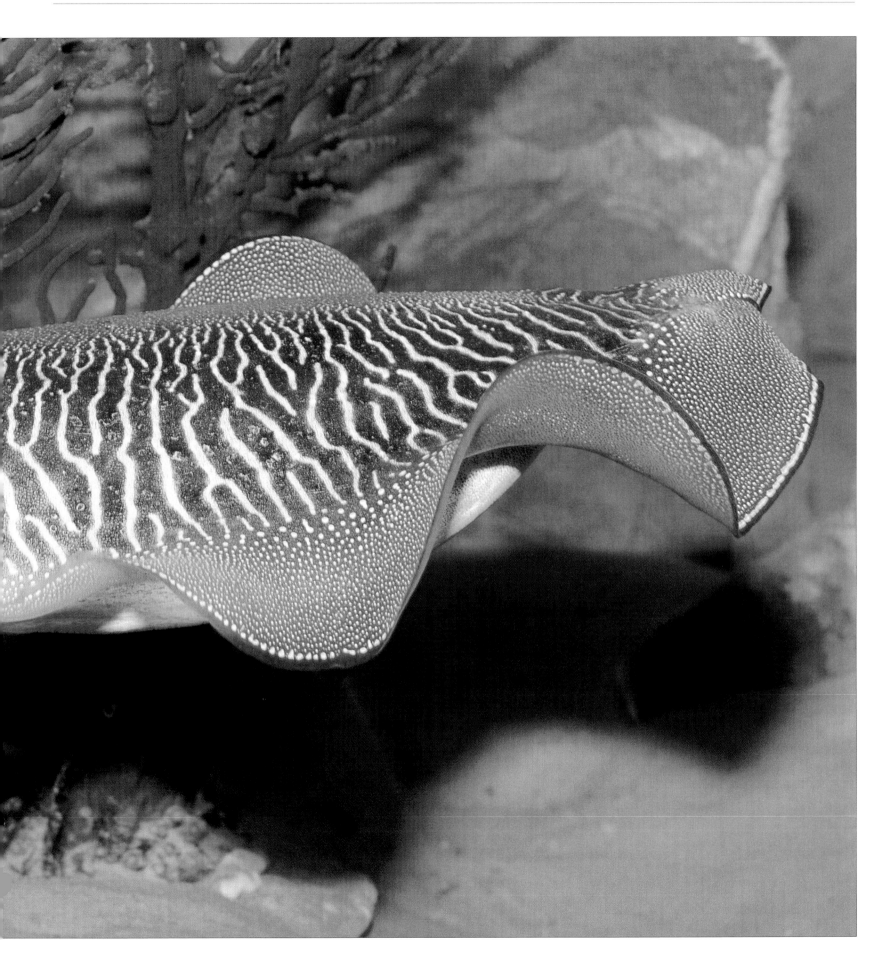

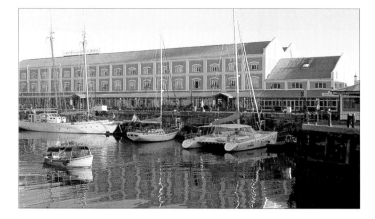

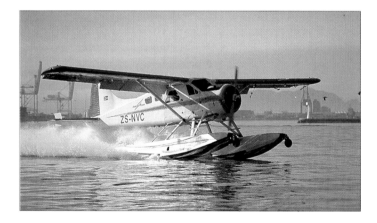

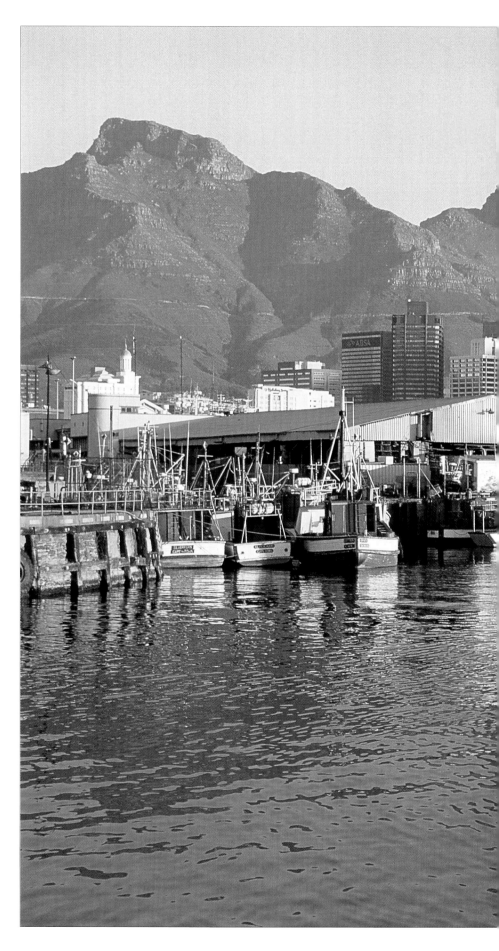

TOP *The Victoria & Alfred was the first hotel to be opened on the revitalised dockland.*

ABOVE CENTRE *The Waterfront complex is also the departure point of sight-seeing ferries that carry visitors around the docks.*

ABOVE *Seaplanes depart and land at the Waterfront, offering unrivalled bird's-eye views over the peninsula.*

RIGHT *The dockland, home too to the Royal Cape Yacht Club, sees its fair share of passing maritime traffic, not the least of which is an endless stream of small leisure craft.*

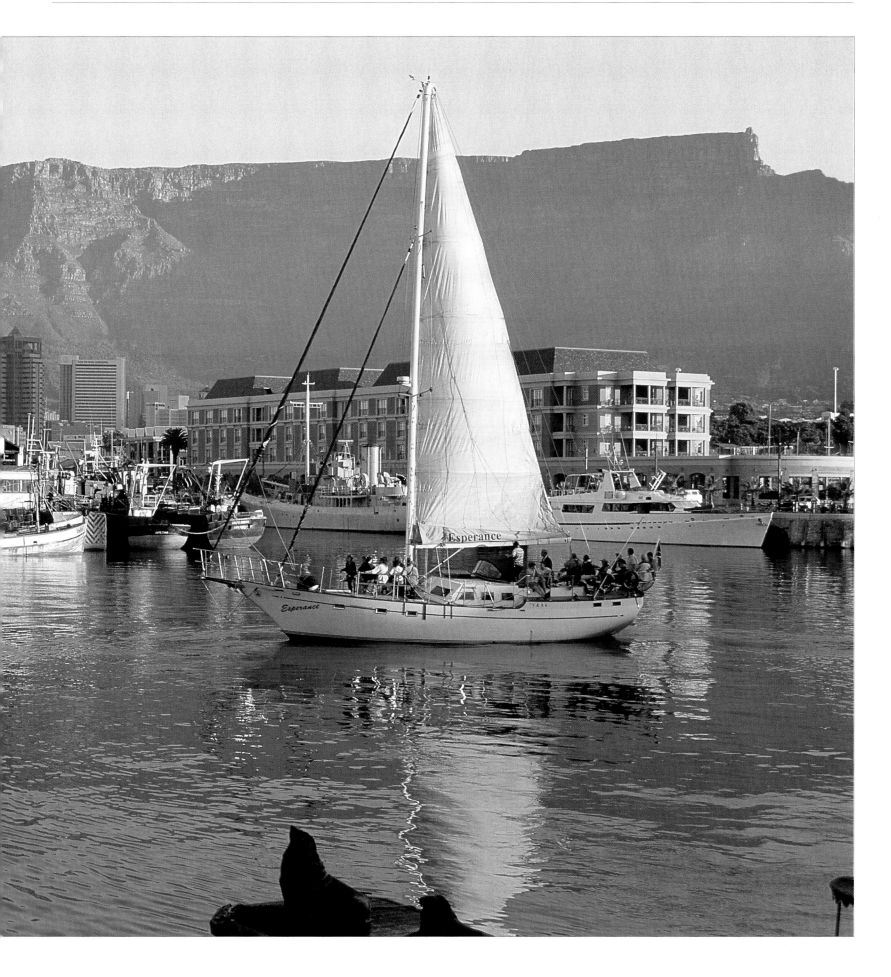

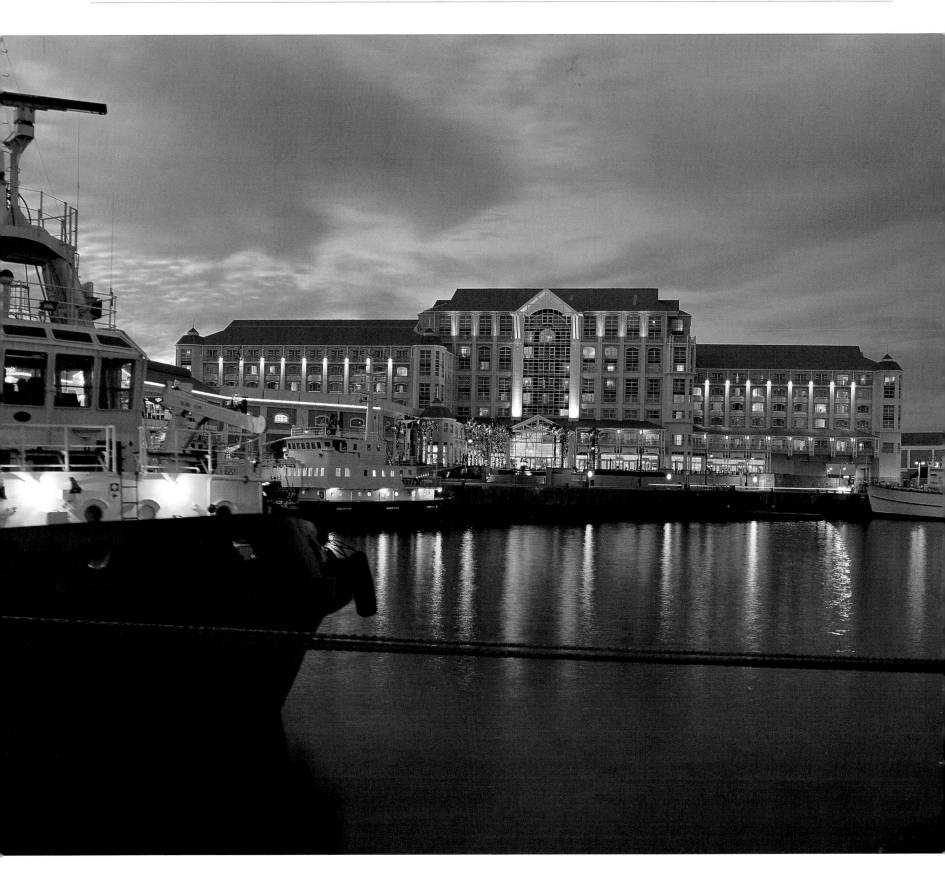

During the day the V&A Waterfront plays host to a constant parade of shoppers and businessmen, but it is at night that it comes alive to the sounds of live music and the laughter from romantically lit restaurants.

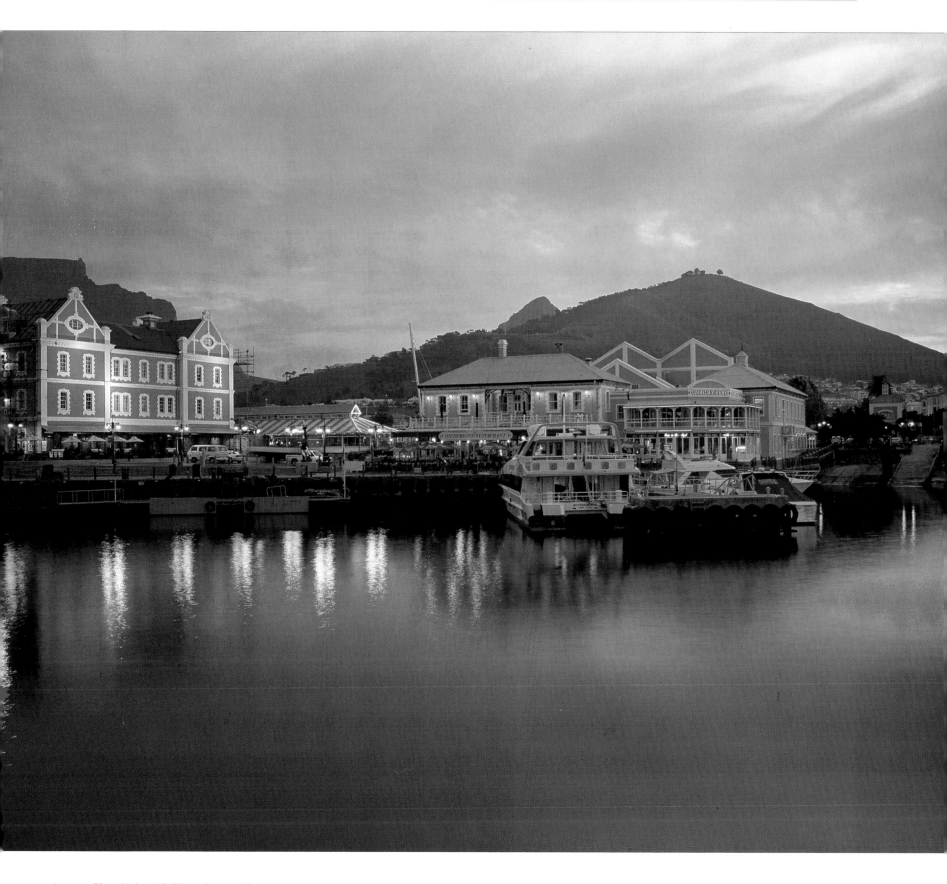

ABOVE *The city's nightlife is focused largely on the piers and jetties of the waterfront and, especially on warm summer evenings, the bistros and cafés of the Pierhead adjacent to the old Port Captain's buildings spill over with patrons enjoying the Mediterranean climate.*

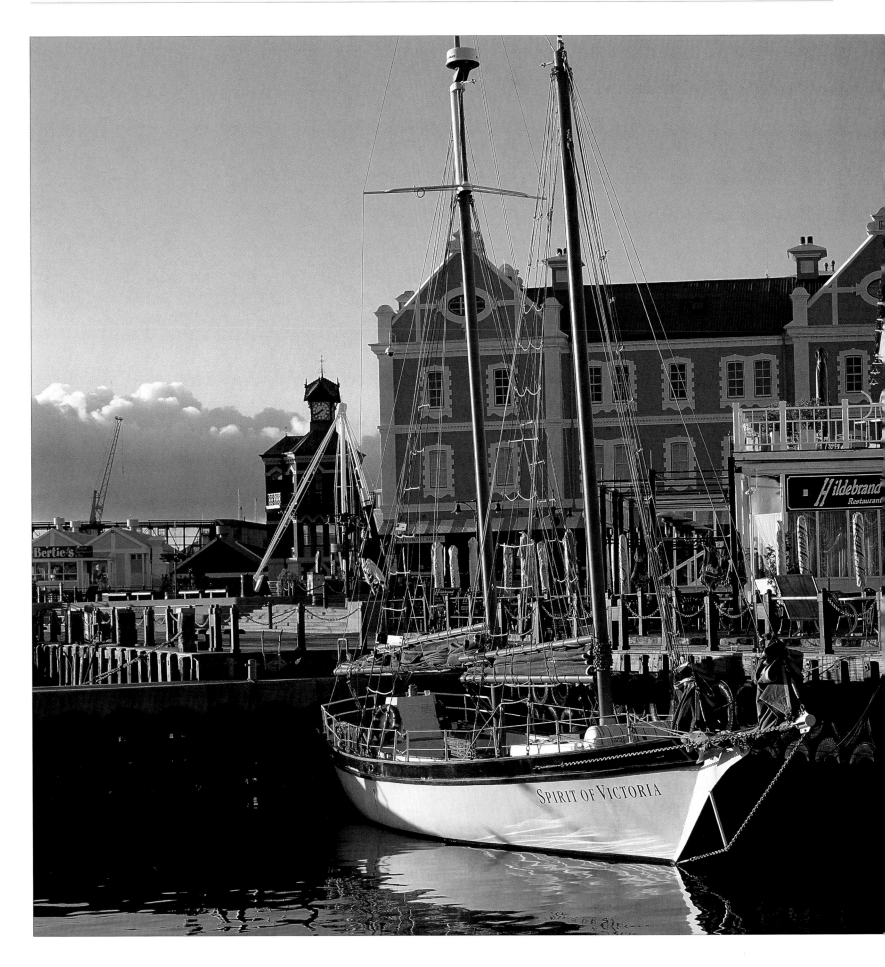

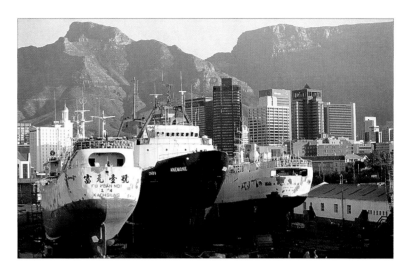

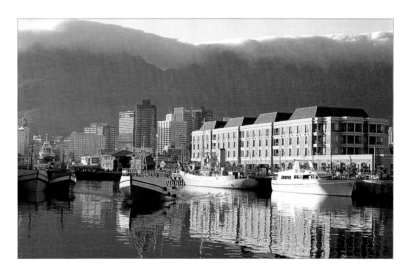

LEFT *The redevelopment of the Pierhead precinct was one of the V&A Waterfront Company's most ambitious tasks, and today the renovated port buildings and docking facilities form an exciting nucleus within the entertainment complex.*

TOP AND ABOVE *With all the modern trimmings of a cosmopolitan port city – chic new hotels and shiny shopping malls lining the canals and yacht basins – Table Bay plays host to both industry-based shipping and pleasure craft.*

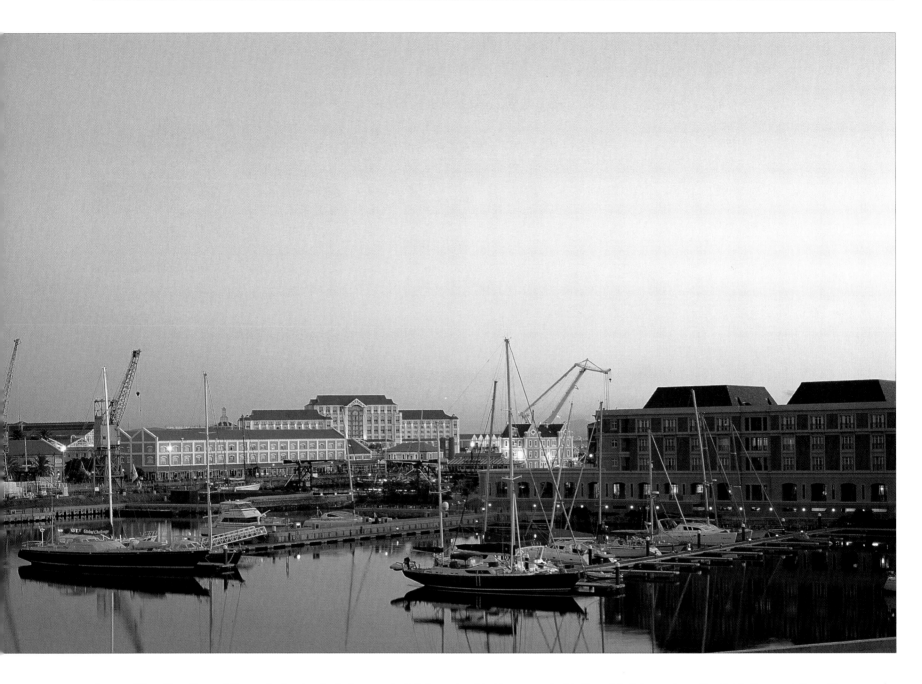

ABOVE *The attractions of the water's edge include an entertaining mix of both new and old. Grand hotels, such as the Table Bay and Cape Grace, and impressive new residential complexes dot the jetties and docks of the old shipping basins and boat moorings that form the focal point of Cape yachting.*
OPPOSITE *Constructed by prisoners in the mid-1800s, the docks of Table Bay and adjoining Granger Bay (shown here) today host not only passing ships and leisure craft, but are also lined with modern office suites, parking arcades and some of the city's most sought-after residential complexes.*

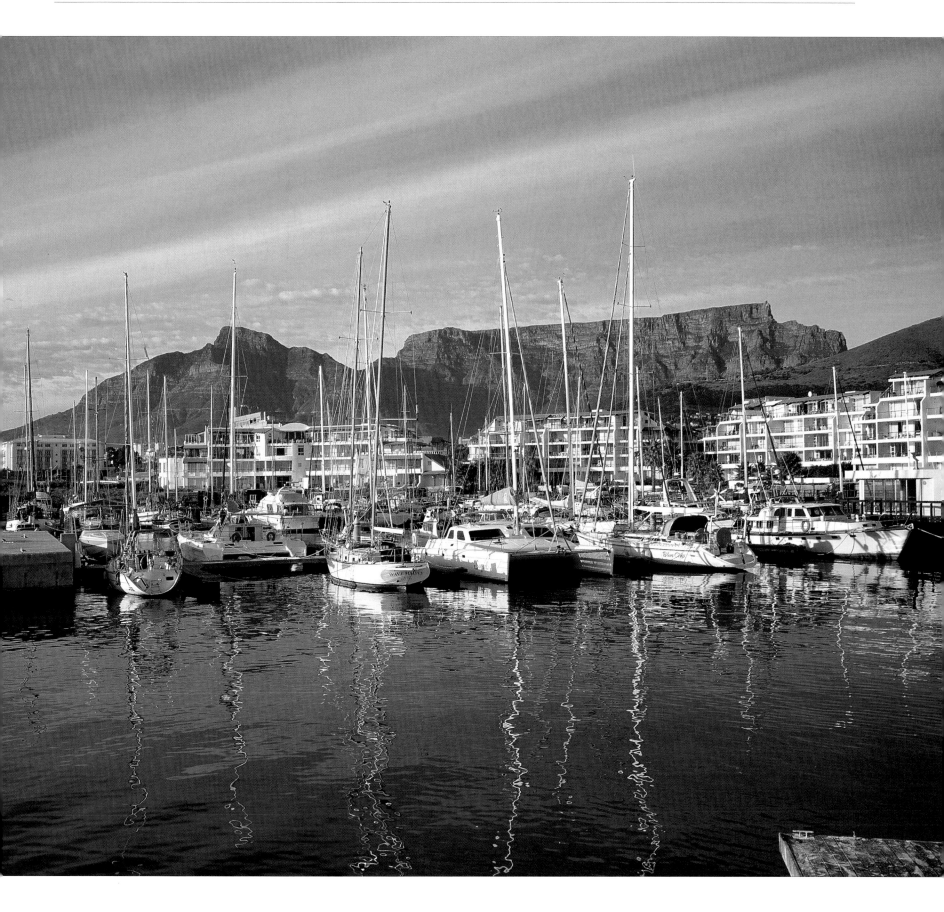

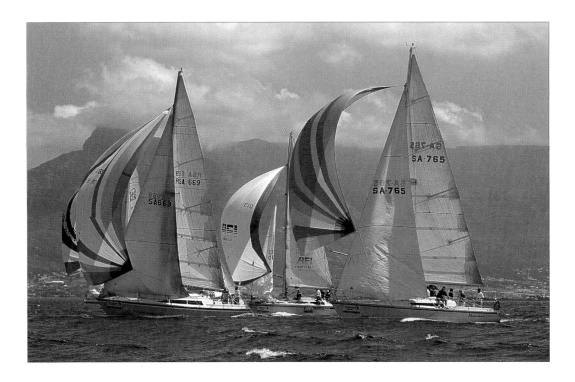

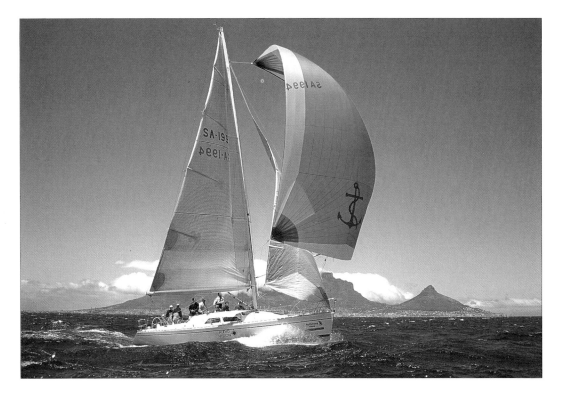

THESE PAGES *It is from Cape Town's picturesque Table Bay that the Cape-to-Rio yacht race departs, but the harbour also acts as a stopover on some of the most ambitious routes in world yachting, including the Volvo Round-the-World Race (formerly the Whitbread) and BOC single-handed round-the-world challenge. The most prestigious local event is the round-the-buoys race, launched amid a spectacle of colour every December.*

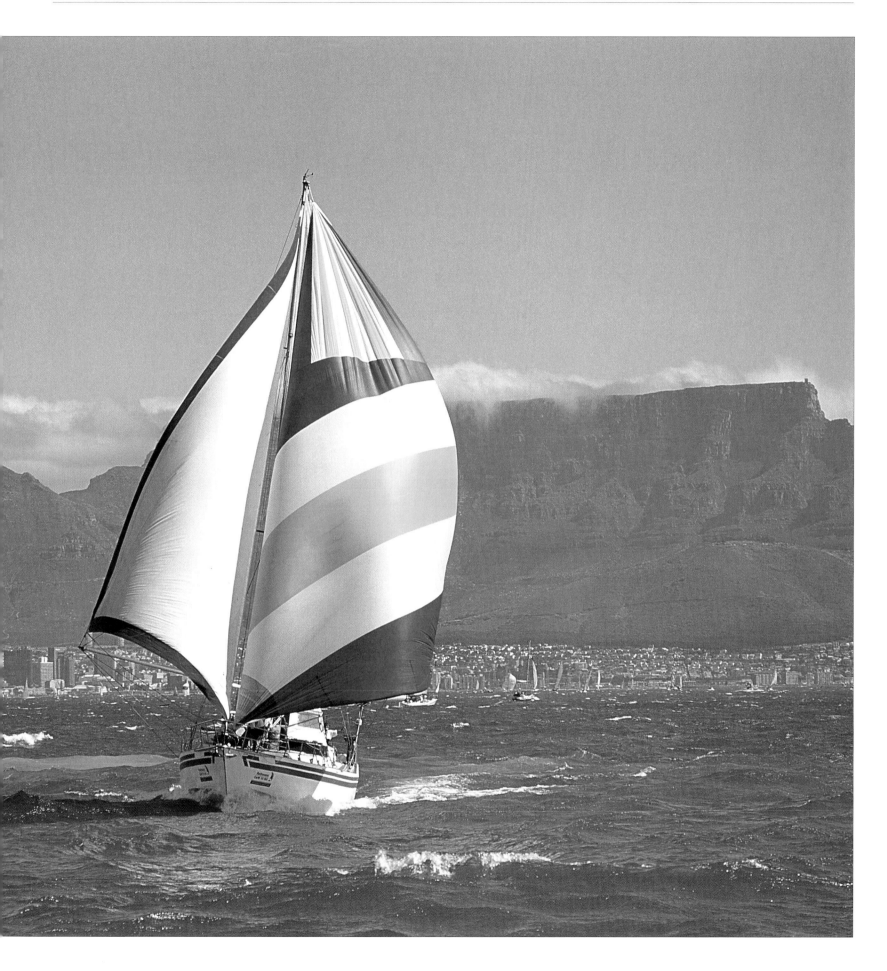

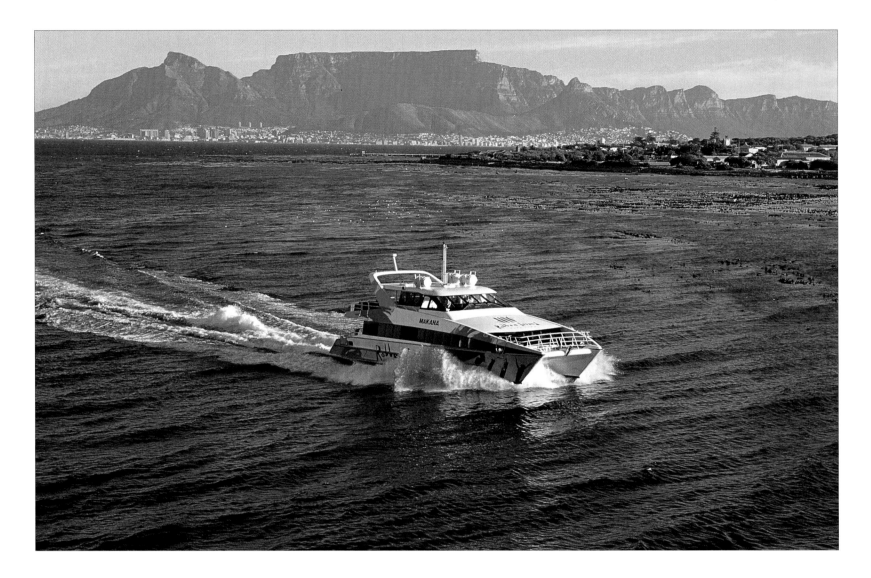

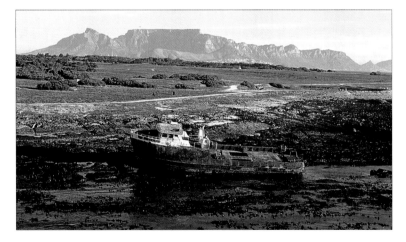

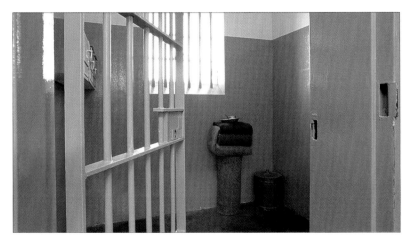

TOP AND ABOVE *In years gone by, the only vessels that travelled the 11 kilometres (7 miles) between Robben Island and the mainland were those carrying prisoners and prison officials. Today, however, since the island reserve was first opened to the public, ferries and tour boats carry hundreds of visitors to the Robben Island Museum.*

ABOVE AND OPPOSITE *Of all the many natural and cultural attractions on Robben Island (opposite), the most popular is miniscule Cell 5 (above) in the prison's B-section, long-time home of former state president Nelson Mandela, who was incarcerated here for many of his 27 years in prison before being transferred to Pollsmoor Prison on the mainland.*

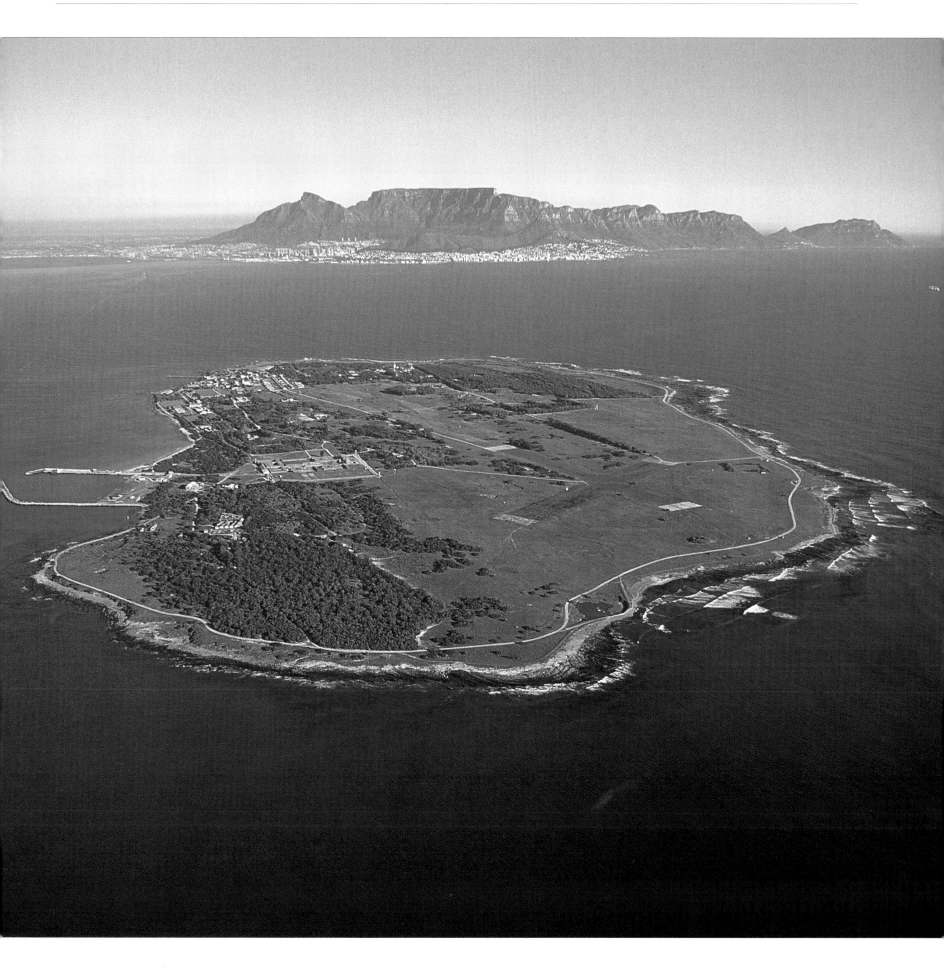

THE PENINSULA

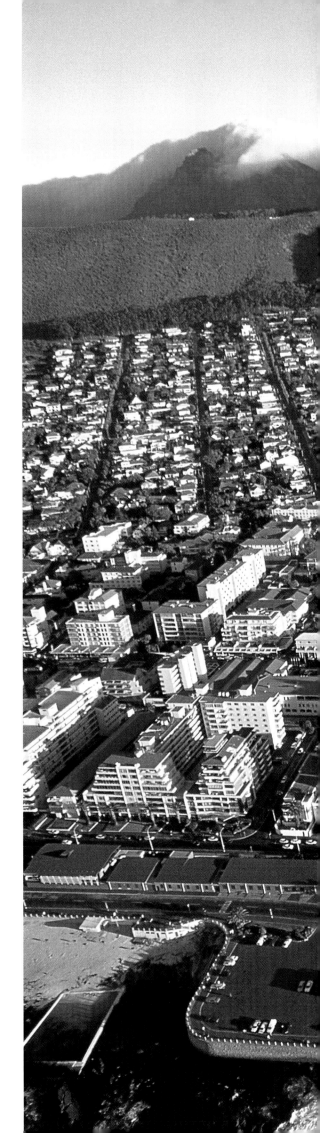

With all its scenic beauty, the city, its magnificent mountain and picturesque bay are but the figurehead of an entire peninsula that seems almost unfairly blessed with one breathtaking panorama after another. The long ridge of rocky mountains that form the spine of this small finger jutting into the ocean is lined for mile after mile with glades of indigenous trees, meticulously tended vineyards, neatly manicured gardens, and a string of pristine beaches stretching along its winding perimeter to the peninsula's ruggedly beautiful southernmost tip.

The shoreline that is referred to as the Atlantic Seaboard weaves its way around the virtual island for some 55 kilometres (34 miles), from the beaches of Table Bay along the western coast to the needle-like outcrop of Cape Point. Apart from the extraordinary vista from the scenic route that circumnavigates the peninsula, the densely forested mountain slopes and wave-lapped beaches at its foot are home to the residential element of the city, dotted throughout with expanses of indigenous vegetation, pockets of cultivated land and open spaces.

Below the ridge of peaks that forms the Twelve Apostles north of the city centre is what is known by many as Millionaires' Mile, a stretch of unparalleled beauty with magnificent views that comprise wildly expensive real estate reserved as the playground for the city's rich and famous. Victoria Drive winds its way from Bantry Bay, through Clifton, Camps Bay, and Bakoven to Llandudno. Further south, beyond these sun-kissed beaches, lie the somewhat more laidback residential areas, with Hout Bay, Noordhoek and other naturalist havens to the west of the rocky spine, and the coastal resort towns of False Bay and the plush, tree-lined Southern Suburbs to the east.

The shore that lines the turquoise waters of False Bay is dotted with small coastal villages, and the landscape alternates between areas of vast natural beauty to compact suburbia, each with its own distinct Cape flavour. Scenic mountain roads command impressive views over the seaside suburbs that extend from Simon's Town to Muizenberg, and further inland through the wooded countryside of Constantia and other similar areas – known as the Southern Suburbs – all of which lie in the shadow of the Table Mountain range.

This 'Green Belt' receives abundant rainfall, especially during the Cape's winter months, and is extraordinarily lush and verdant, an appropriate home for the vines that produce some of the world's most highly acclaimed wines. It is, of course, also steeped in history, the splendid architecture varying from the simple cottages of fisherfolk to the grand and opulent residences of English and Dutch colonists who settled on the dew-covered slopes extending from Bishop's Court to Tamboerskloof and Oranjezicht in the heart of the city.

RIGHT *On the hillside overlooking Table Bay and its waterfront development are the seaside enclaves of Granger Bay, Mouille Point, Three Anchor Bay, Green Point and Sea Point.*

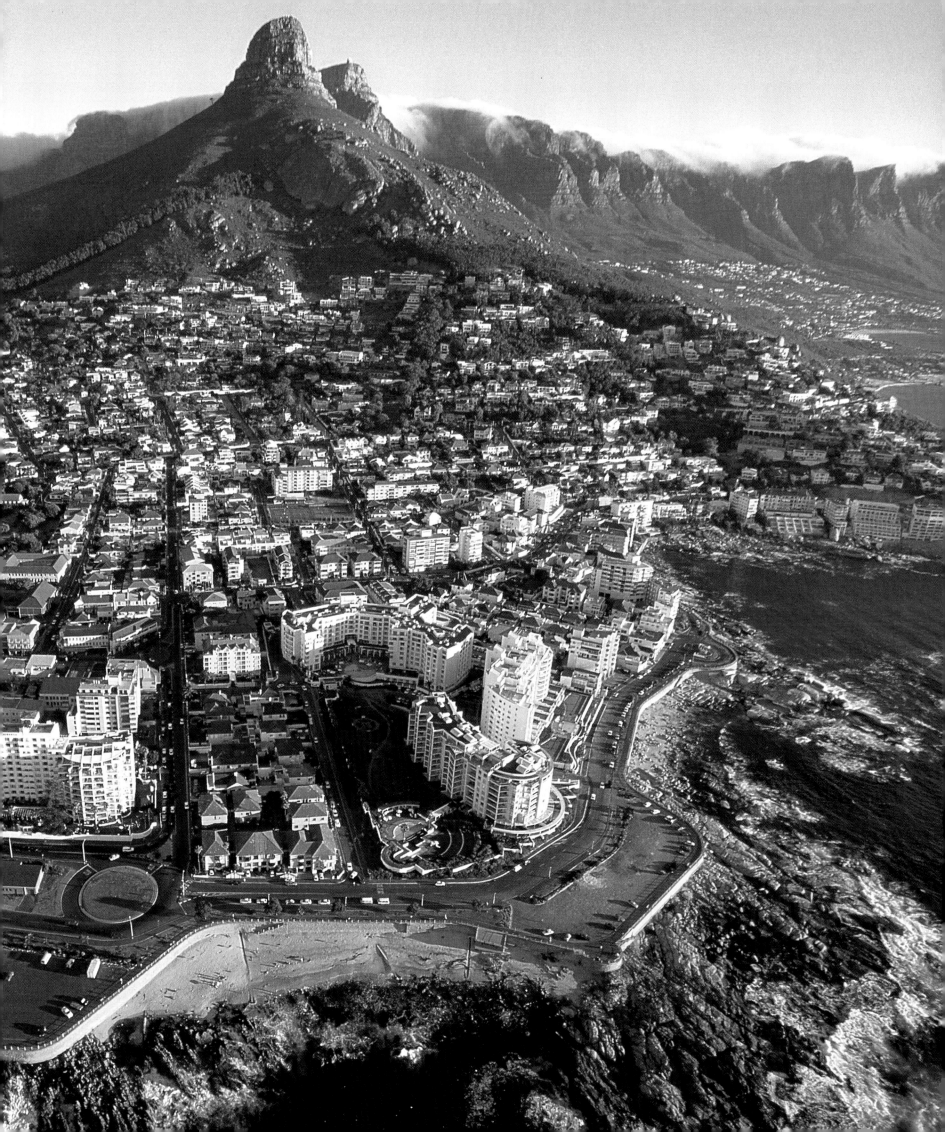

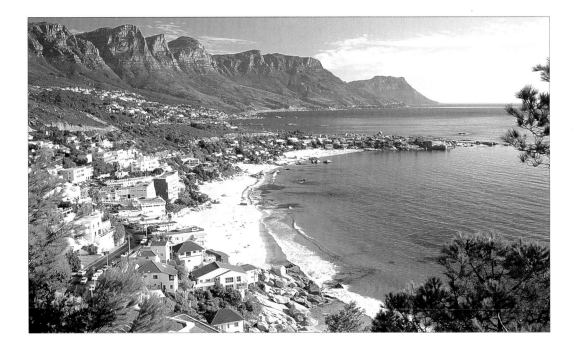

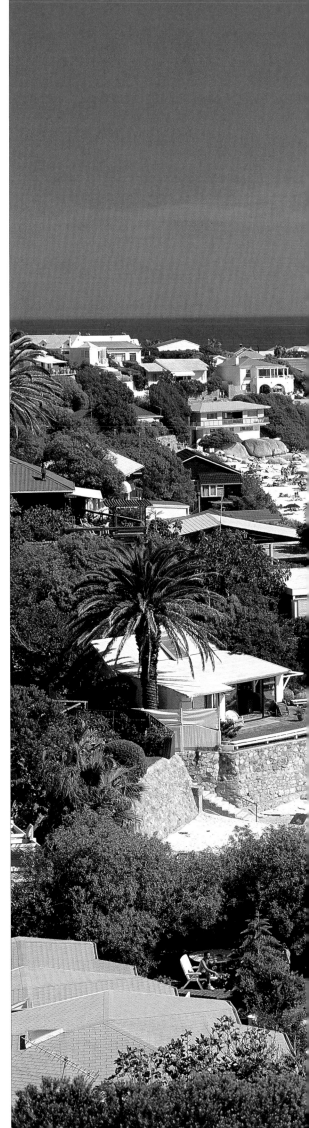

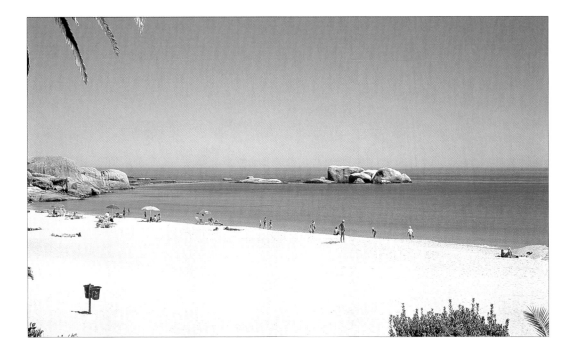

Top *Some call it the finest beach in the world, and Clifton is certainly one of Cape Town's true gems, baking under the African sun and sheltered from the elements by large granite outcrops.*
Above and right *Beyond Bantry Bay lie Clifton's four pristine beaches, with Fourth Beach – which boasts the most convenient facilities – especially popular among young families.*
Overleaf top *Although the sea may be cold and uninviting for the casual swimmer, the beach along Camps Bay offers one breathtaking vista after another, prompting favourable comparisons with the best on the Mediterranean coast.*
Overleaf bottom *The spectacular view of the 17 peaks of the inappropriately named Twelve Apostles is surpassed only by the view from the summits, and the panorama from this extraordinary vantage point covers Camps Bay and the entire western horizon.*

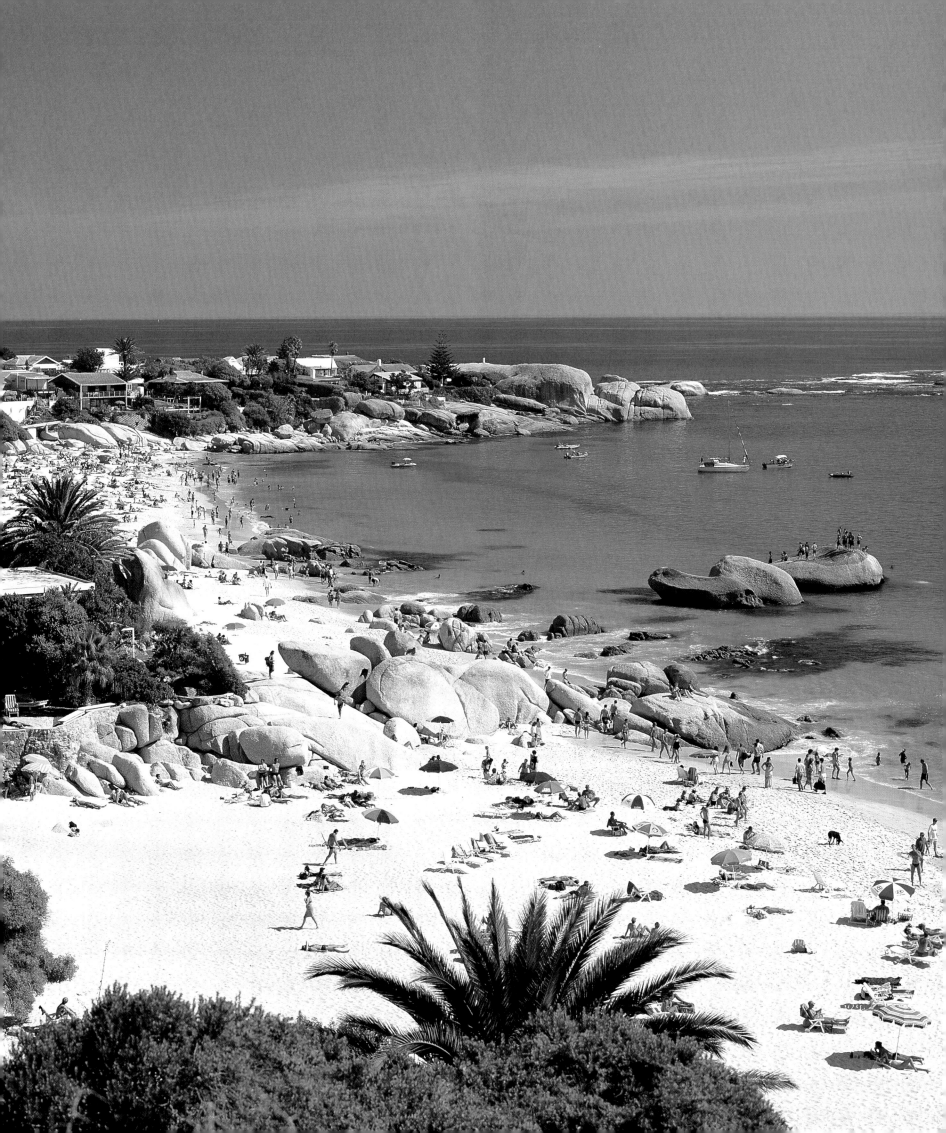

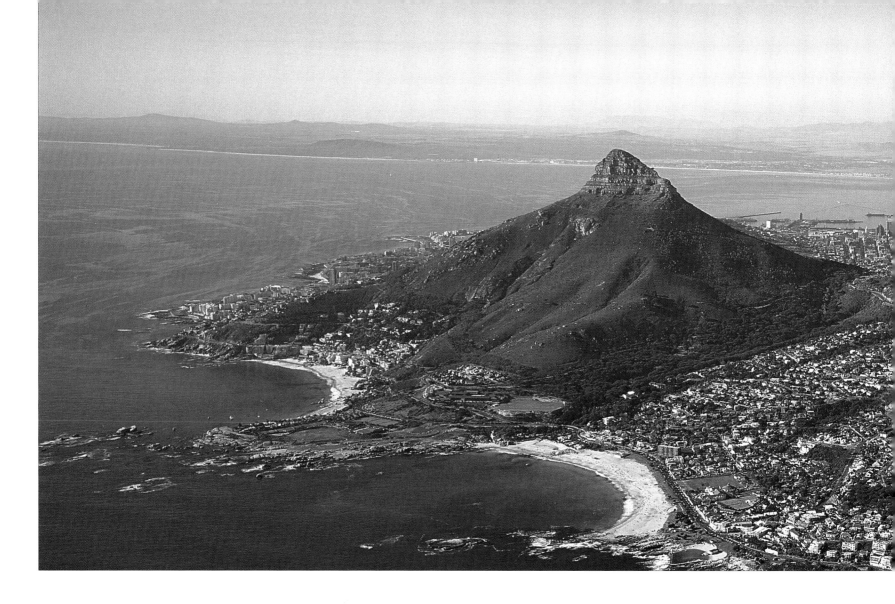

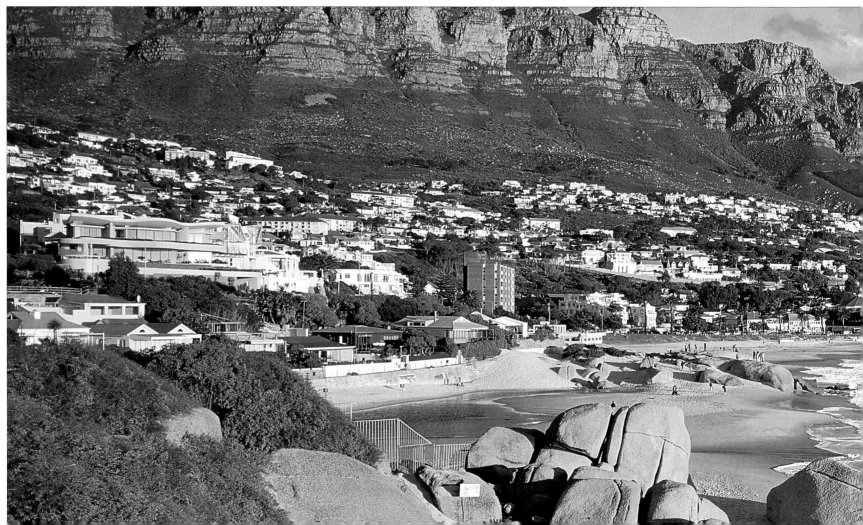

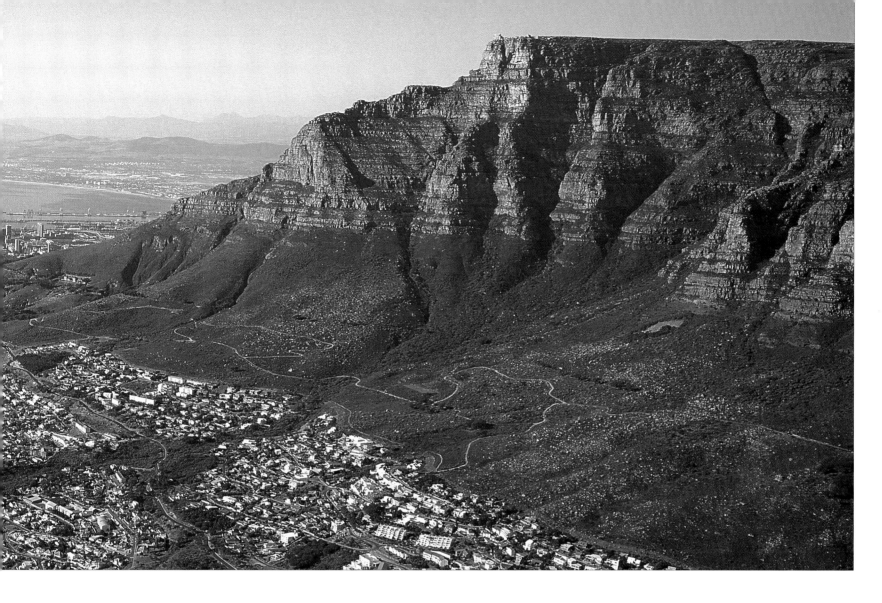

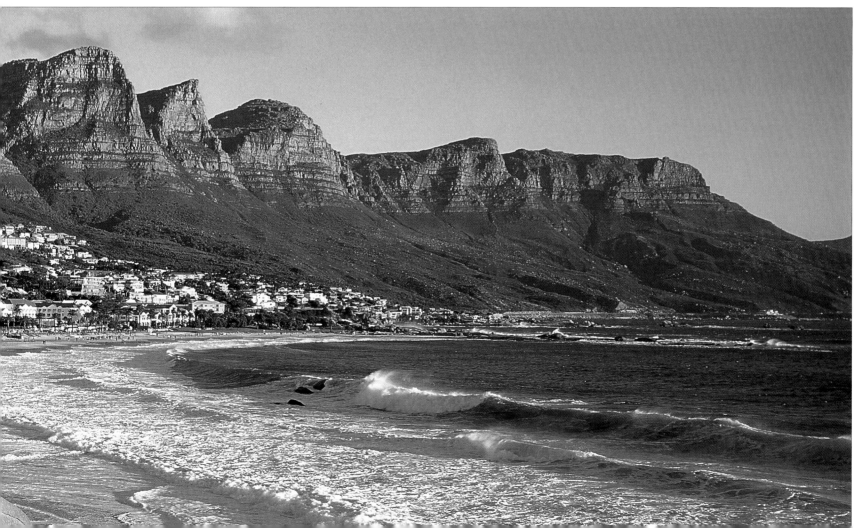

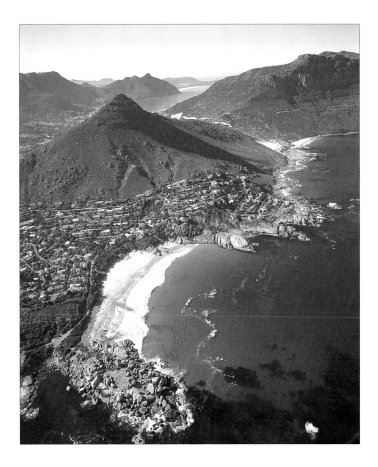

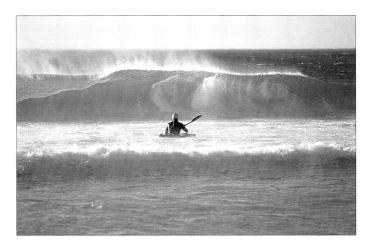

TOP AND ABOVE *Although icy cold and, on occasion, disturbingly turbulent, the waters of the Atlantic that lap Cape Town's western seaboard are a playground for watersport enthusiasts.*
RIGHT *The pristine white sands of Llandudno are sheltered by conglomerations of rocky barriers that not only protect the popular surfing beach from the wind, but also screen nude bathers on neighbouring Sandy Bay from curious onlookers.*

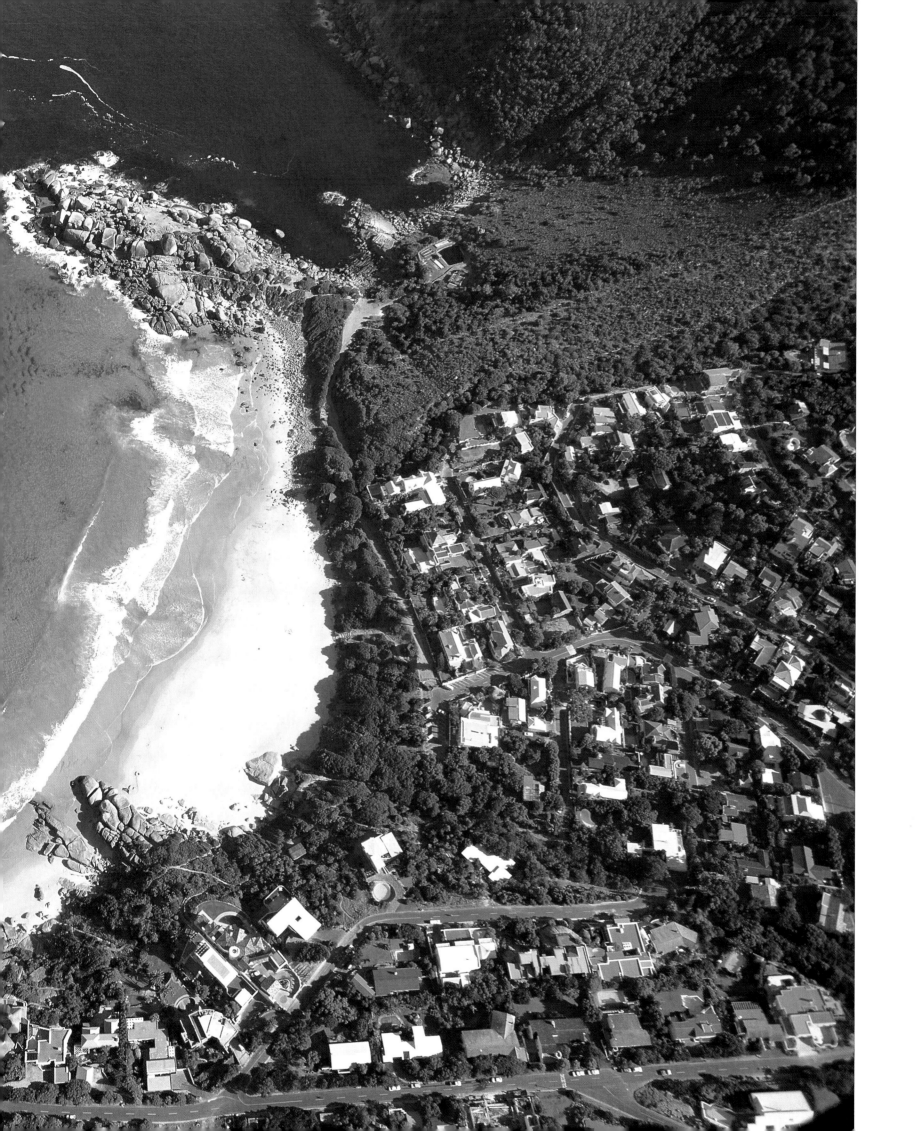

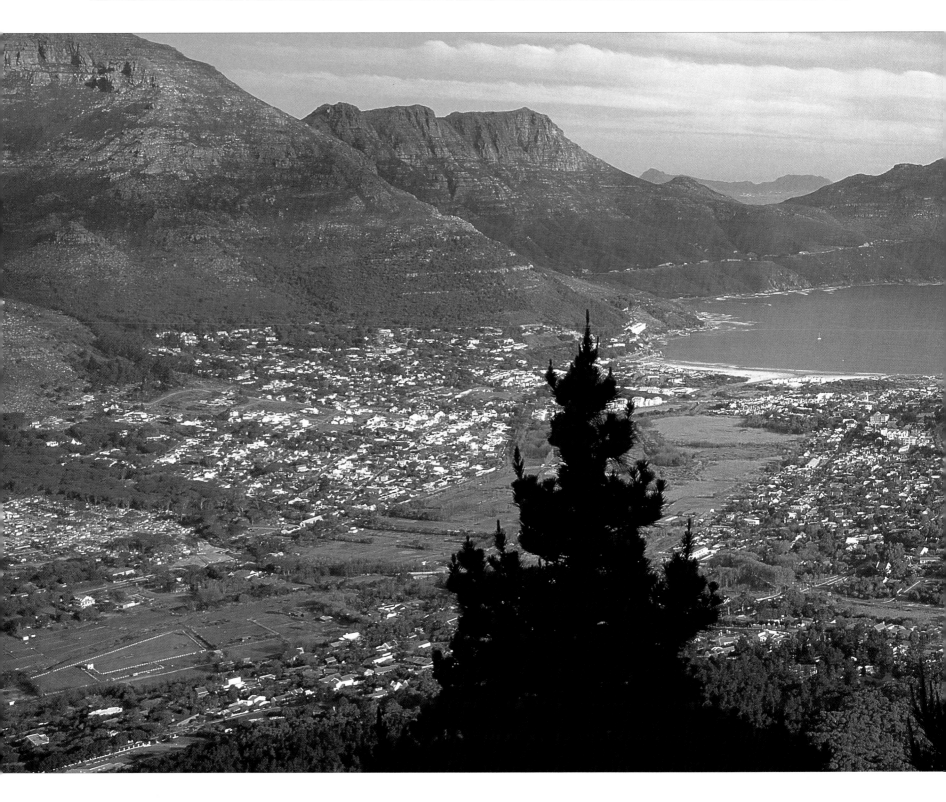

ABOVE *The natural splendour of the charming village of Hout Bay remains relatively unscathed by modern development, and it has retained much of its original charm.*

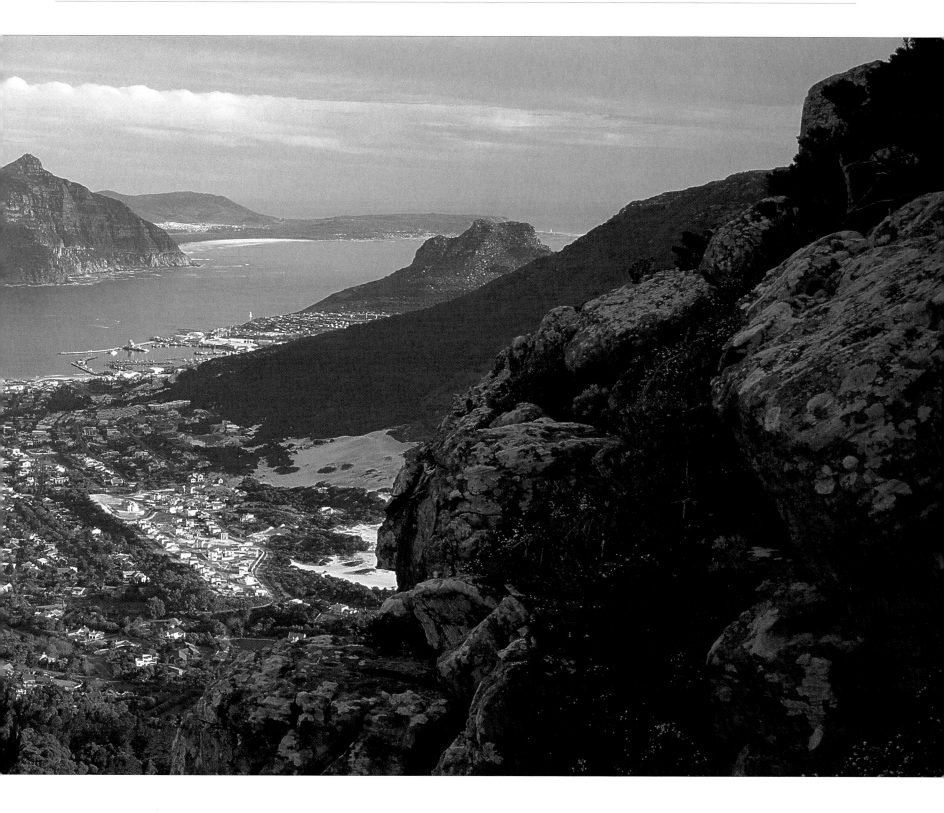

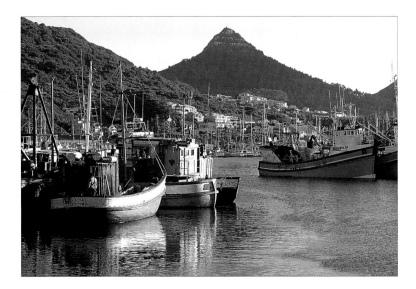

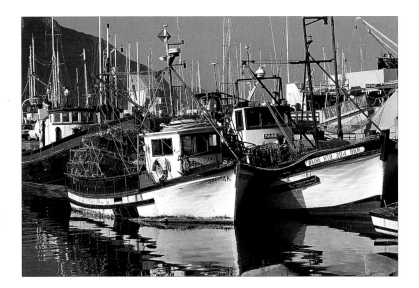

TOP AND ABOVE *The fishing village of Hout Bay remains true to its harbour origins and, for the local fisherfolk, it is an important base for Cape Town's fishing industry.*

RIGHT *The wooded hills and lush vales of semi-rural Hout Bay, today still largely unblemished by suburbia, was a vital source of timber during the early days of the Cape colony.*

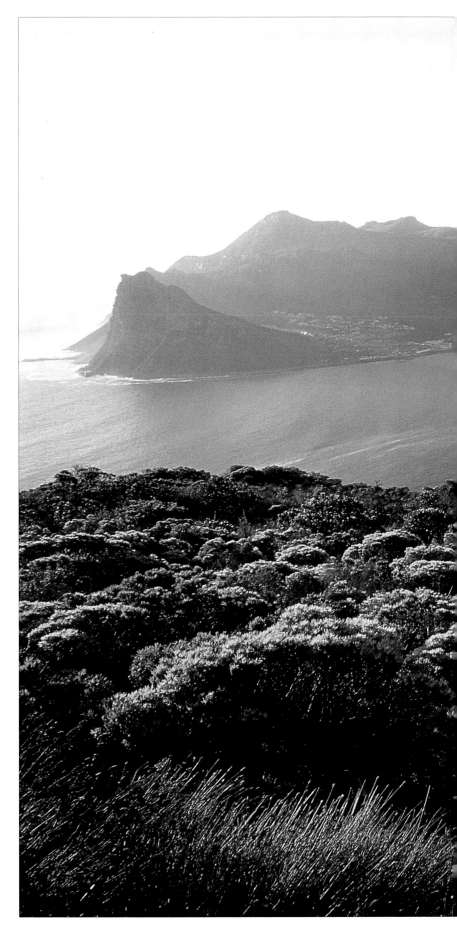

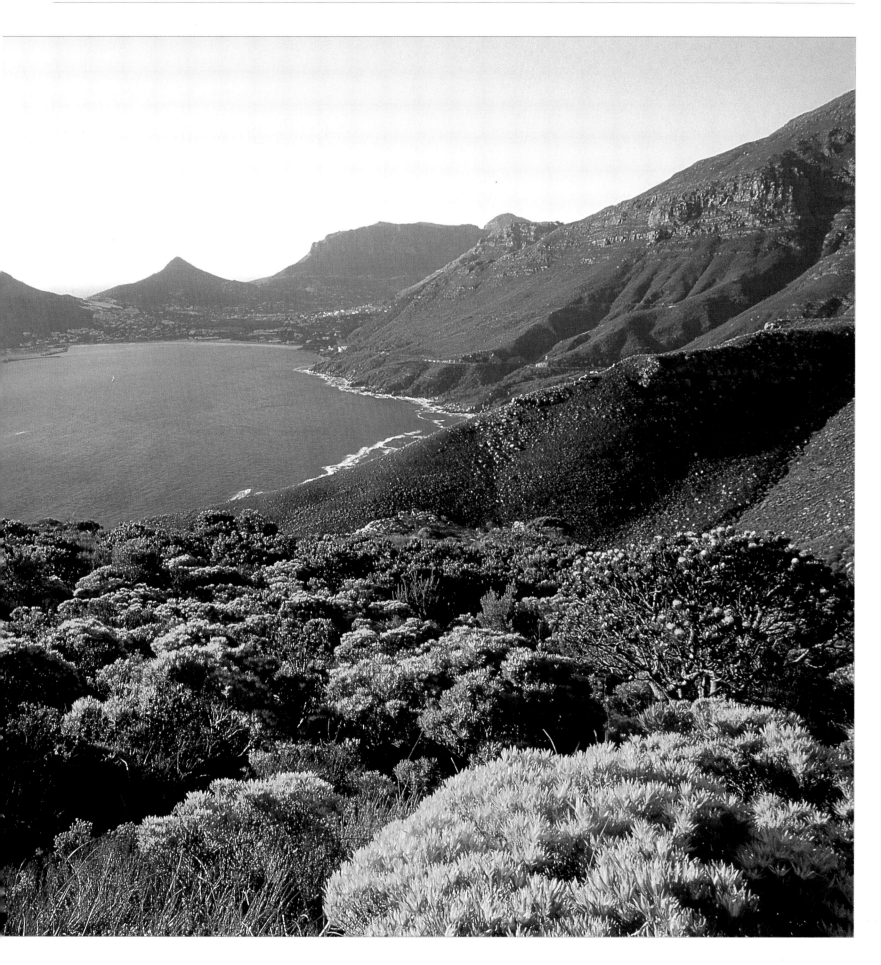

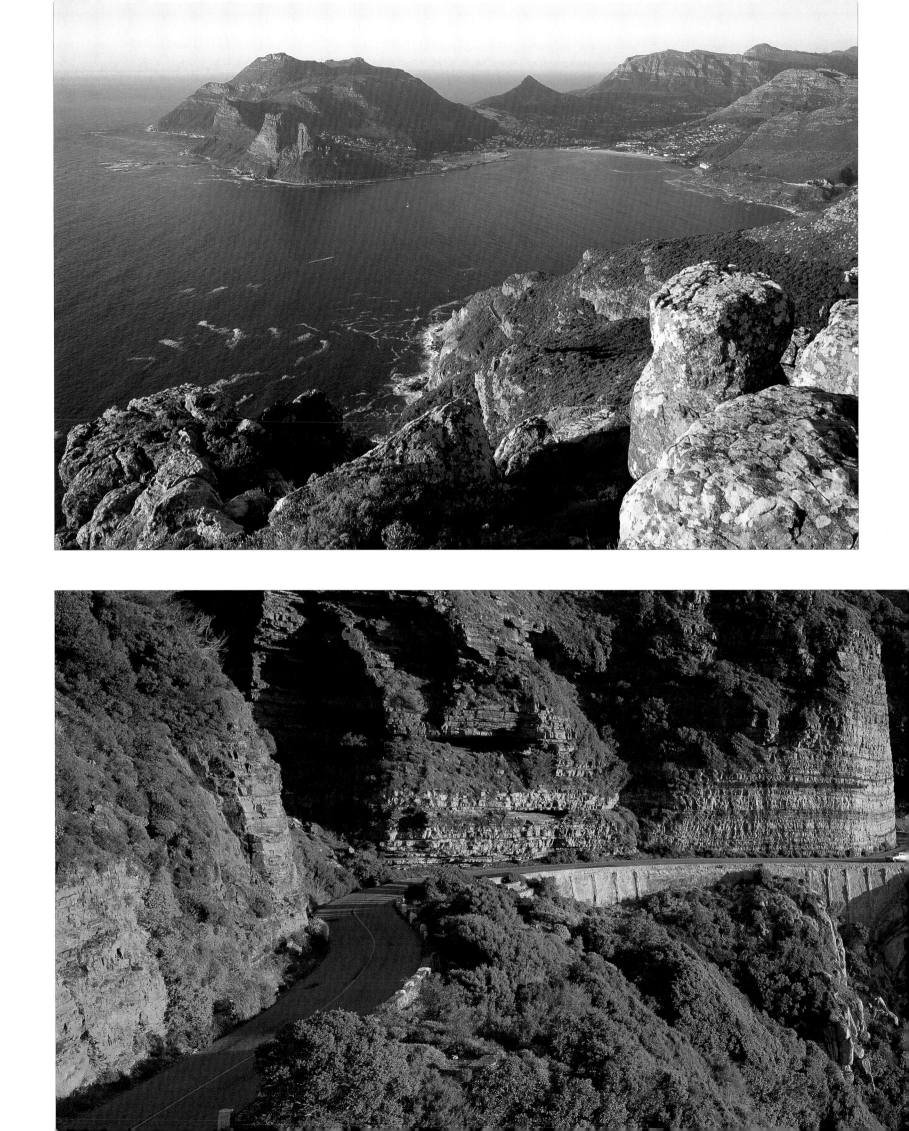

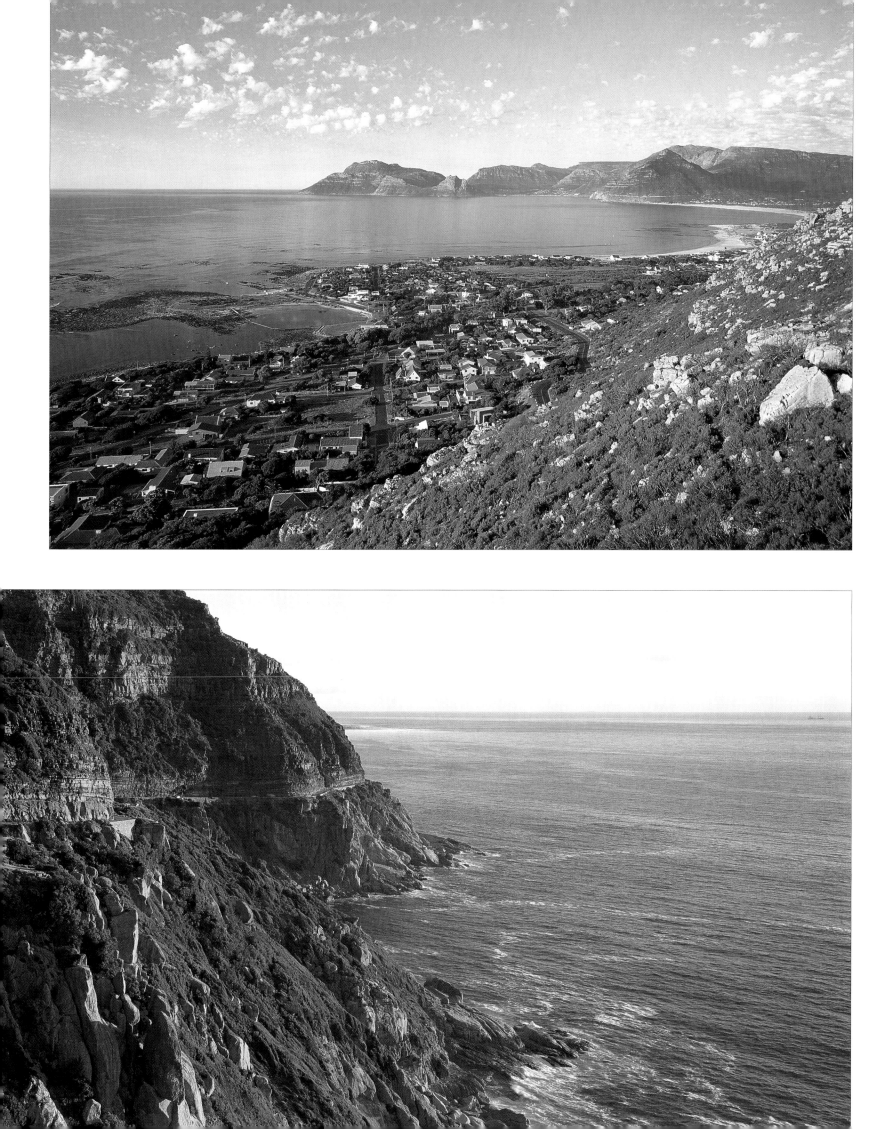

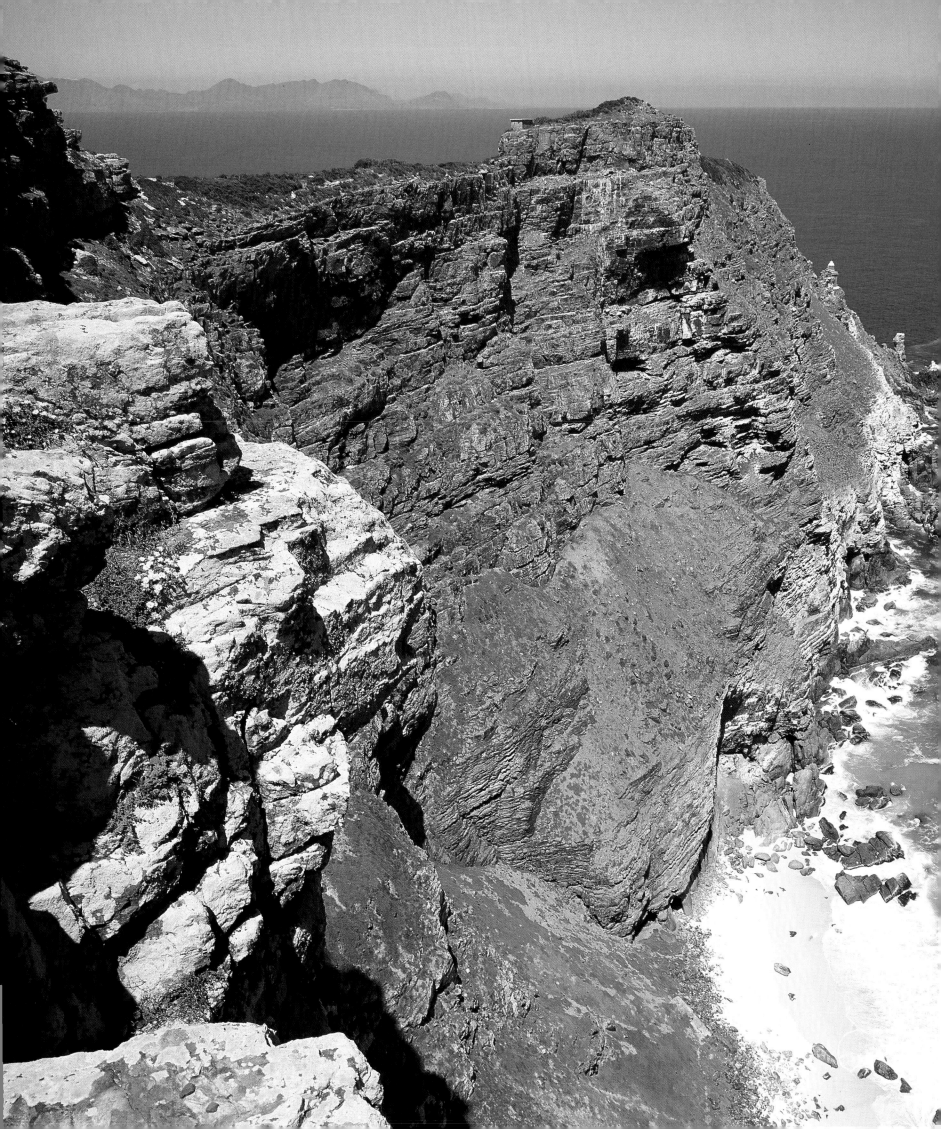

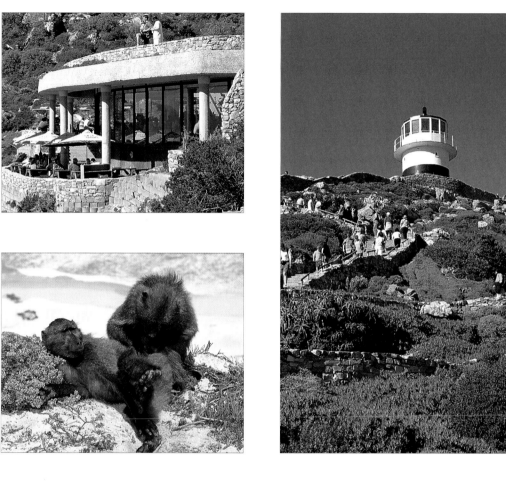

PREVIOUS PAGE, TOP LEFT *Throughout the year, and especially during the annual Hout Bay Festival in August, Hout Bay harbour is home to boats of every description, and the Mariner's Wharf complex, with its seafood cafés, fish markets, and curio shops, is a popular pit-stop.*

PREVIOUS PAGE, BOTTOM *As the peninsula's most scenic coastal route, Chapman's Peak Drive is at once breathtaking and precarious, with steep, rocky inclines dipping right to the ocean below.*

PREVIOUS PAGE, TOP RIGHT *Boasting some breathtaking vistas, the Cape coastal route that includes Kommetjie, Long Beach and the Sentinel at Hout Bay is dotted with a multitude of off-road vantage points, which allow visitors to take in some of the peninsula's restful views.*

LEFT *The 40-kilometre (25 mile) stretch of rock-strewn coastline that comprises the Cape of Good Hope Nature Reserve incorporates at its southernmost tip the paradise that is Cape Point.*

TOP LEFT *Facilities at Cape Point were upgraded in recent years to accommodate the nearly half a million tourists who flock here every year to take in the superlative views. Among the new attractions is the acclaimed Two Oceans Restaurant.*

ABOVE *The baboons that visit the roadsides of Cape Point and surrounds are so acccustomed to the visiting public that many have become aggressive foragers, forsaking their hunting instinct for scraps provided by delighted but ill-formed onlookers.*

ABOVE RIGHT *The precarious coastline along the southern peninsula has seen many a ship flounder on the boulder-strewn shore, and the new lighthouse at Cape Point continues to warn passing maritime trade of the dangers of this often turbulent stretch of water.*

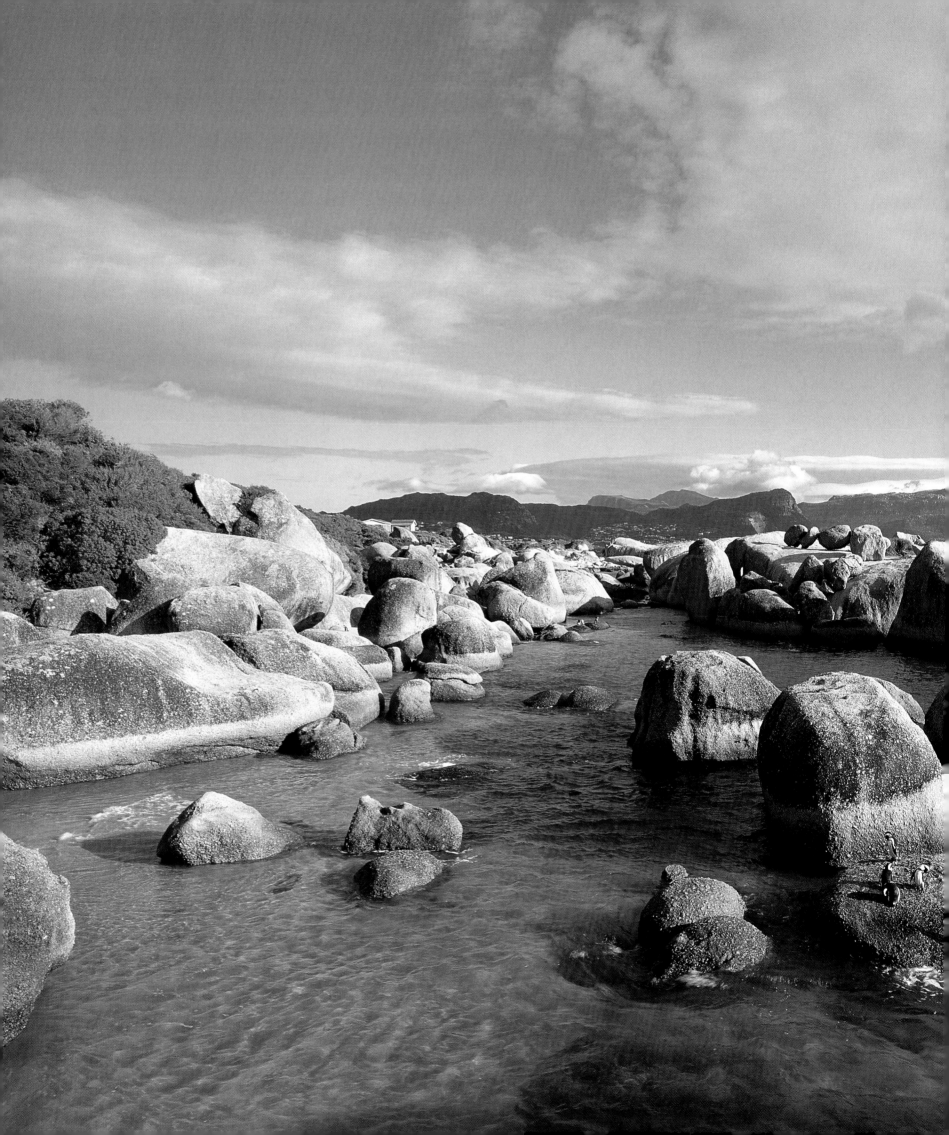

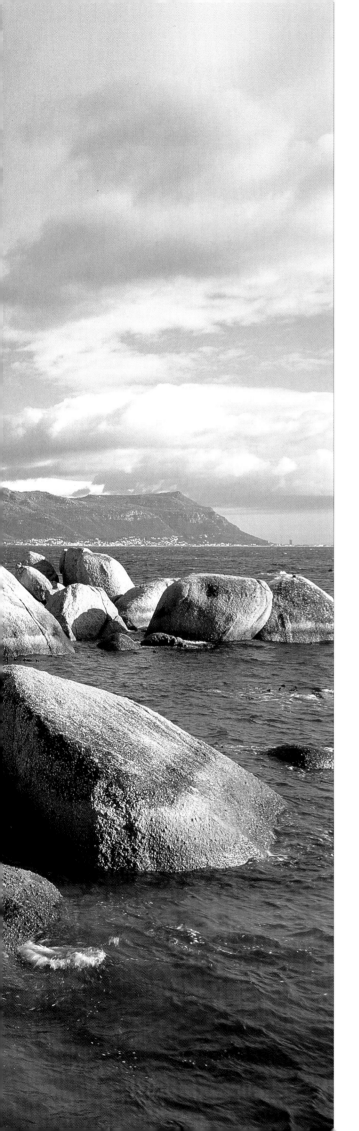

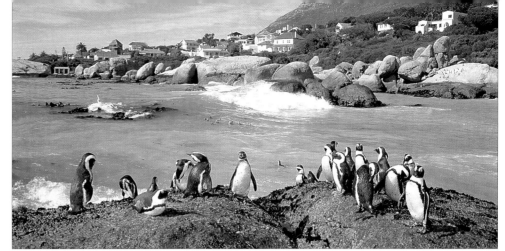

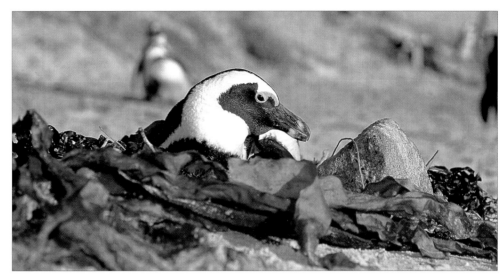

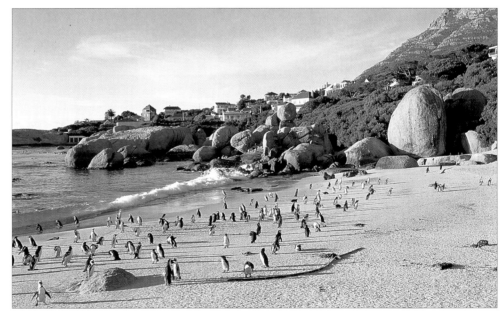

THESE PAGES *Simon's Town and neighbouring Boulders Beach boast crystal clear waters protected by huge granite outcrops that have encouraged the development of an African penguin colony on its shores. African penguins, previously known as jackass penguins, are the continent's only endemic penguin species. During the breeding season, the female lays two eggs, and the greyish-blue chicks – with no hint of the distinctive black-and-white markings of the adult – hatch after little more than a month of incubation.*

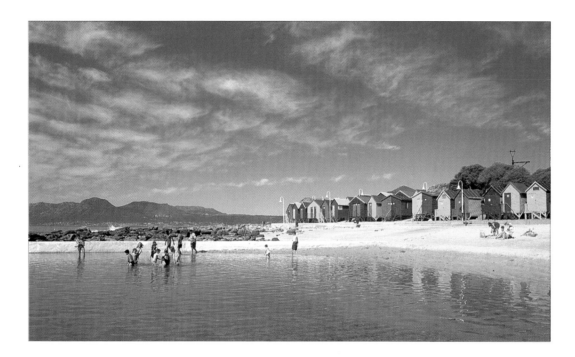

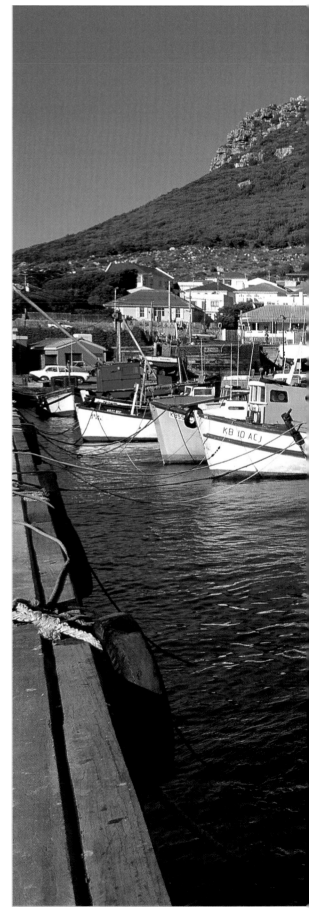

TOP *The beach and enclosed tidal pool at St James saw its heyday in the 1930s and '40s when
the sleepy seaside suburb became a popular getaway for well-heeled holidaymakers.*

ABOVE *The False Bay coast, with its warm sea and sparkling sands, remains the domain of
watersport enthusiasts, such as catamaran sailors who ply the waters around Fish Hoek.*

RIGHT *The fishing village of Kalk Bay, first settled by marooned sailors in the 1600s, remains
a productive harbour from which local fishermen work the fleet of brightly painted vessels, plying
the southern waters for snoek and other fish staples.*

OVERLEAF *The Kirstenbosch National Botanical Gardens run along Table Mountain's eastern slopes
up to MacClear's Beacon. Acknowledged throughout the world for the unparalleled diversity of its
nearly 7 000 species of flora, Kirstenbosch covers some 500 hectares (1 235 acres).*

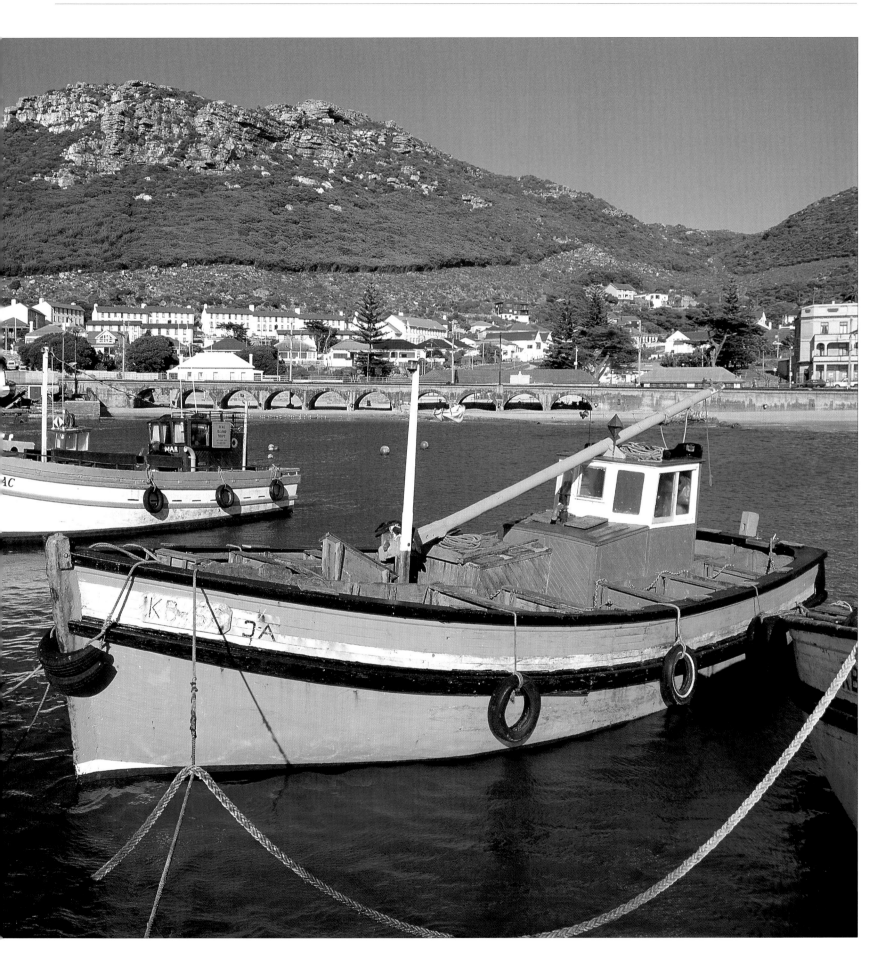

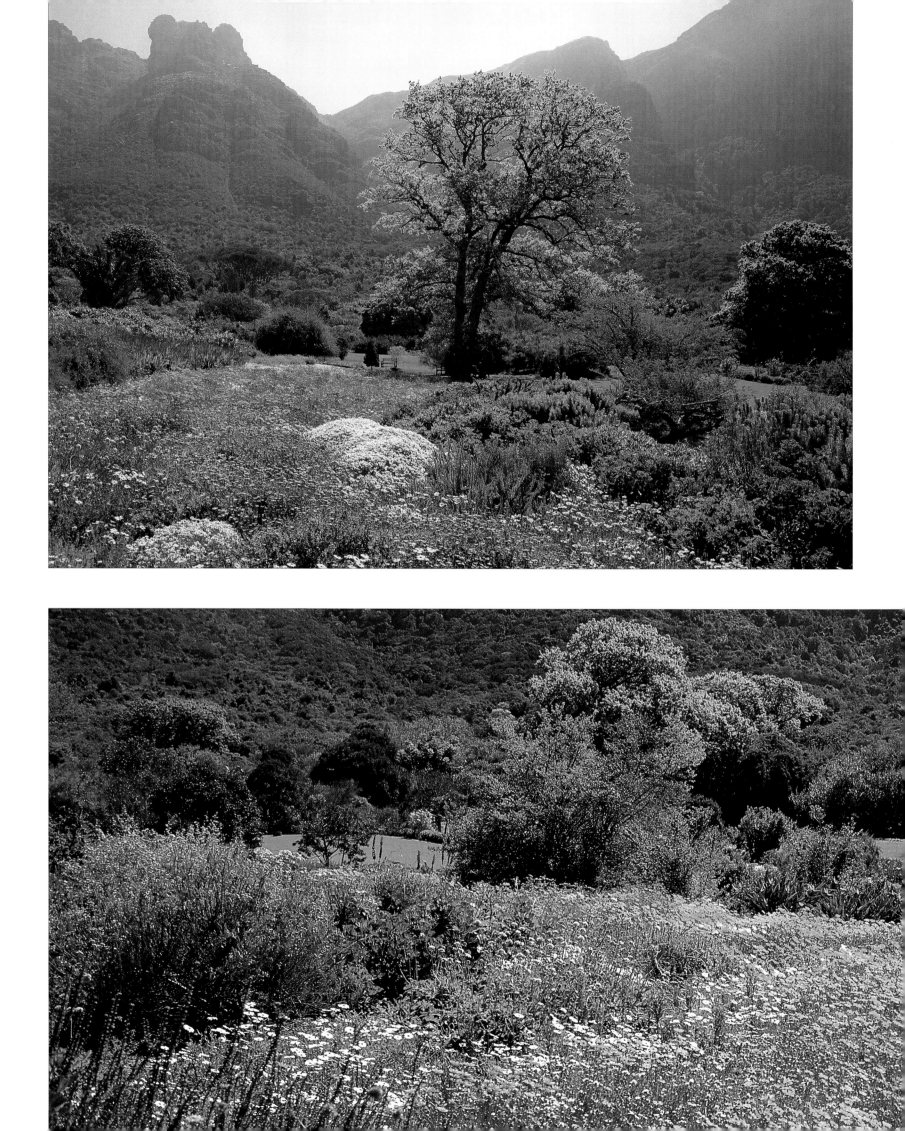

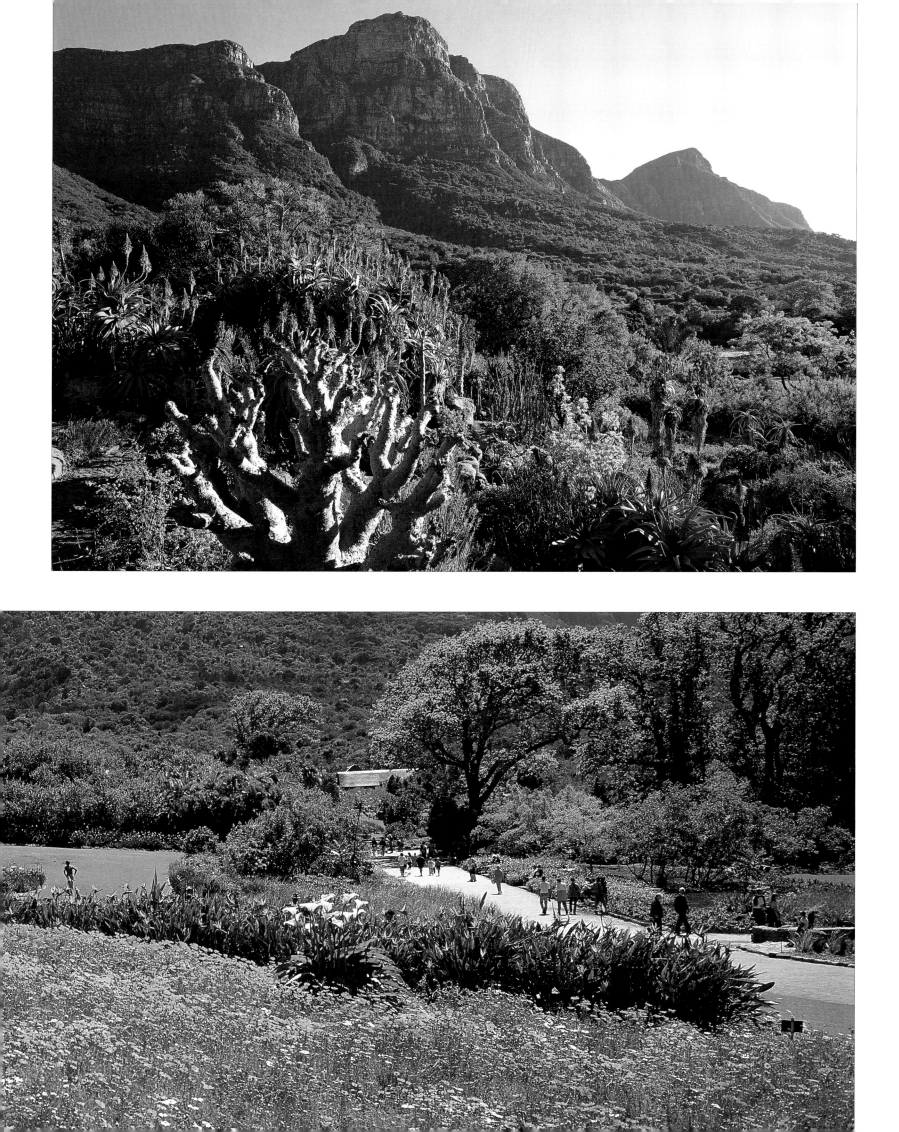

RIGHT AND OPPOSITE TOP RIGHT *The unusual sculptures erected at Kirstenbosch are the work of Zimbabwean stonesmiths.*

BELOW *Of the many treasures that may be found on the slopes of Kirstenbosch is the narrow-leaf sugarbush, which is visited regularly by nectar-seeking birds.*

BOTTOM RIGHT *Non-flowering seed-bearing cycads were among the first inhabitants to be planted in the newly established Kirstenbosch in 1903.*

OPPOSITE, TOP LEFT *Flowers of the clivia provide a profusion of bright orange splashes in the warm spring months in Kirstenbosch.*

OPPOSITE, BOTTOM LEFT *The bulbs of Kirtsenbosch's star-shaped watsonias, some of the most spectacular during the spring bloom, were once an important food source of Cape-based communities.*

OPPOSITE, BOTTOM RIGHT *The familiar red disa, also known as the pride of Table Mountain, has been incorporated into the provincial emblem of the Western Cape.*

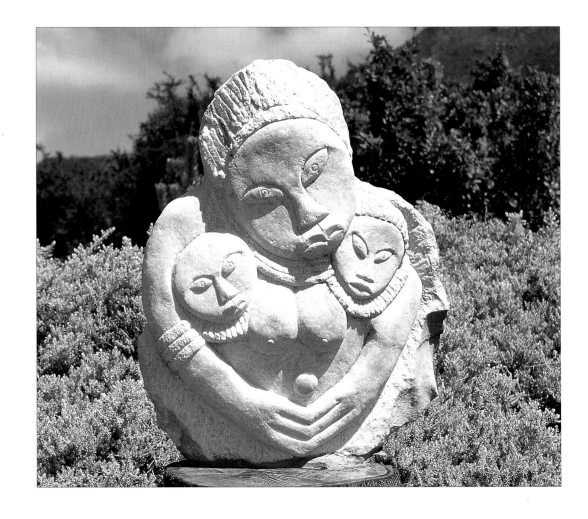

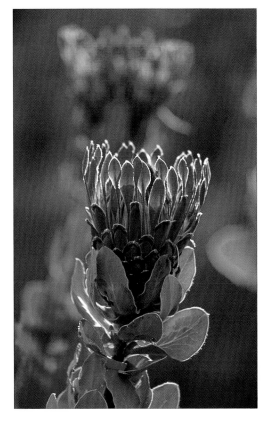

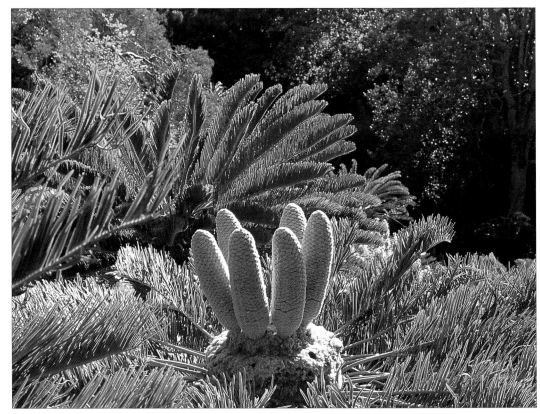

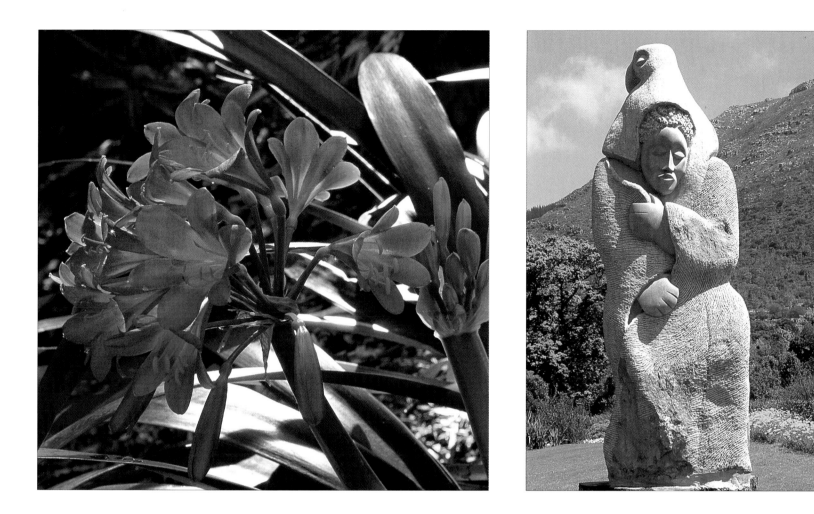

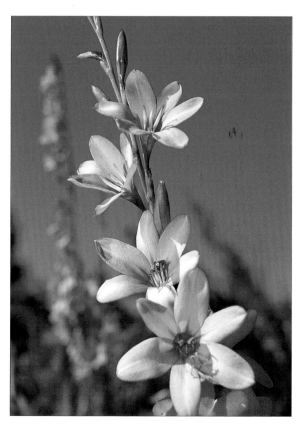

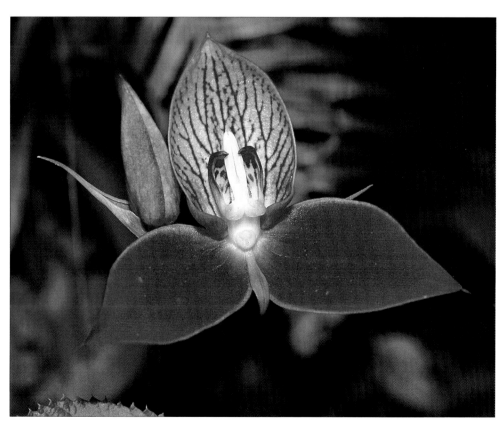

THE WINELANDS

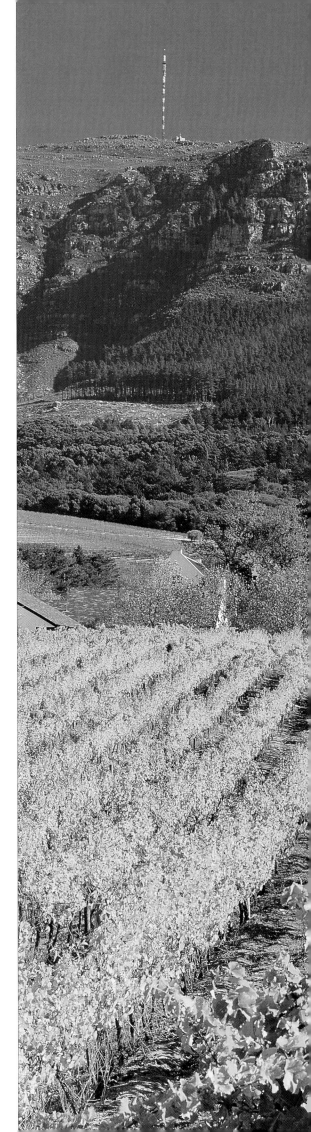

The Fairest Cape is internationally acclaimed for the exceptional wines that originate in the sun-drenched vineyards of the hinterland. Although the early vines were initially planted on the new farms established on the peninsula, some of the finest wineries today lie scattered throughout the Cape Winelands, originally settled by French Huguenots in the seventeenth century. The mineral-rich soils and well-watered landscape create idyllic conditions for the vines, producing plump and juicy grapes, pressed and aged to create full-bodied reds and delicate whites.

The university town of Stellenbosch and the surrounding hamlets are the pride of the winelands. Although so much of the arable land has been given over to vineyards, the landscape here is also a protected haven for indigenous flora and fauna, an unspoilt wilderness of wide open spaces, rivulets and mountain gorges.

The towns of Stellenbosch and Franschhoek form not only the centre of local farming communities, but also settings for the arts and other entertainment.

Highlights on the Cape's Wine Routes incorporate renovated and upgraded facilities, which include highly acclaimed restaurants, wine centres, and theatre and cabaret venues. Here the sounds of live jazz mix with the clink of wine glasses and the delighted squeals of young children. Such is the warmth of the Cape Winelands.

Although relying on state-of-the-art technology of the twenty-first century, vintners here continue to draw on centuries-old skills and expertise passed down from one master winemaker to another. Wines continue to be matured in old oak barrels, and wines of the Cape Winelands continue to grace the tables of connoisseurs the world over.

Stellenbosch, Paarl and Franschhoek are the most important civic and agricultural centres of the Winelands, and can trace their origins to the early days of the Dutch and English colonists. The old streets, wide enough to accommodate the lumbering pony traps and horse-drawn carts of yesteryear, are lined with monuments and museums offering a glimpse of life as far back as the seventeenth century.

But these charming old towns do not rely on their history to carry them into the new millennium.

All today are thriving modern towns that contribute not a little to the heritage of the nation and the local economy. Stellenbosch is the seat of one of the country's finest universities, and 'capital' of the Winelands; Paarl is a centre for the fruit and tobacco industries, and headquarters of the 100-year-old Ko-operatiewe Wijnbouwers Vereniging (KWV); while Franschhoek is the unofficial home of the country's finest cuisine.

Beyond the vineyards of the Cape Winelands lie the fertile orchards of Grabouw and Elgin, Tulbagh and Ceres, Robertson and the magnificent Breede River Valley.

RIGHT *The gabled manor house, prized cellars and original slave quarters and stables of Buitenverwachting comprise one of the Cape's finest and most acclaimed wine estates.*

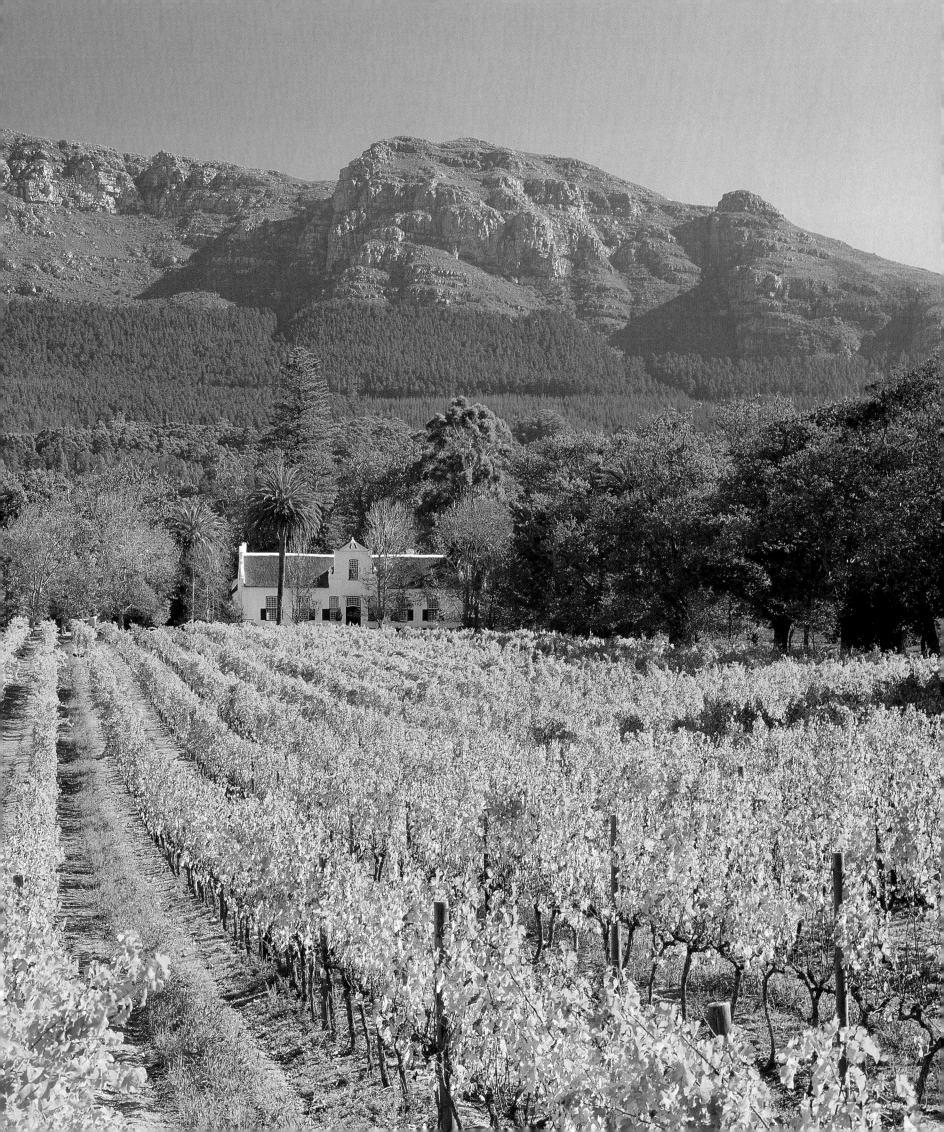

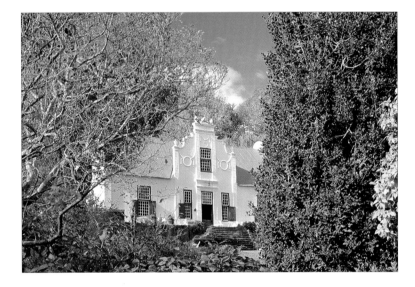

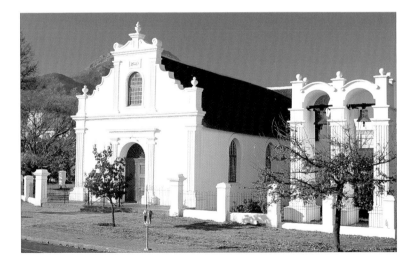

THESE PAGES *The buildings of Stellenbosch comprise an amalgamation of architecture that reflects its colonial heritage. Dorp Street (top) carries fine examples of Victorian-style buildings, while Oude Nektar manor house (top centre) is in classical Cape Dutch style; the Rhenish Church (above) is in Cape Dutch and English style, while many of the university buildings (right) reflect a more modern neoclassical design.*

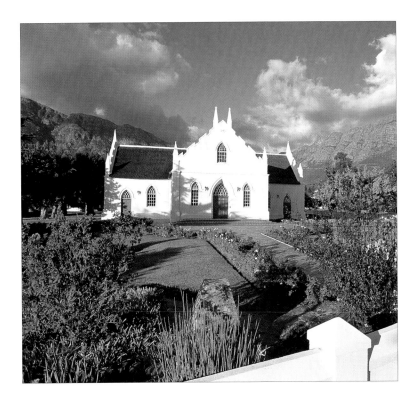

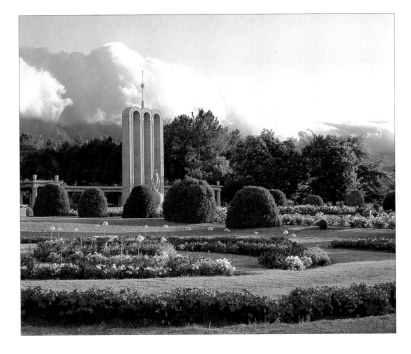

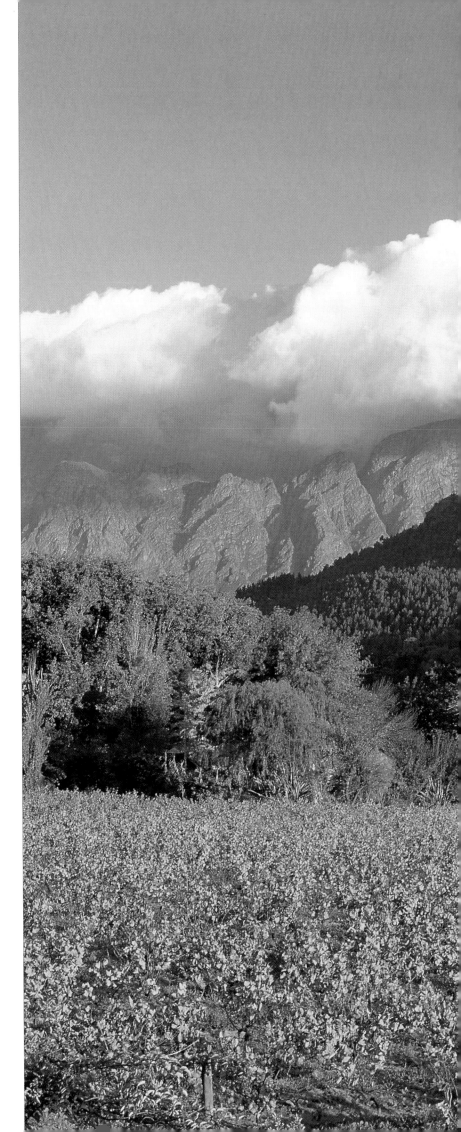

TOP *Although assimilated into local culture over the centuries, the French and Dutch heritage of Franschhoek is still abundantly apparent in its architecture, most notably in the town's Dutch Reformed Church.*
ABOVE *The arches of Franschhoek's Huguenot Memorial symbolise the Holy Trinity, while the woman carrying the Bible represents freedom of Religion, rejecting Oppression by casting off her cloak.*
RIGHT *The vineyards of the Franschhoek Valley represent one of the country's most prolific wine-producing regions.*

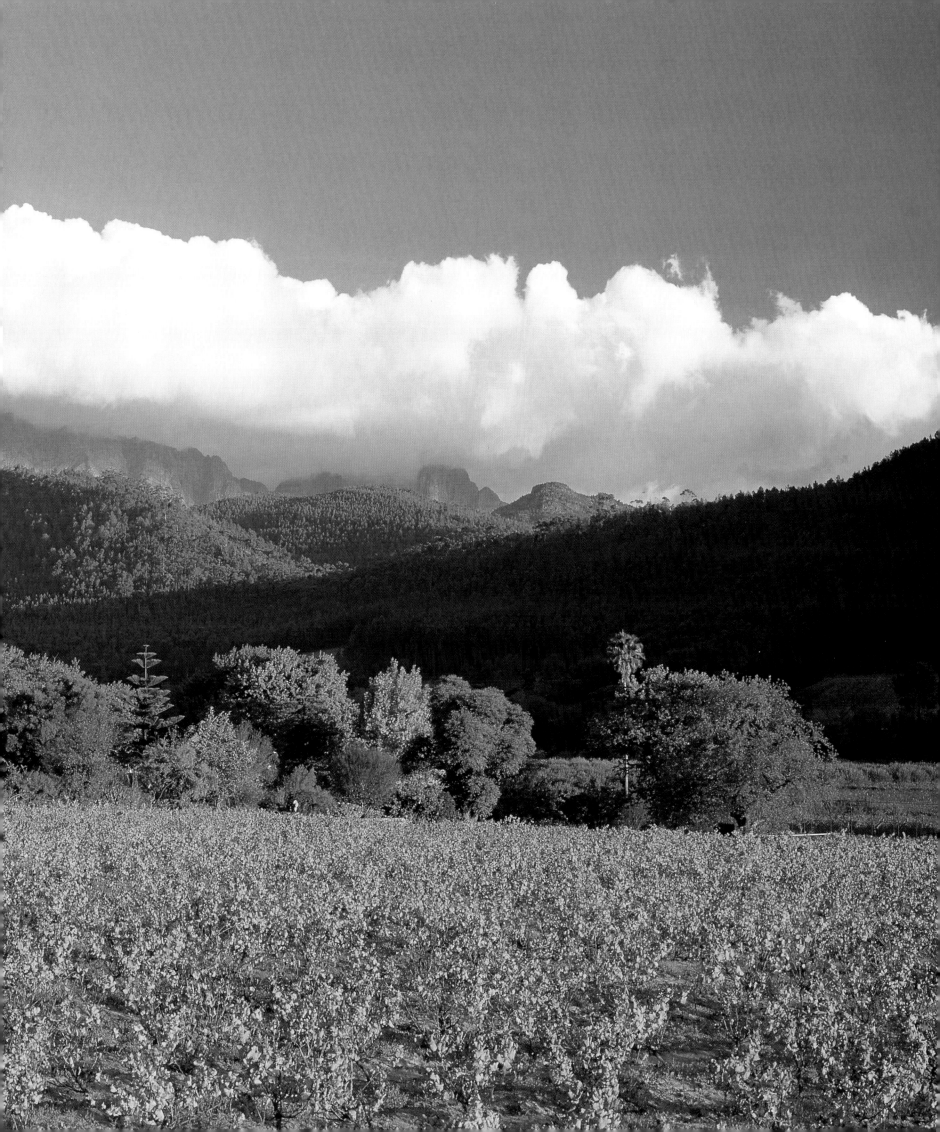

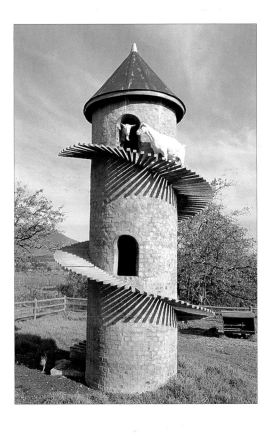

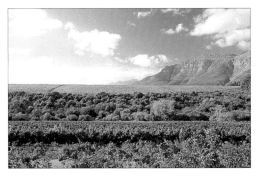

Top *One of the most unsual sights on Paarl's wine route are the Swiss mountain goats of the Fairview Estate climbing a specially erected staircase to their loft home.*

Above *The vineyards of the Rust-en-Vrede estate at the foot of the Helderberg range were planted in 1730, but lay dormant for some time in the twentieth century, until restored to their full potential in 1979.*

Right *The conical structures that peek up beyond the vineyards of the Paarl valley are the pillars of the Taal Monument, which honours the Afrikaans language.*

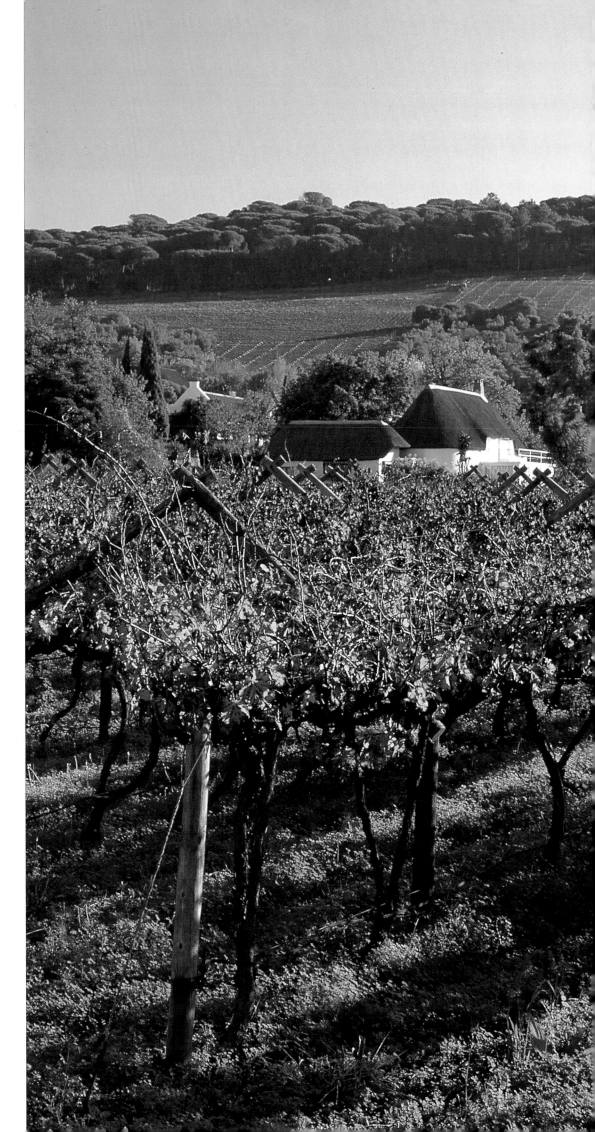

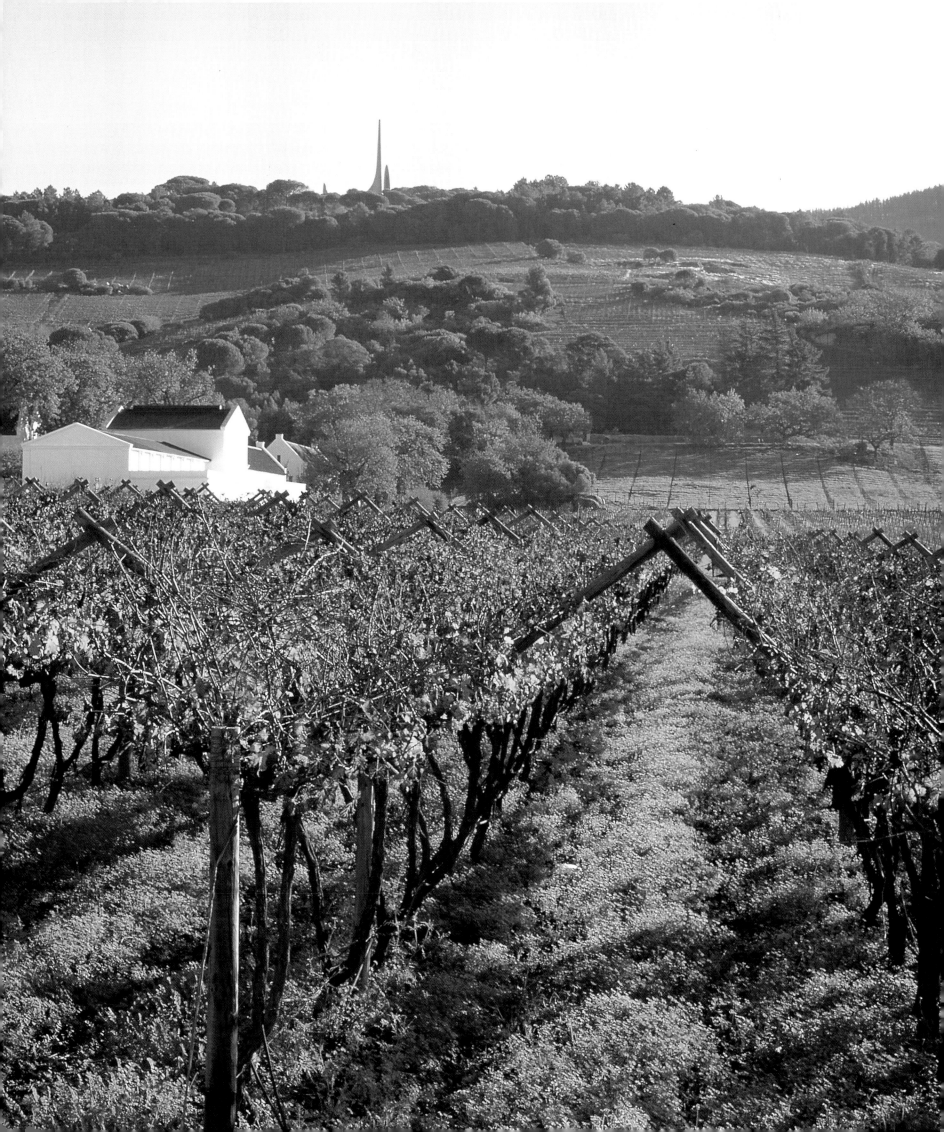

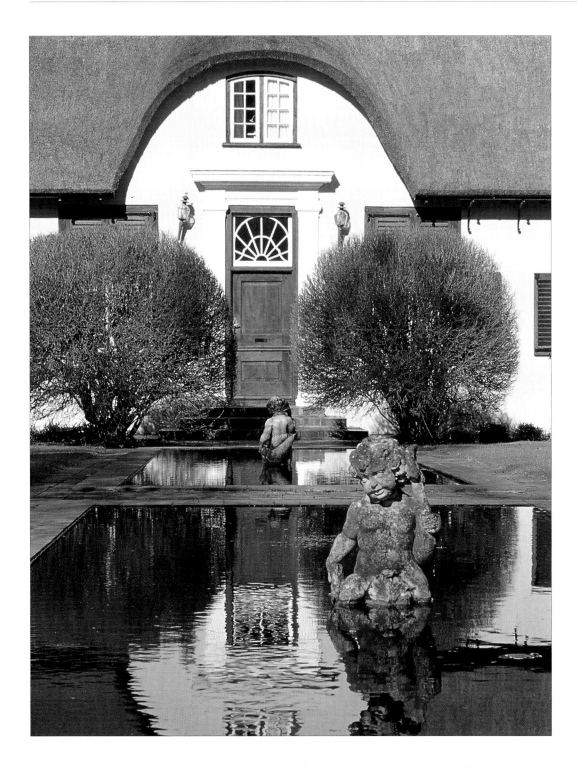

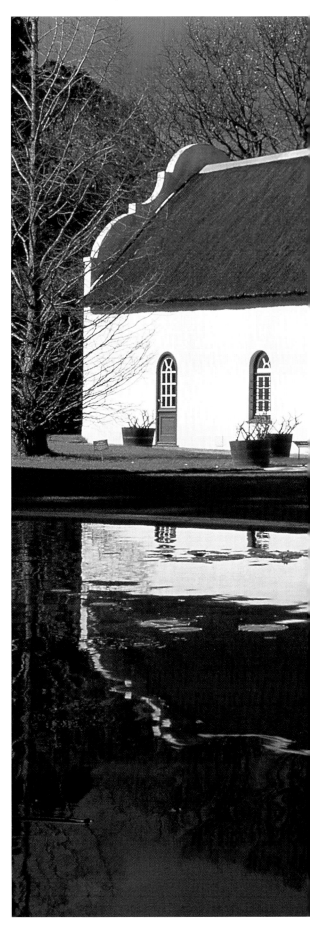

ABOVE *Since the establishment of the early vineyards at the Cape, wine estates such as Vergelegen have consistently produced some the world's finest stock and today the wineries continue to draw hundreds of thousands of wine-tasters to the Cape Winelands.*

RIGHT *Many of the old Cape Dutch-style structures on the Vergelegen wine estate, built originally to accommodate the early wine-making processes, have been given over to more contemporary uses, such as the estate's impressive library.*

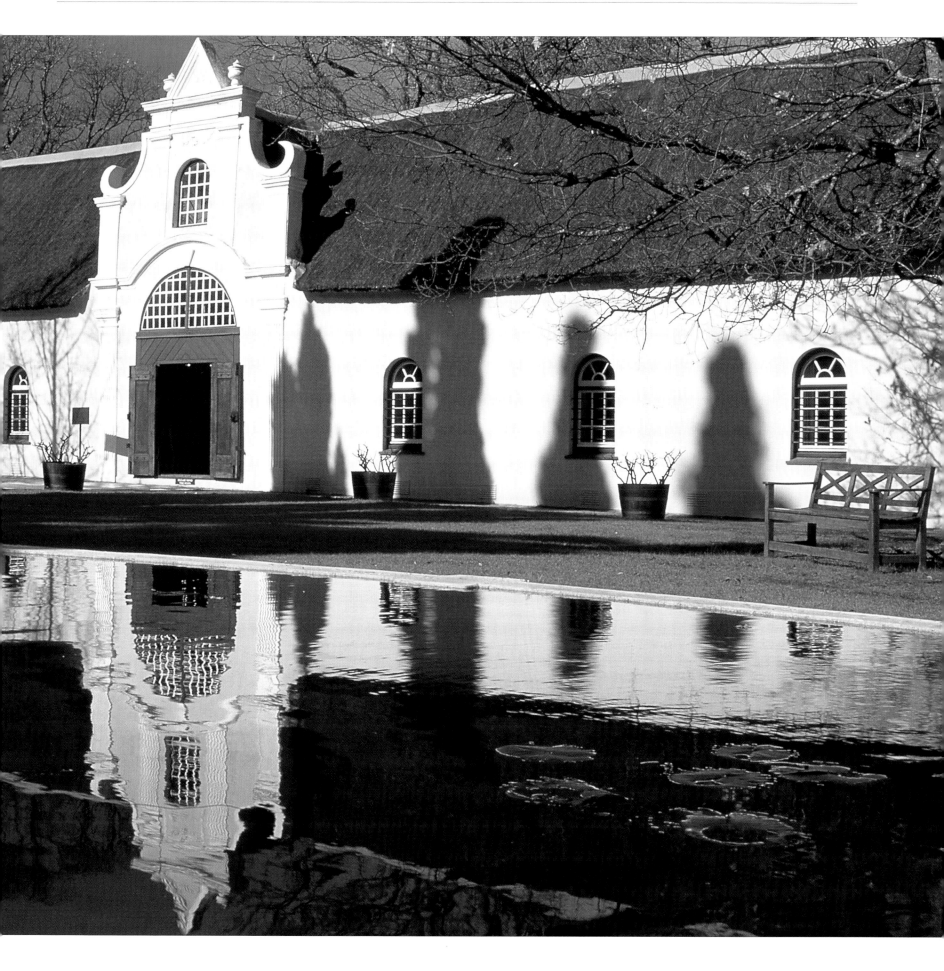

The Cape Dutch farmhouse, manor house and the numerous outbuildings of the Vergelegen estate are set against a lush and productive backdrop, which includes stands of camphor trees that are more than 300 years old.

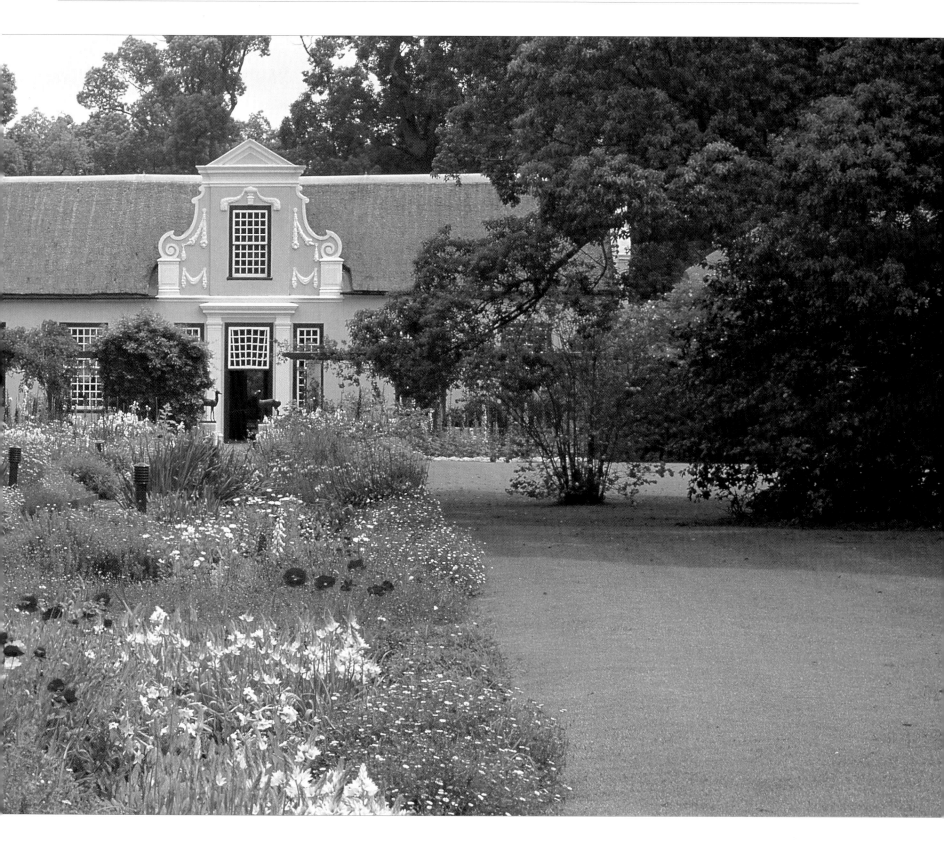

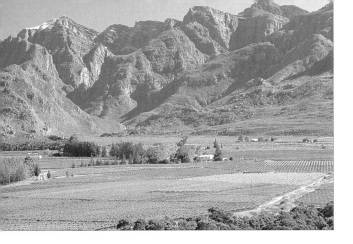

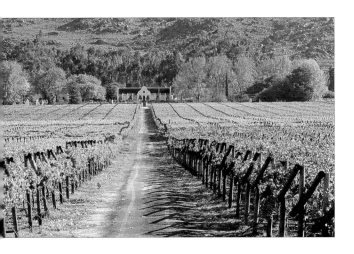

TOP *Set against the magnificence of the Hex River mountains, it is no wonder that the vineyards of the Cape Winelands are hailed as the continent's most picturesque.*

ABOVE CENTRE *Although the winter months in the Cape interior around the towns of Tulbagh and other hamlets can be brutal, come summer the fruits of some of the country's most prized orchards are harvested.*

ABOVE AND RIGHT *Known throughout the world for the quality of their produce, the orchards of the Hex River Valley, in the Ceres region, burst with fruit during the summer.*

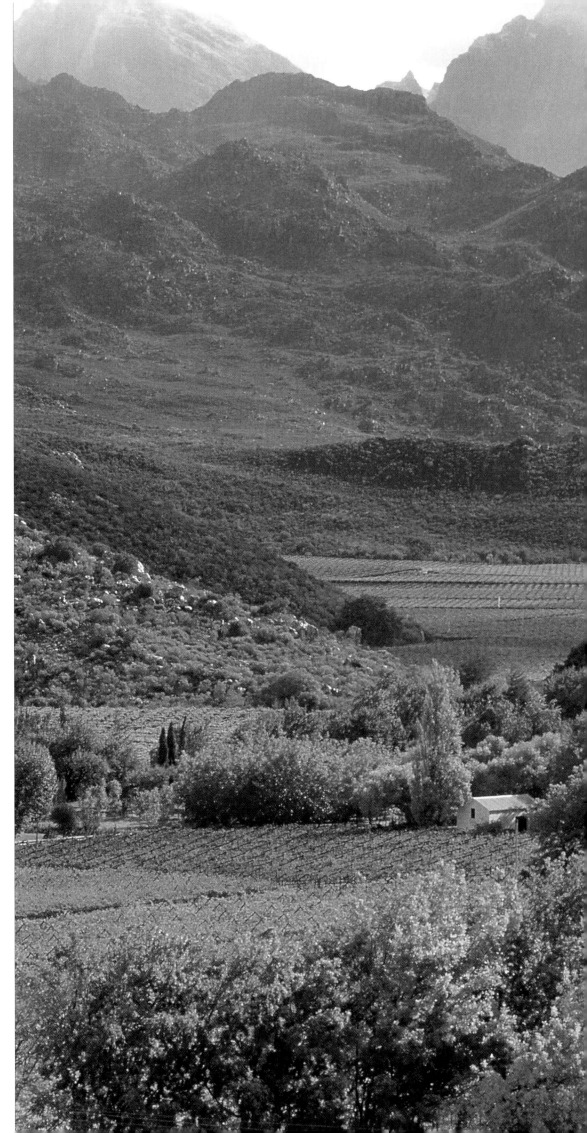

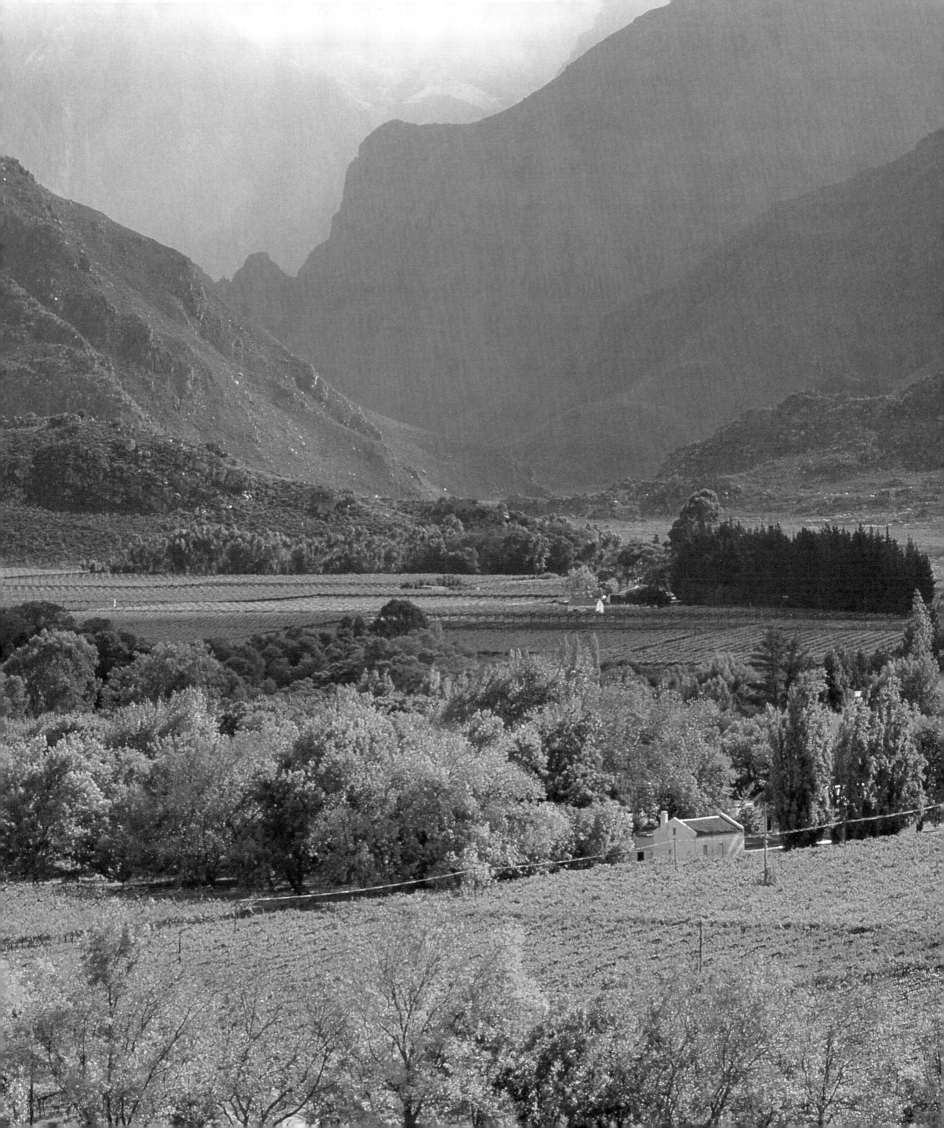

THE WEST COAST

The Cape's West Coast is one of the subcontinent's most unspoilt stretches of uninterrupted shoreline, extending in a concave line from the point at which the peninsula joins the mainland, north and beyond to the tiny hamlet of Velddrif. For virtually all its length, one expanse of rugged fynbos, wave-lapped beach and endless sea of dunes meets with another. This is a world of simple living, of humble fisherfolk who, for generations, have eked an existence from the all-too-often hostile environment posed by land, sea and wind.

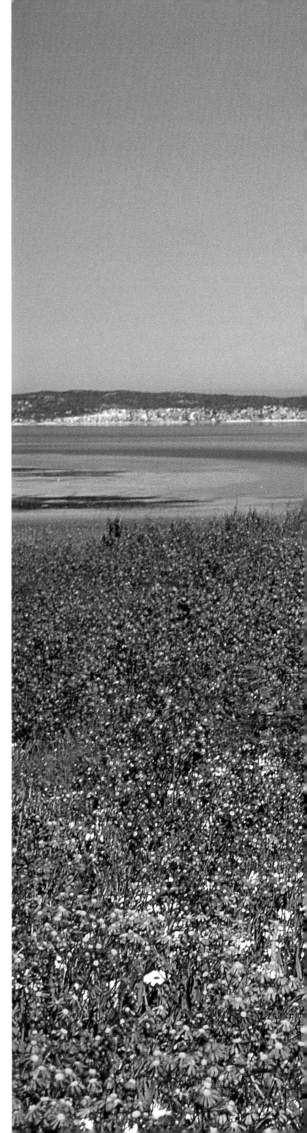

The landscape of the West Coast is empty and open, an inspiring remnant of a simpler time when much of South Africa's shoreline comprised little more than a fascinating amalgamation of fauna and flora, teeming with bird life and blessed with the offerings of the Atlantic on which many of the local inhabitants still rely.

But this rather romantic notion of inviolate pastoralism is somewhat scarred by the sheer hardship of life on the rugged coast. There are impressive holiday getaways scattered at various points along the sandy stretch, but the communities who have made their home here are generally a modest lot. Homes are simple, whitewashed cottages or rudimentary shacks housing families that continue to lead a lifestyle passed down from one generation to the next, a lifetime of trawling fish from the sea.

The wealth of the region's natural heritage – from Saldanha to Langebaan, Paternoster to Lambert's Bay, Doringbaai to Hondeklipbaai – is unrivalled anywhere else along the South African coast. Hundreds of bird species nest and breed along these beaches, while the spring brings an unparalleled floral display that attracts visitors from far and wide to the paradise of Namaqualand and its surrounds.

The West Coast is an integral part of the distinctive Cape Floral Kingdom, and includes flowering plants numbering more than 1 000 species, more than 80 of which are unique to this shore.

Much of this impressive coast – the landscape and the villages it cradles – is protected as it presents a rich and vivid look at important elements of the area's colourful past. Towns and settlements here are dotted with simple monuments and quaint museums dedicated to the region's history, from its wildlife heritage to the all-important fishing industry.

The West Coast National Park is one of the most impressive wetland areas in the world, and recent discoveries have shown that this may be where humankind first evolved. As communities began to grow, they forged intrinsic links with the land and some hamlets erected small harbours on their pristine beaches. Apart from fishing, the region is one of the country's most popular whale-watching sites, visited as it is by southern right whales between May and October each year.

RIGHT *The coastal stretch and 17-kilometre (11 miles) lagoon at Langebaan lie at the very heart of conservation efforts on the Cape's West Coast.*

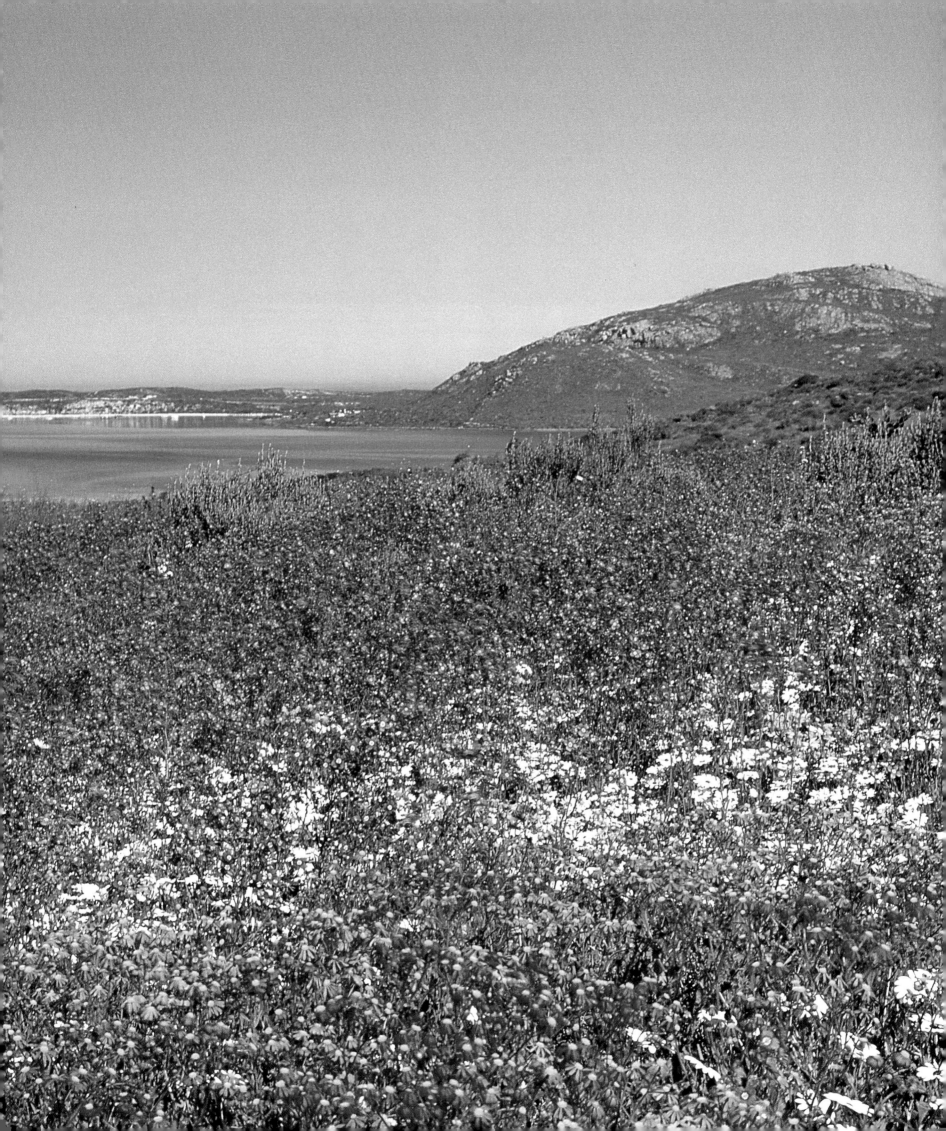

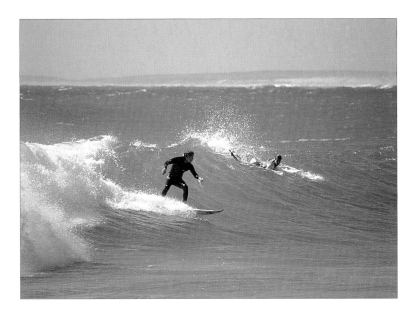

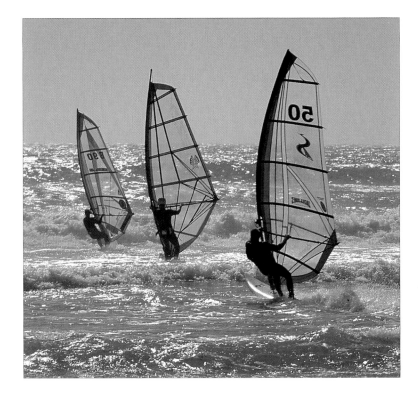

Top and above *The early days of the twentieth century saw the establishment of the southern hemisphere's largest whaling station on the West Coast. Today, however, whaling has long been abandoned and has made way for more contemporary pastimes such as surfing and windsurfing.*

Right *The small hamlet of Yzerfontein – Dutch for 'iron fountain' – was named after its somewhat metallic-tasting spring water, but it has grown considerably from the original grazing land reserved for the cattle of the Dutch East India Company.*

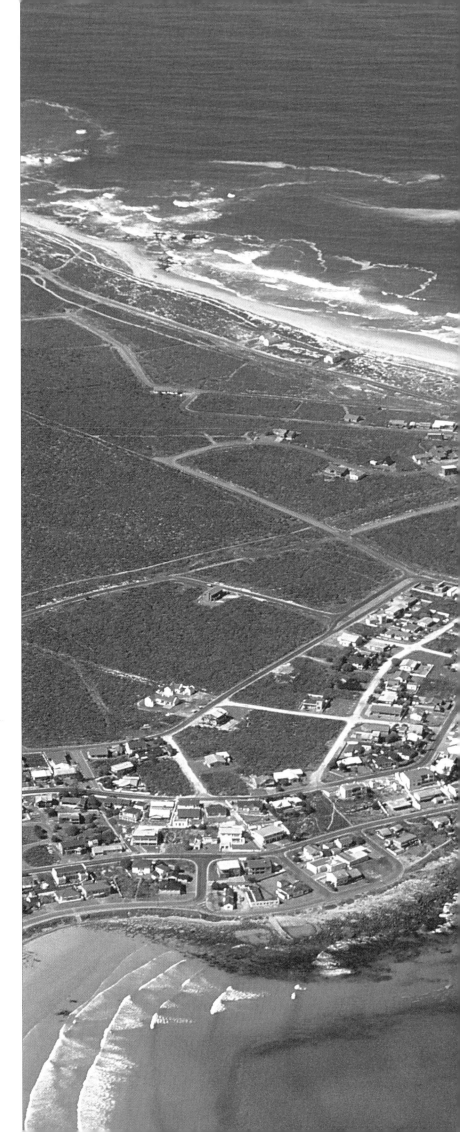

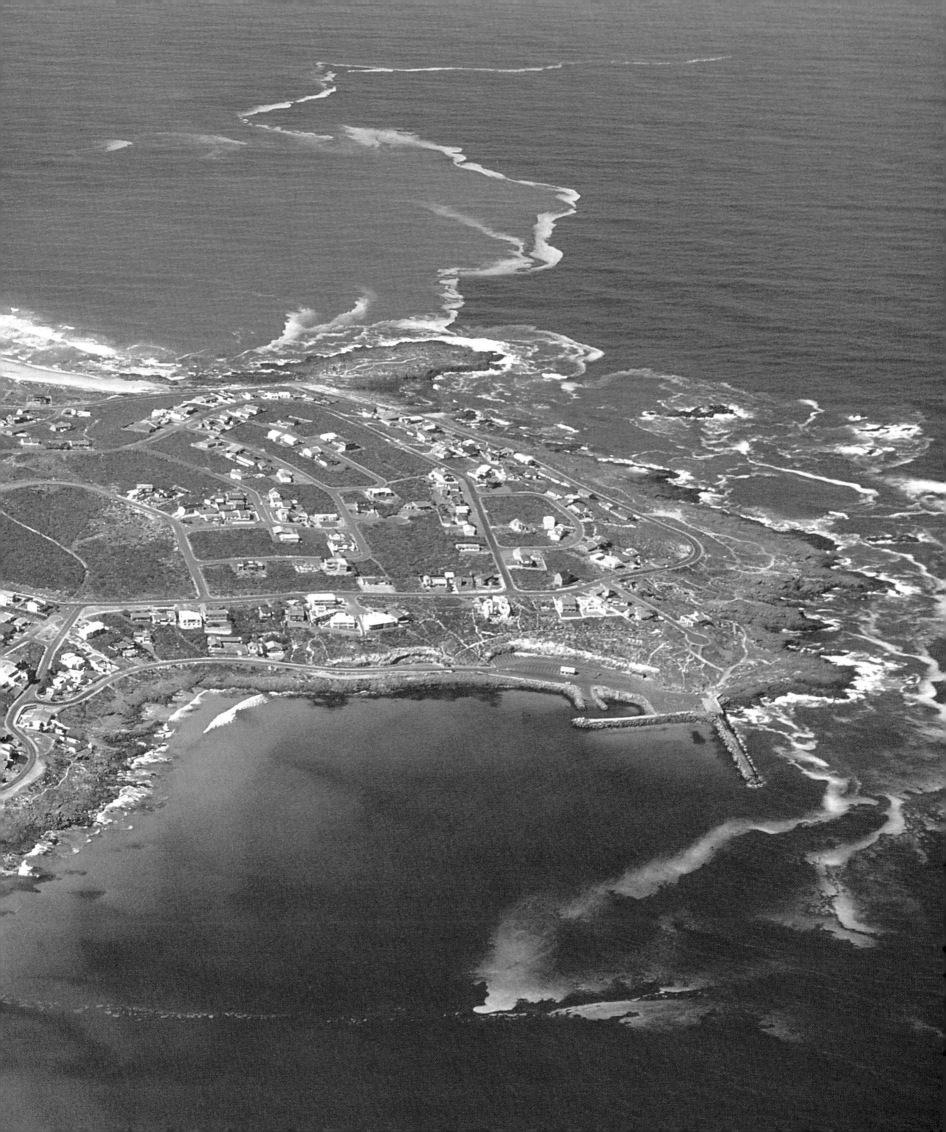

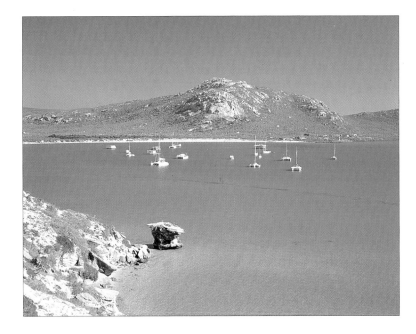

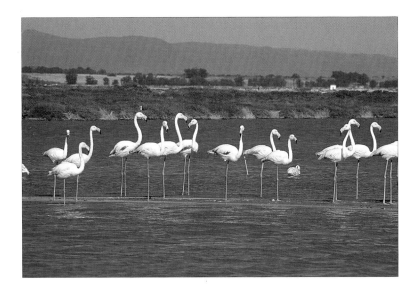

TOP *Like Langebaan, many other towns and villages on the West Coast rely almost entirely on what the sea has to offer the communities that reside here. Apart from the steelworks, small industries are few here, and fishing remains the principal occupation of locals.*

ABOVE *Development on the West Coast is restricted to town precincts and the natural splendour of the region remains largely intact, so that its impressive wetlands are home to an extraordinary variety of bird life, including flamingoes.*

RIGHT *Today, the fishing village of Yzerfontein boasts a small harbour and boat club, and the seas here are visited every year by pods of southern right whales that come to breed and calve along the South African coast.*

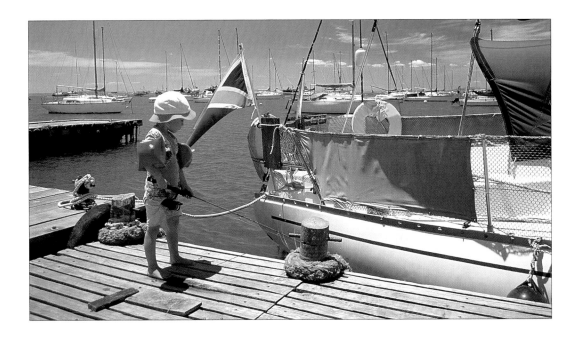

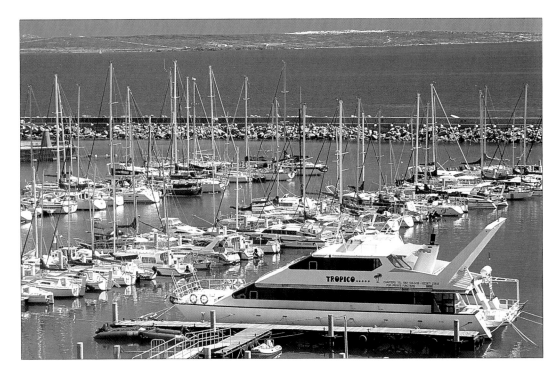

THESE PAGES *Although the West Coast is largely about wild flowers and abundant bird life, it is also the home of one of the Cape's most popular leisure resorts, and Club Mykonos, with its Greek-style kalifas and fleets of pleasure craft, provides an accessible weekend getaway for Capetonians.* OVERLEAF *The spectacle of wild flowers along the Cape West Coast is at its best from mid-August onwards, depending on rains, when the Strandveld and Namaqualand come into bloom, and the seemingly endless spectrum of flowers – seen here in the delightful little town of Darling and the Tienie Versveld Flora Reserve – attracts thousands of travellers from across the globe.*

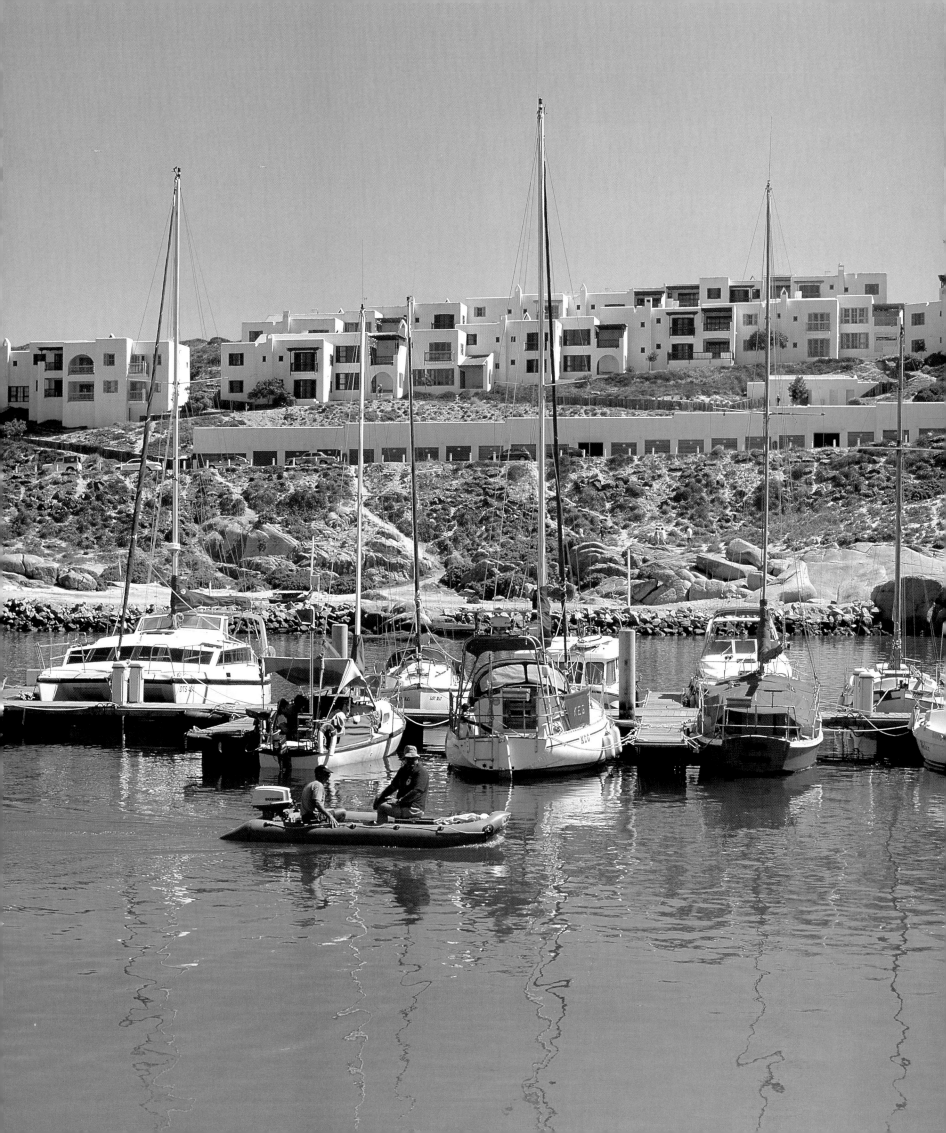

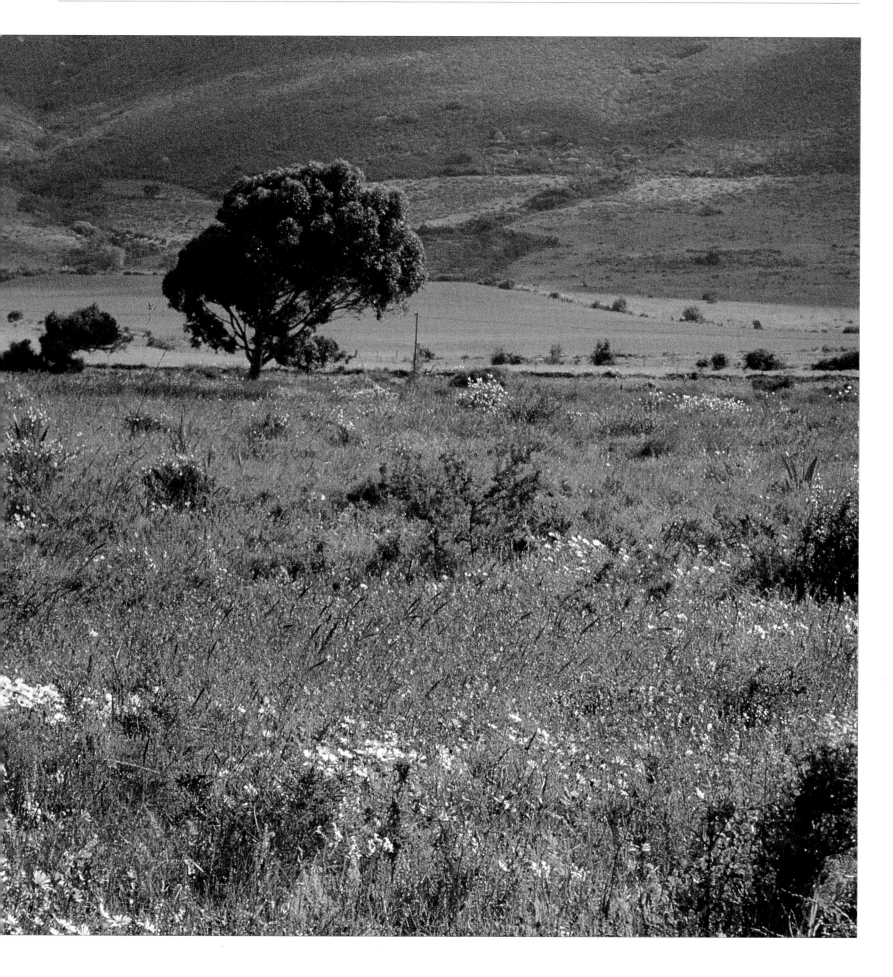

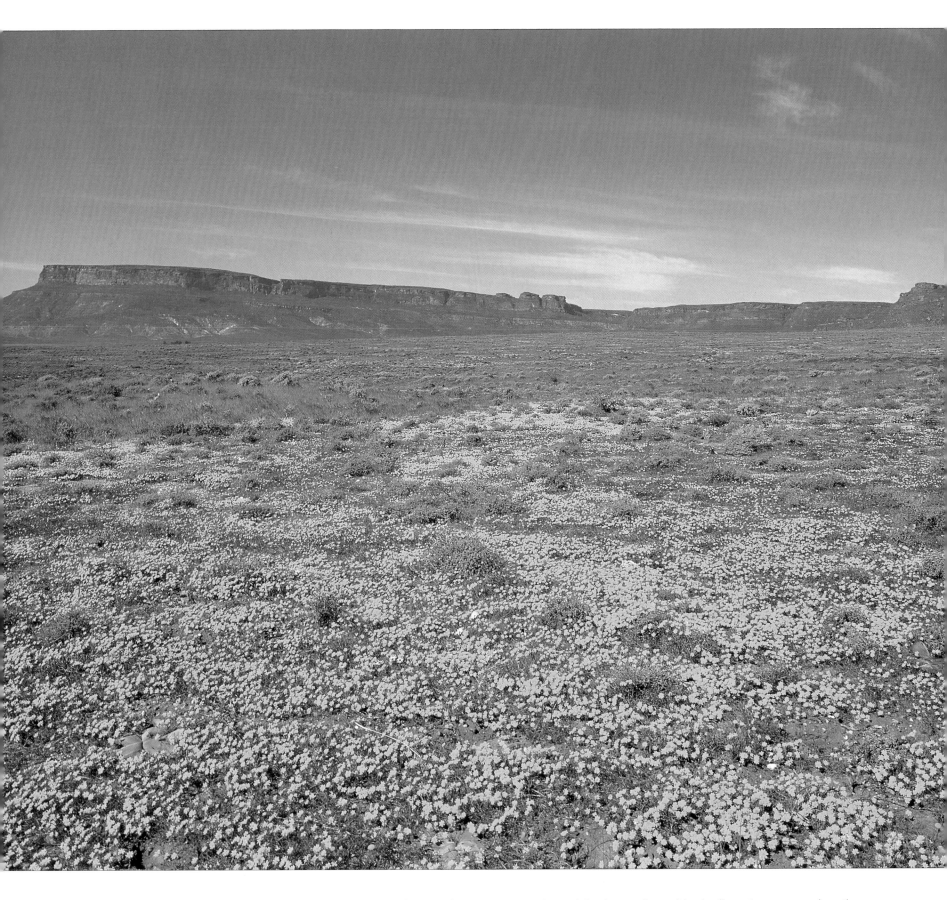

ABOVE *Although not usually picturesque in the conventional sense, the quartz-strewn Knersvlakte is transformed in the flowering season when the foothills around Vanrhynsdorp are carpeted with spring flowers of every hue.*

ABOVE *With the onset of the rainy season, the arid Namaqualand region is blessed with a bounty of life: daisies and gazanias are interspersed with perdebos and kapokbos as they spread over the rough valleys and rocky plains.*

THE OVERBERG AND LITTLE KAROO

The imposing mountain peaks and steep inclines of the Overberg region, with its breathtaking passes and fertile agricultural land, stretches along the southern Cape coast from the purple-hued Hottentots Holland mountain range in the southwest, east across the Riviersonderend range to the Breede River Valley and then north to the rugged landscape of the Langeberg and Outeniqua mountains. Abundant winter rainfall ensures that orchards flourish virtually throughout the year, and the small towns that punctuate the route into the Little Karoo are typically rural.

Some of the country's most picturesque and charming towns lie in the Cape hinterland, and include Robertson, Montagu, Swellendam, Caledon, Bredasdorp and the plantations of the fertile Breede River Valley. Blessed with extensive stands of orchards, vineyards and pastures, these towns are small but vital centres of industry, commerce and, most importantly, agriculture.

The rough farm roads that wind through this scenic countryside offer splendid vistas of country life at its finest, still embracing a long-gone era of well-tended vegetable gardens, pretty orchards and an untainted mountain and fynbos wilderness hailed as a hiker's dream.

Quaint old buildings and a distinctly rustic character form the heart of this landscape, and although there are indeed elements of the twenty-first century, this world is the last bastion of a simpler life: tractor rides through lands covered with indigenous flora, hot springs that act as welcome getaways for city dwellers, gentle diversions into any one of the numerous parks and reserves that dot the landscape, and hikes up little-trod mountain paths leading to breathtaking views that stretch across the Breede and Hex river valleys to the outskirts of the Little Karoo.

The country attractions of these small Overberg towns extend to the semi-desert climes of the Little Karoo, a craggy stretch of what seems dry and inhospitable terrain, but is in reality a fertile and productive land. Reaching from the towering Langeberg and Outeniqua mountains to the Swartberg, this 3 000-square-kilometre (1 160 square miles) stretch forms part of the Great Karoo, the much larger and far less arable plains that lie scattered to the north. At the heart of the Little Karoo lies sleepy Oudtshoorn, most noted for its fascinating museums, the ancient wonder of its Cango Caves, the vestiges of its once-thriving ostrich-feather industry and the crocodile, ostrich and wildlife ranches that dot its perimeter. It is, however, an important contributor to the economy of the region, forming as it does the focal point of not only the local farming community, but also a lively and exciting centre of contemporary arts and crafts.

RIGHT *Flanked by the mountains of the Swartberg, the 'ostrich kingdom' of Oudtshoorn lies in the heart of the Little Karoo.*

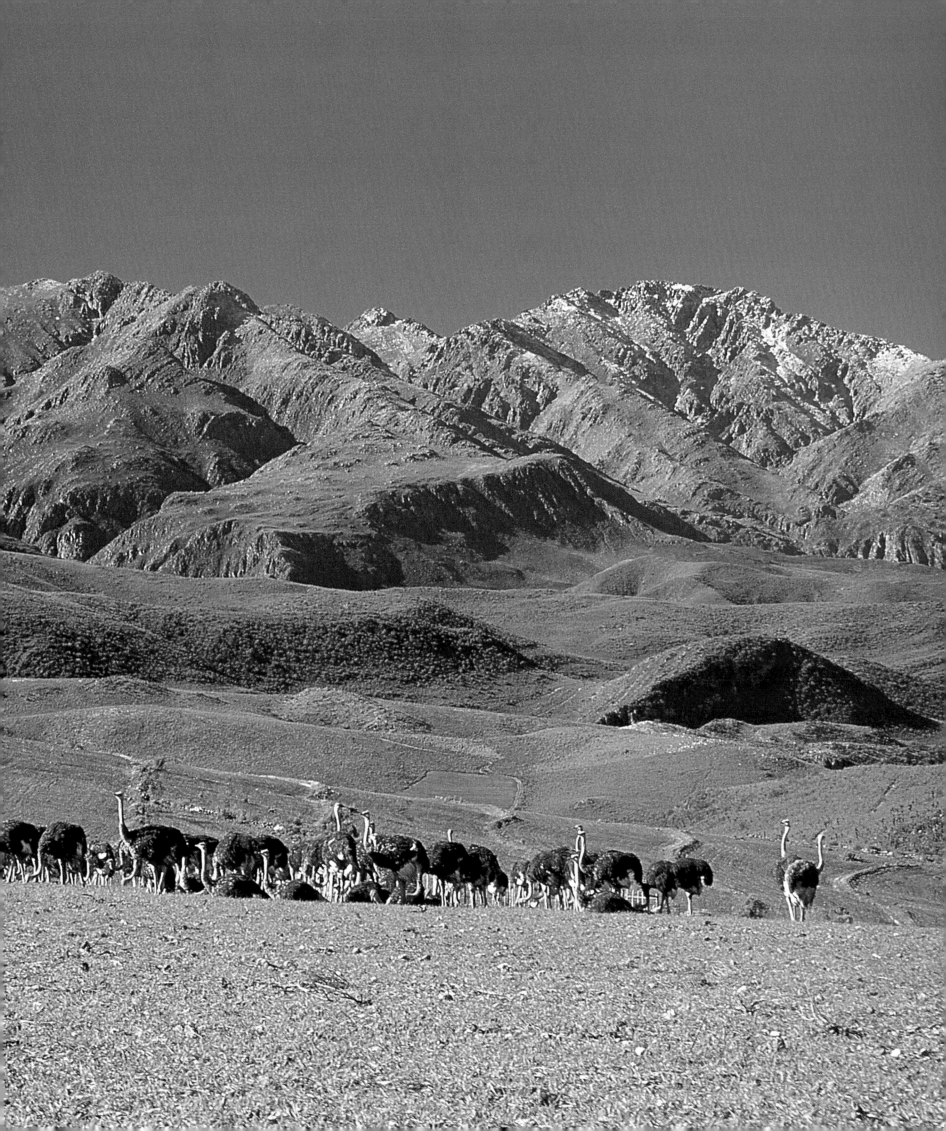

Top, centre and above *The charming Lord Milner Hotel may be Matjiesfontein's most enduring landmark, but many of the town's old structures are gracious reminders of a Victorian era in which elaborate interiors, intricate ironwork and turreted façades were de rigueur.*

Right *Backed by the Hex River Mountains – the peaks covered in winter by snowfall – the landscape of the Little Karoo is a haven for a fascinating diversity of plant and animal life, and the expanse of its landscape opens into a vast panorama.*

BELOW AND BOTTOM *Stretching for some 500 kilometres (310 miles)*
across the Western Cape interior is a series of vineyards, pastures and
orchards that have brought the small towns and hamlets, such as
Ceres, Robertson (seen here) and Worcester, world renown for their
export-quality produce.
RIGHT *The fertile valleys of the Koue Bokkeveld burst with deciduous*
fruit during the summer months, but in the winter, when the
mountains are dusted with snow, the trees stand bare.

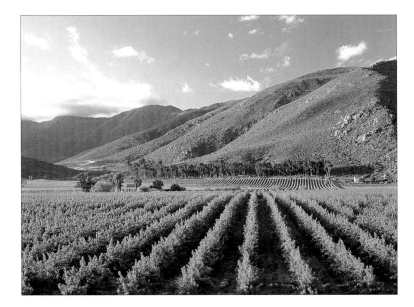

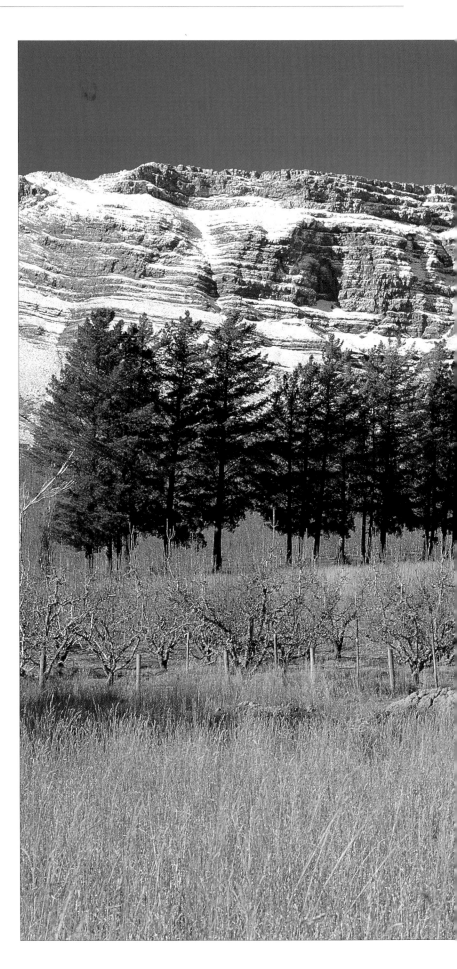

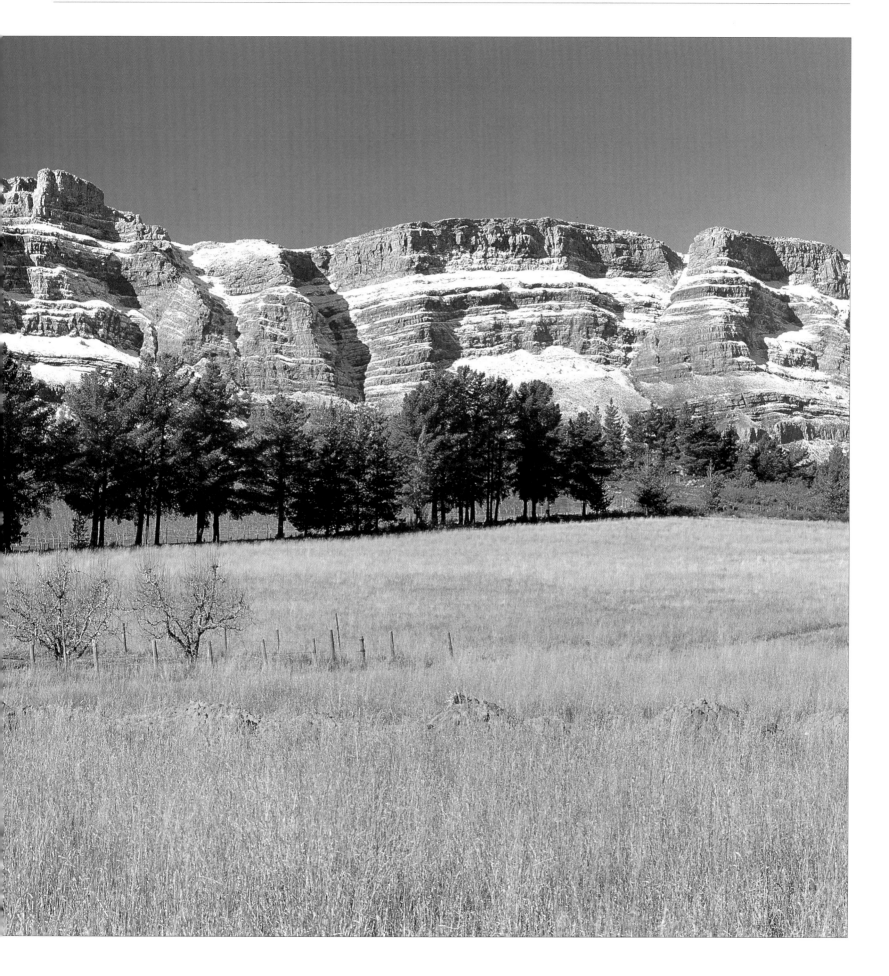

LEFT *The rocky ridges that rise above the plains of the Little Karoo at Schoemanspoort are typical of the rugged landscape of the Groot Swartberge, meaning 'great black mountains'.*
ABOVE *Separated from the coastal stretch of the Garden Route, the Little Karoo is a narrow strip of spectacular passes and scrubland wedged between the Outeniqua and Swartberg ranges that shield it from the dry interior.*
OPPOSITE TOP AND BOTTOM *Golden wheatfields are interspersed with a patchwork of apple and pear orchards that makes the Overberg one of the country's most successful farming regions. The small rural communities here depend on the agricultural lands for their livelihood, and rely on the rainfall initiated by the lie of the land and its mountain slopes.*

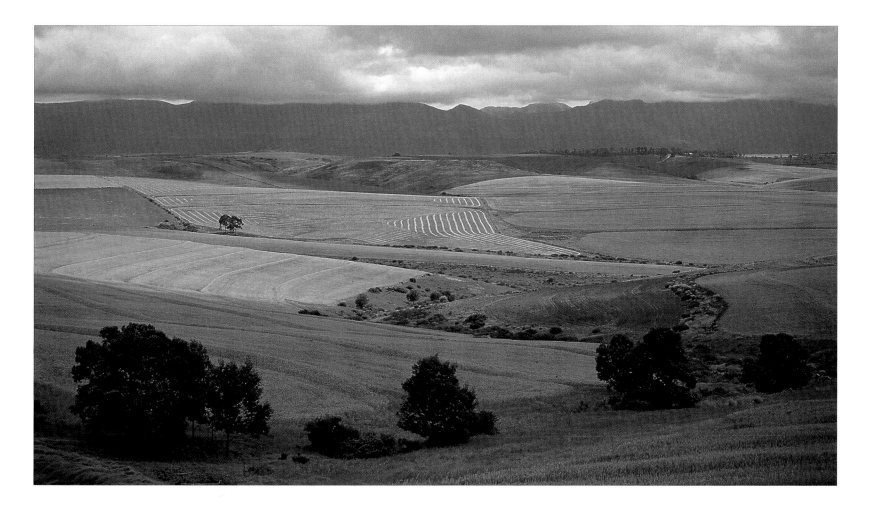

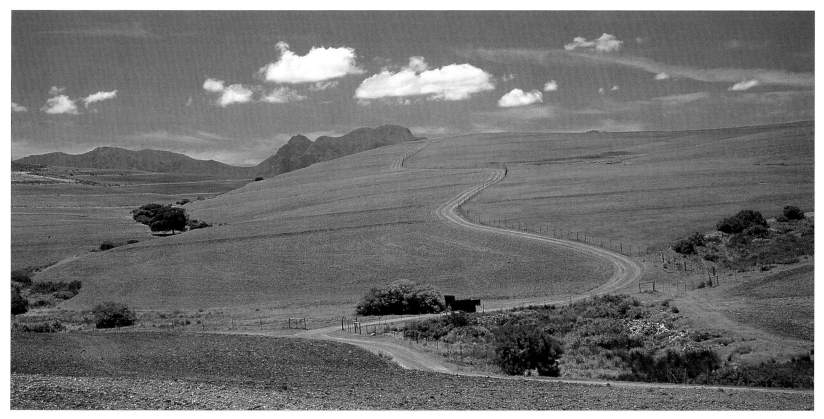

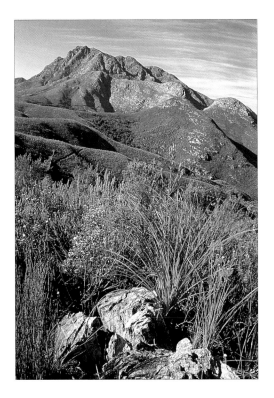

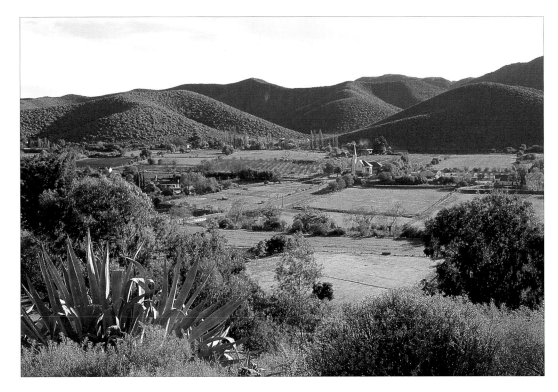

ABOVE *Although the far-flung tracts of the Little Karoo do not offer the traditional vistas offered in tourist brochures, the region's jagged mountain peaks and scrub vegetation has a beauty of its own.*

TOP RIGHT AND RIGHT *Like the land skirting Oudtshoorn, the Schoemanshoek area north of the town comprises a varied landscape of rocky outcrops and scrappy vegetation of succulents and scrub alternating with irrigated farmland.*

OPPOSITE *Backed by the impressive Hex River mountains, the Karoo National Botanic Gardens near the small town of Worcester stands in the intermediate vegetation zone on the outskirts of the Little Karoo, where the semi-desert climate provides the perfect home to succulent plants and shrubs.*

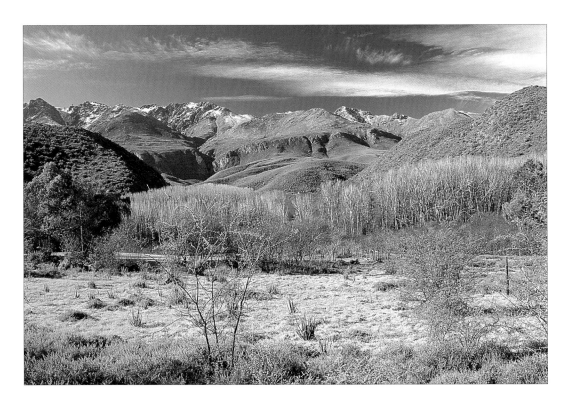

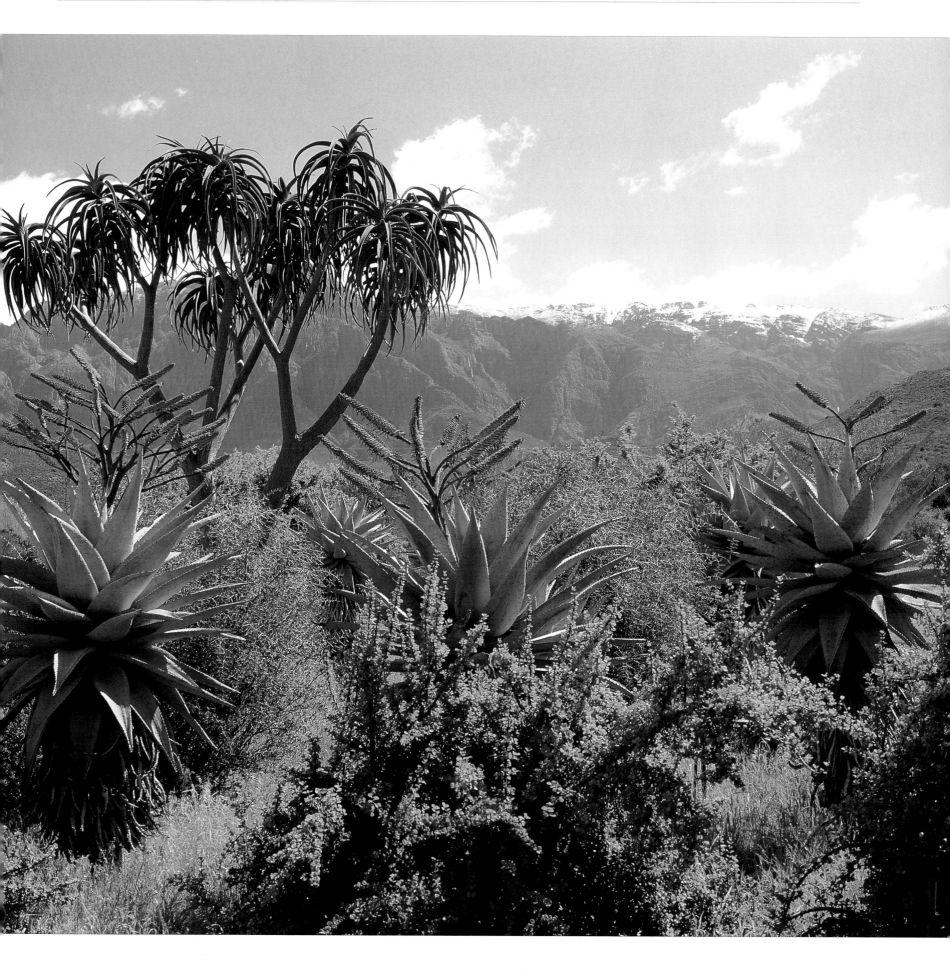

THE GARDEN ROUTE

The more than 200-kilometre (125 miles) stretch of scenic coastline between the harbour town of Mossel Bay and the natural splendour of the Storms River is a remarkable expanse that covers craggy cliffs, soft beach sand, a veritable garden of wild flora and gentle inland waters. Barricaded from the arid Great Karoo of the interior by the mountains of the Outeniqua and Tsitsikamma ranges, the Garden Route is a world of cliffs and coves, lakes and lagoons fed by the mighty Indian Ocean, and a forest playground with a fascinating diversity of animal life.

The Garden Route is it not only a region of immense importance as a natural heritage sanctuary, but also a popular holiday destination, visited by thousands of travellers and naturalists every year. Second only to the peninsula in its contribution to the tourism trade of the Cape, the wild ocean, lazy lagoons and magnificent forestsof the Garden Route attract a wide variety of adventurers, and remain one of South Africa's most fashionable holiday getaways.

The captivating towns that lie along the picturesque shore are laidback little settlements, whose townsfolk take enormous pride in what the broader region has to offer its many visitors.

Sleepy Knysna boasts fresh oysters, secretive louries, world-renowned forests and a gentle lagoon. George is steeped in a fascinating history that includes the legend of a bastard pretender to the British throne. Mossel Bay is the proud progenitor of the region's rich maritime history, while Plettenberg Bay plays host to sparkling beaches lapped by crystal waters against a verdant backdrop.

Lazing in the shadows of the Outeniqua and Tsitsikamma mountains, these resort towns – all blessed with warm, sunny summers and, in the most part, temperate winters – are some of the oldest established settlements on this coastal stretch. The harbours here continue to process fresh seafood as they have done over the centuries. Each town has its fair share of colourful history and modern industry, but the Garden Route, true to its name, is best known for its natural glory.

Bountiful rivers, fertile farmland and brilliantly coloured flowers only add to the spectacle of more than 200 bird species that flit across the blue skies, and the dolphins and southern right whales that cavort beyond the breakers. Seals and penguins visit throughout the year – as do the hikers that trek along the numerous trails that lace the wild interior of the Garden Route.

Thousands of hectares of protected reserves and dozens of separate conservation areas lie along the shore, incorporating spectacular natural forests and craggy foothills that lead down to these sparkling southern Cape beaches.

RIGHT *Swartvlei is the most extensive and deepest lake on the Garden Route and, although the mouth is silted up for at least half the year, the lagoon links with the ocean via a tranquil estuary.*

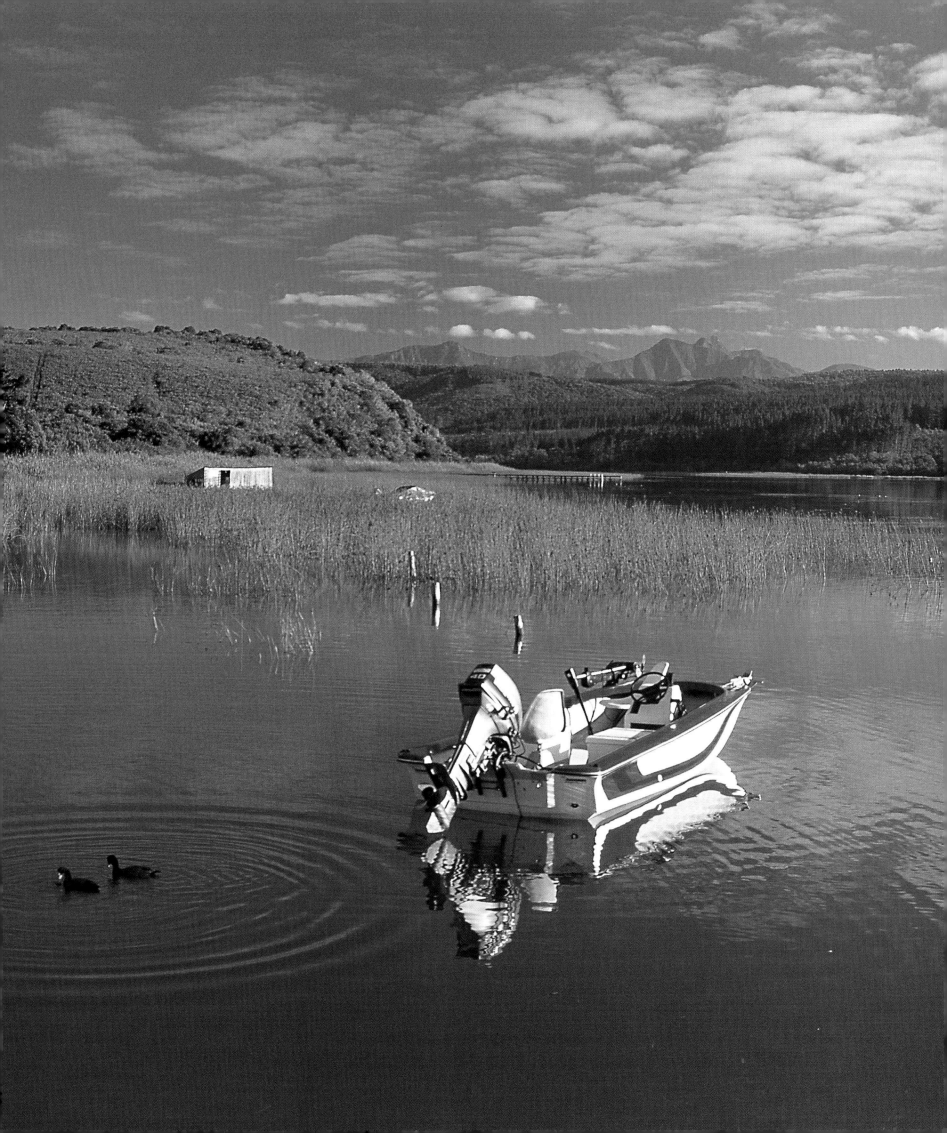

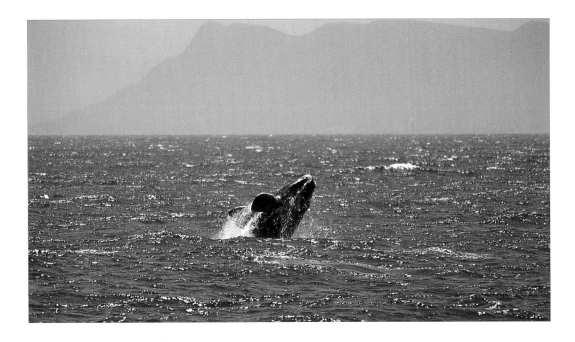

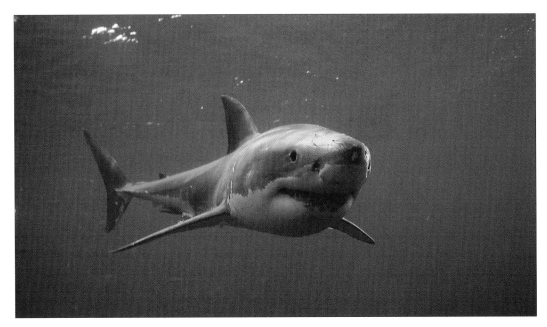

TOP *The famed Garden Route stretches along the southern Cape coast, its warm waters attracting southern right whales, which congregate off these shores between May and October in order to calve and mate in the turquoise waters.*

ABOVE *The waters off the Garden Route are a paradise of exploration, and the marine reserves here boast a bountiful sealife, from rare molluscs to great white sharks.*

RIGHT *The water sources of the Garden Route are not only the domain of anglers and holidaymakers, but also a parade of birds and small mammals such as the Cape clawless otter, after which the acclaimed 50-kilometre (31 miles) Otter Trail is named.*

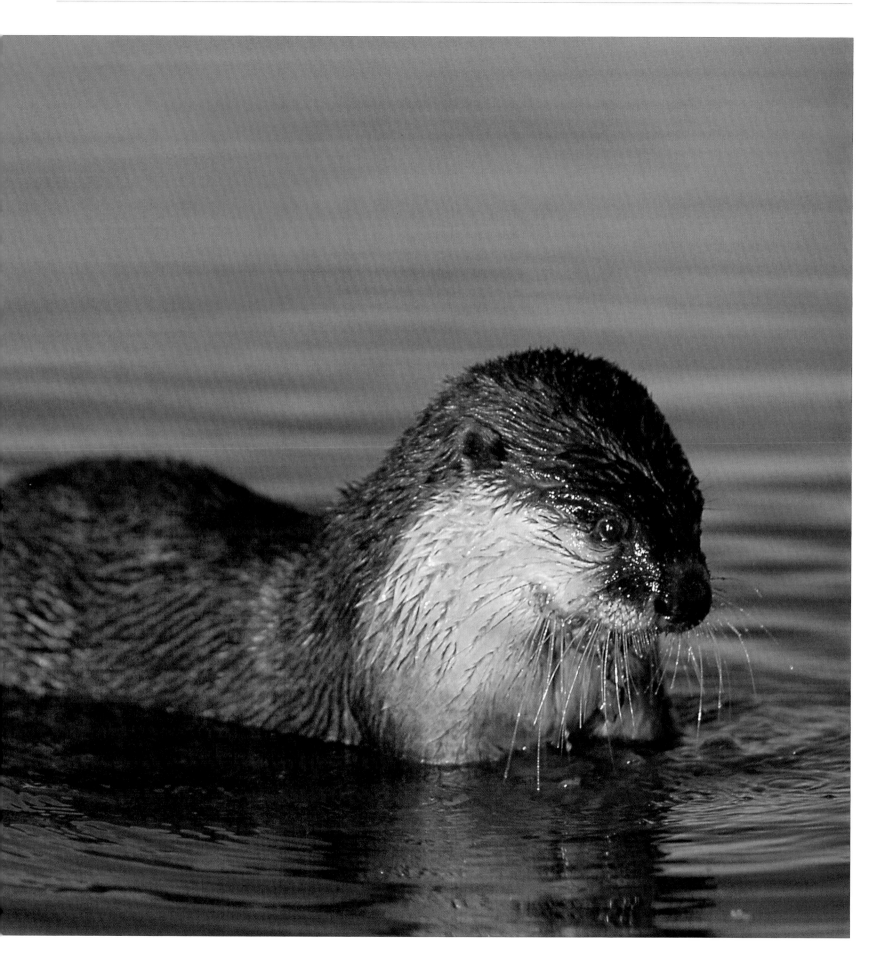

THESE PAGES *The landscape of the Garden Route is interspersed with bountiful rivers, prosperous farmland and the colourful flora that gives the region its name and, as a result, the towns – among them Little Brak (below), Heroldsbaai (below centre), Mossel Bay (bottom) and Great Brak (right) – have become extremely popular leisure stops for sailors, fishermen and watersport enthusiasts.*

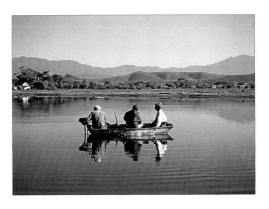

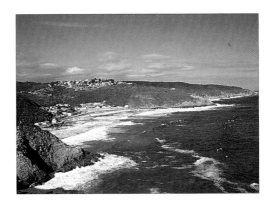

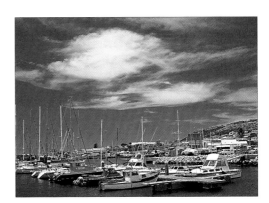

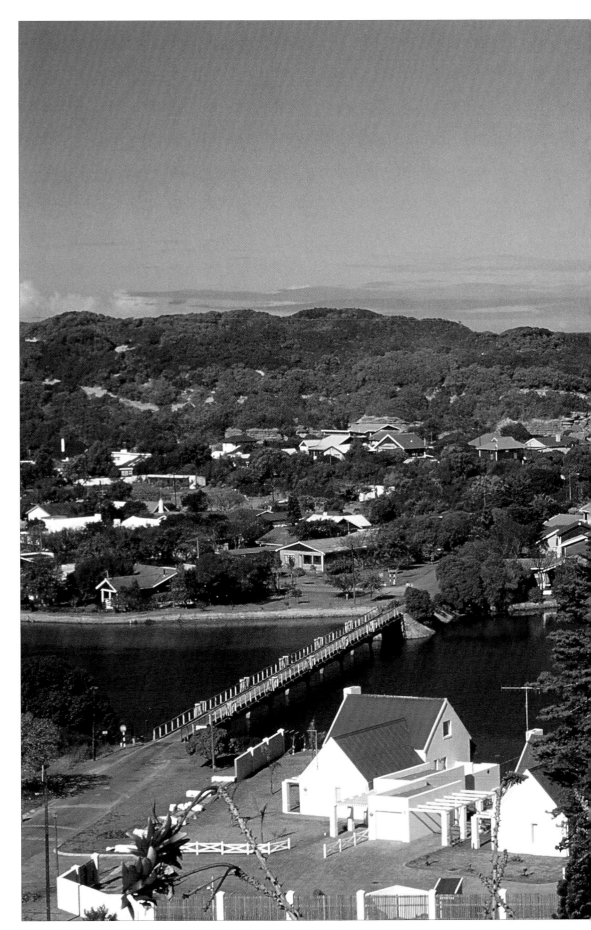

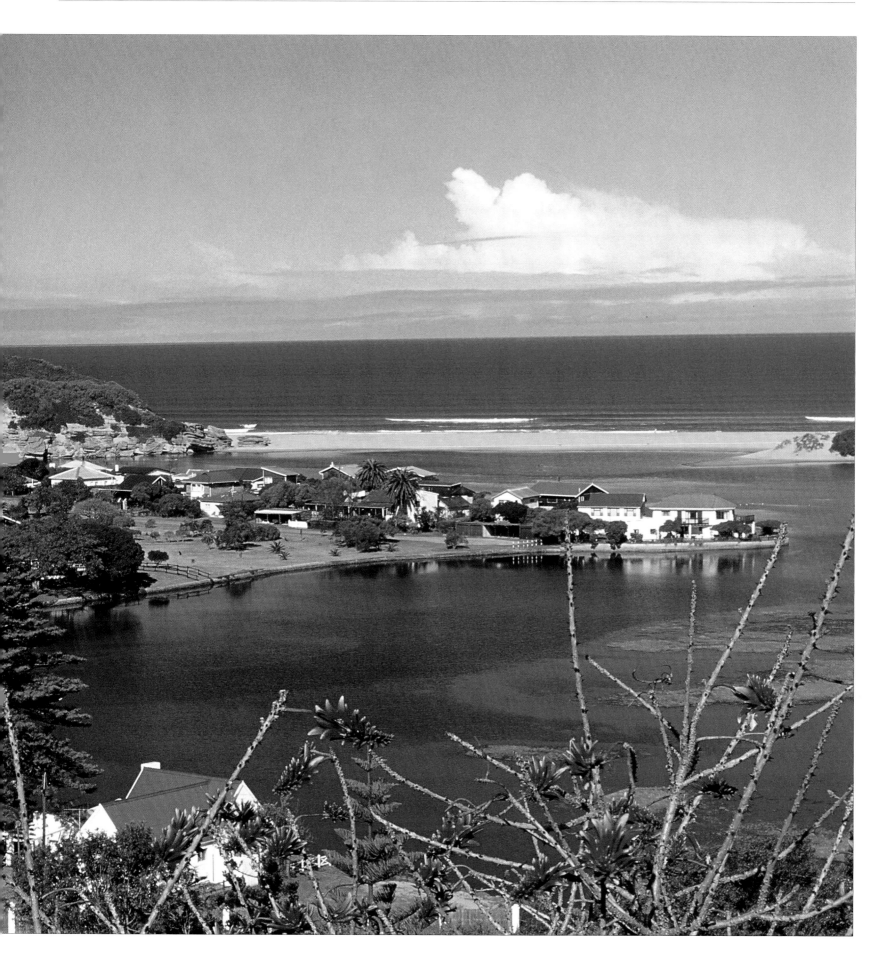

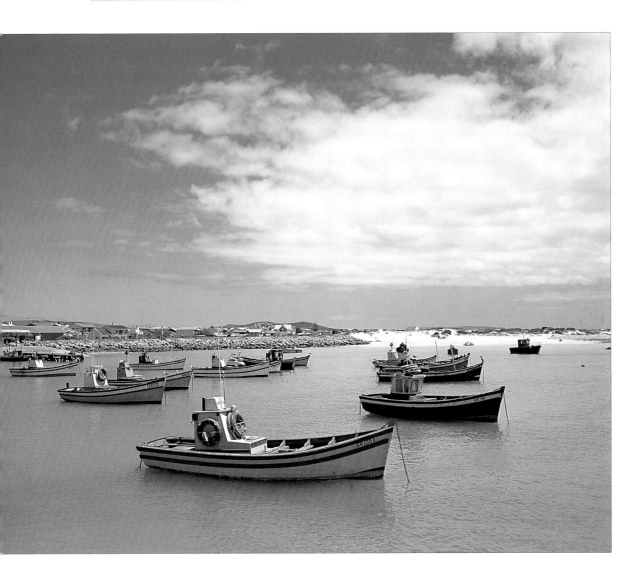

ABOVE *The earliest recorded inhabitants of Stilbaai were the hunter-gatherers known as Strandlopers, or 'beach walkers', who harvested marine resources along the striking stretch of coast. Today, the town remains a sleepy little holiday enclave.*

RIGHT *Because much of this world of tranquil lagoons and sheltered bays is protected by law in the form of marine reserves, development and recreation facilities along the Garden Route, in the most part, are limited to areas that have been specially set aside for the leisure industry that has made this coastal stretch South Africa's most favoured seaside destination.*

OVERLEAF, TOP LEFT *Carrying passengers through some of the most spectacular scenery on the southern Cape coast, the ever-popular Outeniqua Choo-Tjoe – which travels between George and Knysna – crosses the mouth of the Kaaimans River near Wilderness.*

OVERLEAF, BOTTOM LEFT *Wilderness, like much of the scenic Garden Route, comprises stretches of sensitive ecosystems, in themselves vital to the local tourism industry.*

OVERLEAF, TOP RIGHT *Although the picturesque town of Knysna is well known for the oysters offered by its equally impressive lagoon, the shores of the town are also synonymous with that other unique marine fauna, the tiny Knysna seahorse.*

OVERLEAF, BOTTOM RIGHT *The marine wonderland of the Knysna National Lakes Area is a spectacularly unspoilt expanse that includes the town, its famed forests, the lagoon and the looming Knysna Heads that guard the sanctuary.*

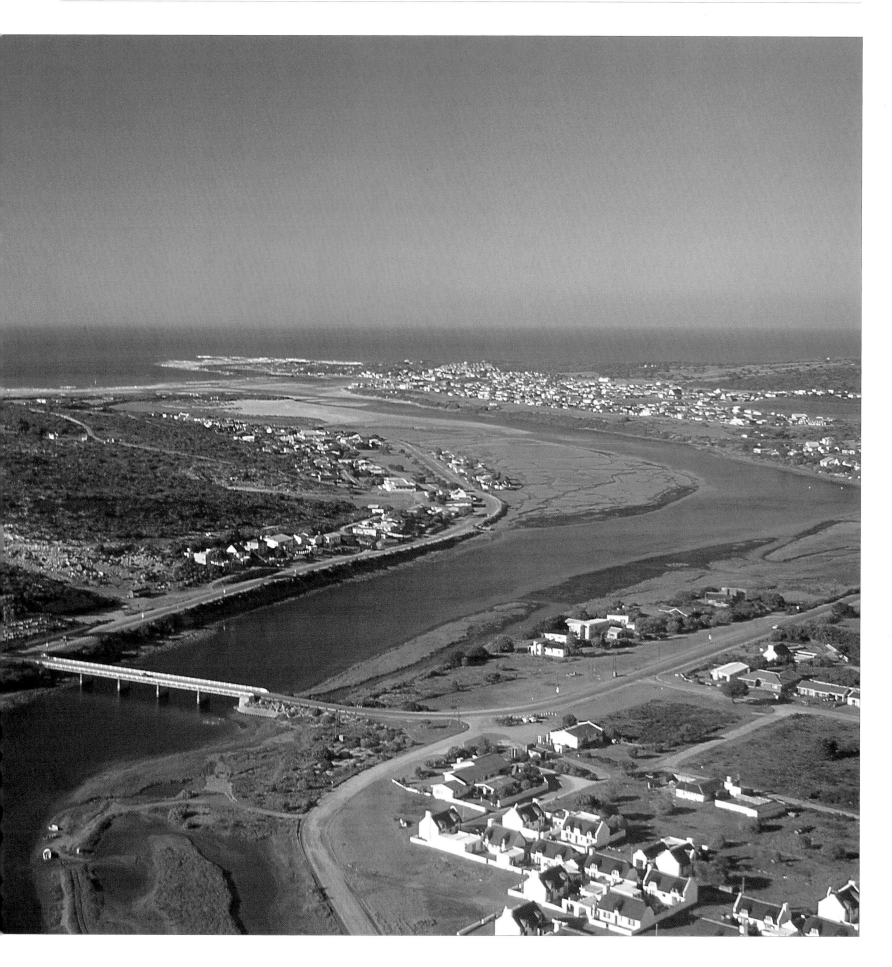

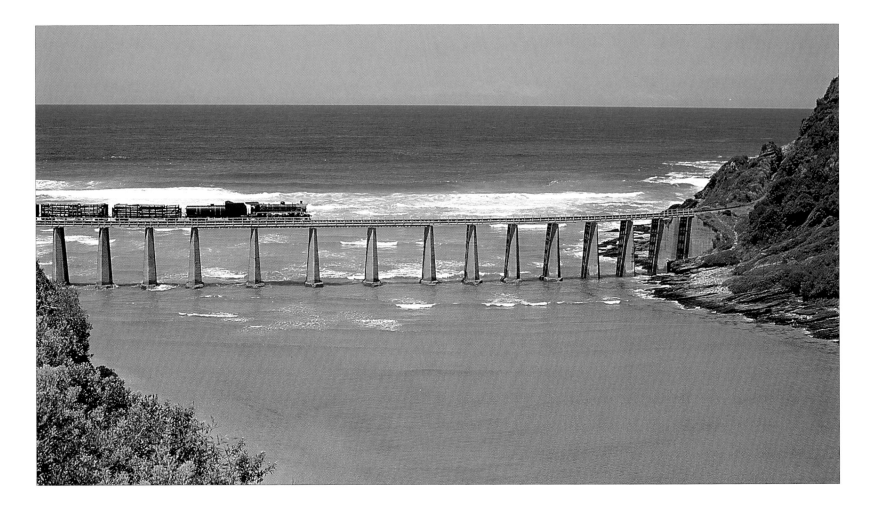

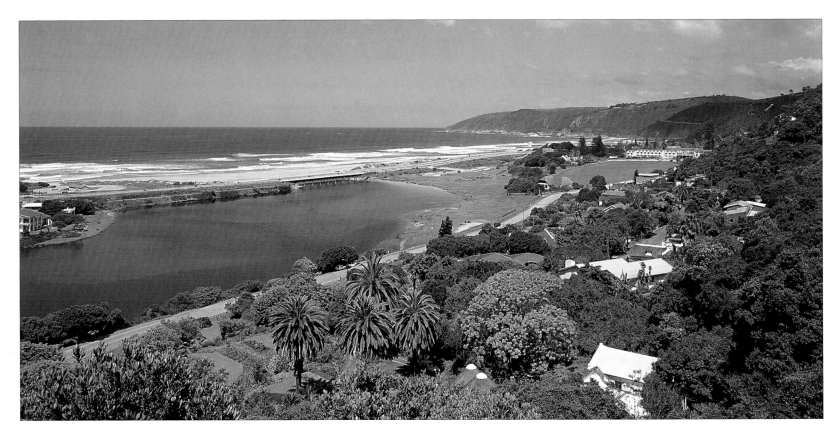

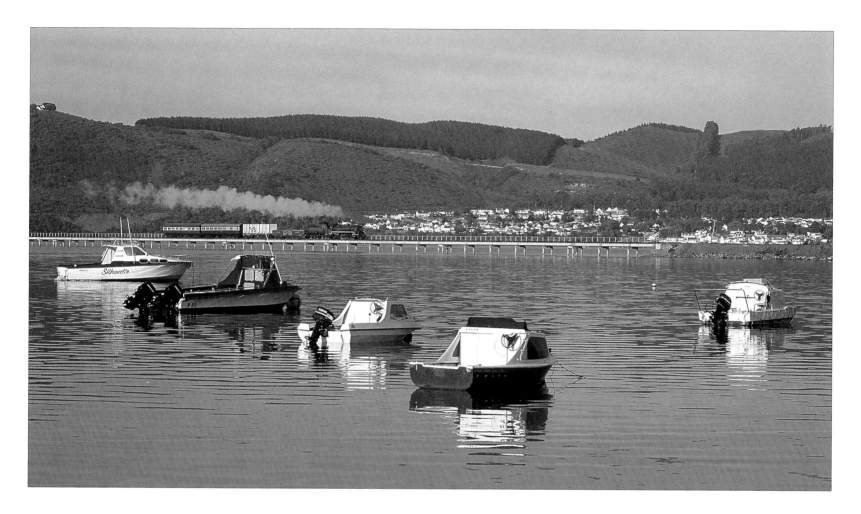

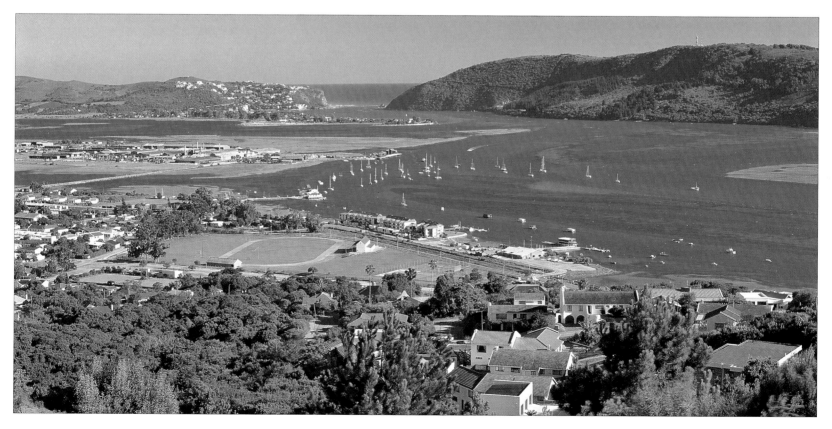

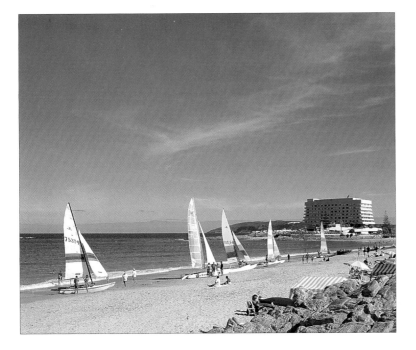

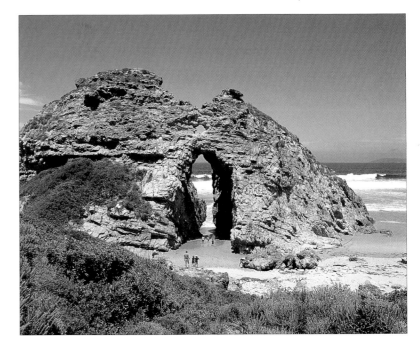

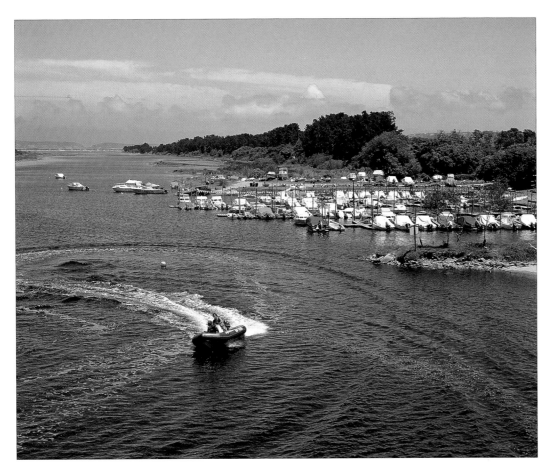

TOP LEFT AND LEFT *Magnificent Plettenberg Bay is the undisputed leisure capital of the Garden Route, its beaches – among them Hobie Beach – hosting every conceivable watersport and water-based activity.*

ABOVE *The combined action of the ocean waves and the windswept sands of Keurboomstrand have carved from craggy beach outcrops such unusual formations as Cathedral Rock near Plettenberg Bay.*

RIGHT *The extraordinary abundance of plant species on the Garden Route – epitomised by the splendour of the shoreline at Lookout Beach, popular swimming and walking terrain – provides a visual and tactile wonderland for the naturalist and conservationist.*

OVERLEAF *Almost entirely encircled by stands of tall trees and the verdant woodland of the Tsitsikamma forest and surrounding mountains, Nature's Valley is an engaging little village and reserve located at the foot of the Groot River Pass.*

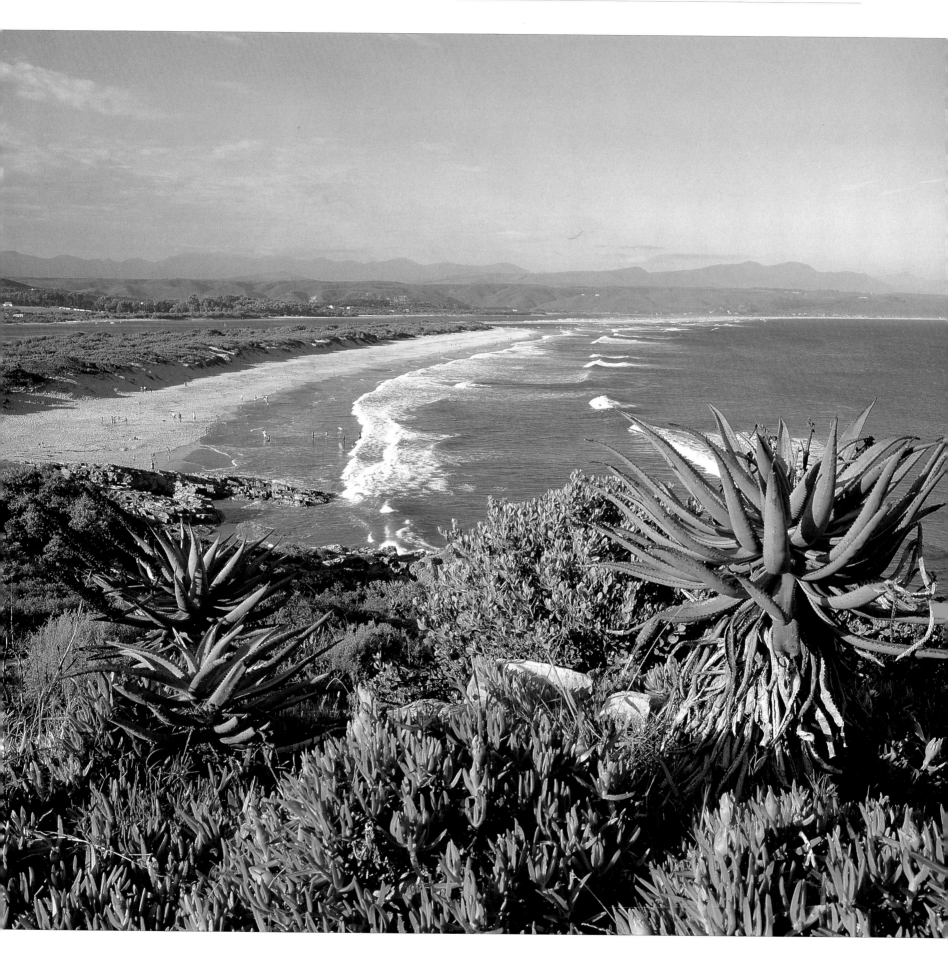

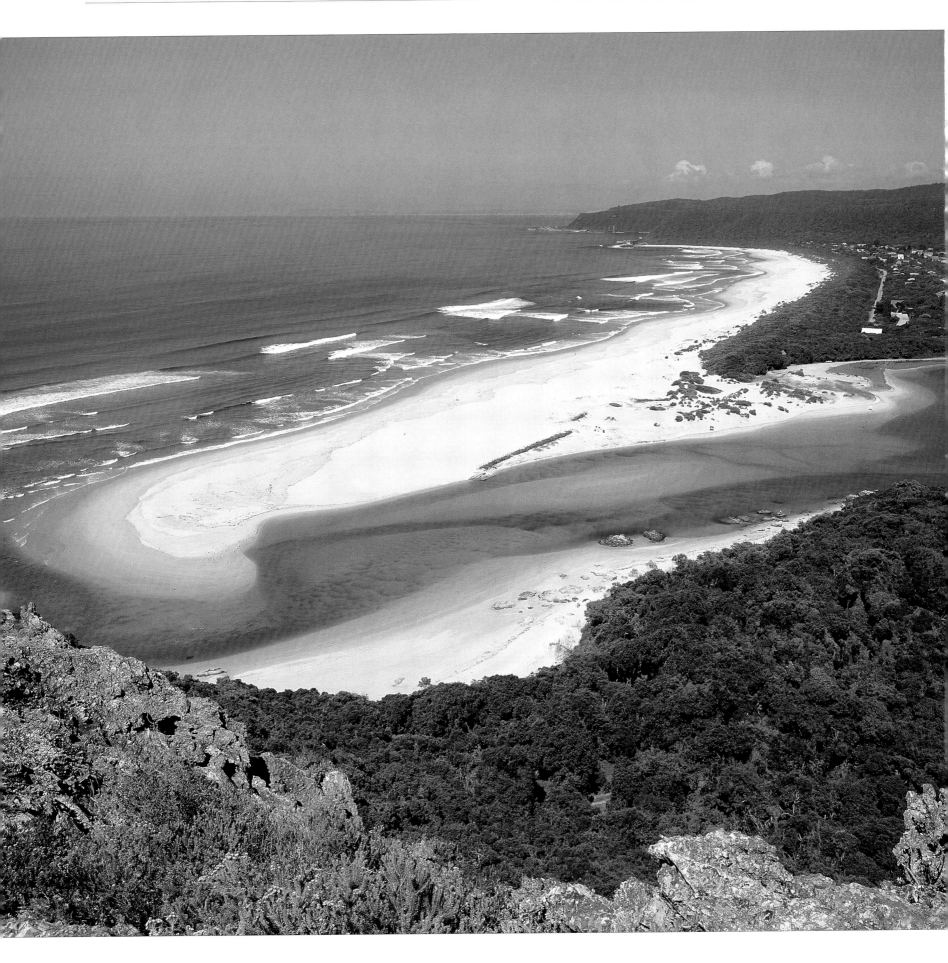